T0129272

Praise for Craig Seligman's
Sontag & Kael

"A remarkably sustained study in intellectual contrast."
—Martin Levin, *The Globe and Mail*

"Refreshingly unconventional . . . coolly astute . . . an excellent guide
to their work."
—D. W. Young, *The New York Observer*

"Playful and passionate . . . sets dozens of ideas spinning."
—Joy Press, *The Village Voice*

"Engagingly written, provokingly partisan . . . casually brilliant."
—Sarah Kerr, *Bookforum*

"This book's dwelling on the contradictions these women created
in a young writer's mind is continually revealing and insightful. It's
Seligman's *Portrait of a Critic as a Young Man*."
—Cornel Bonca, *OC Weekly*

"Probably the most purely pleasurable book of the year."
—Dan Callahan, *CultureDose.net*

"It is a work strong enough to captivate even those with no prior
knowledge of either Kael or Sontag."
—Allison Burnett, *Variety*

"A unique, uniquely interesting, and totally personal examination of the
work of two writers he knows backward and forward."
—Meredith Brody, *SF Weekly*

"Seligman's analysis of Sontag and Kael is nearly perfect in its symmetry."

—Myles Weber, *The Georgia Review*

"A dazzling performance of close reading in which he so vigorously parses each critic's style, ideas, temperament, politics, and emotional valence it's almost as though he's broadcasting color at a boxing match."

—*Booklist*

"Susan Sontag and Pauline Kael were literary titans who defined their era by challenging its precepts. In his insightful and magisterial work, Craig Seligman delineates how their reports from the front not only defined culture but also helped shape it. Seligman is a critic's critic."

—Hilton Als, author of *The Women*

"If this book were merely a collection of glittering aphoristic baubles—the finely honed, brilliantly turned insights of the Mss. Kael and Sontag—it would be a treasure trove worth prizing. But what with Seligman's deliciously discerning eye, his adventuresome taste, his pitch-perfect tone: the free play of such a vividly engaged mind over such dazzling material—it's much more than that. Not the least of its virtues is that it's such continuously tumbling *fun* to read."

—Lawrence Weschler, author of
Mr. Wilson's Cabinet of Wonder

"Craig Seligman has achieved something truly remarkable here: an insightful analysis of two very different yet equally influential writers that doubles as a candid intellectual autobiography. It's the sort of thing that many writers have tried, but it's tough to think of very many who have pulled it off so gracefully."

—Francis Davis, author of
Afterglow: A Last Conversation with Pauline Kael

Sontag & Kael

Opposites Attract
Me

Craig Seligman

COUNTERPOINT
BERKELEY, CALIFORNIA

Designed by Lovedog Studio

The Library of Congress cataloged the hardcover edition as follows:

Seligman, Craig.
 Sontag & Kael : opposites attract me / Craig Seligman.
 p. cm.
 Includes bibliographical references.
ISBN-13 978-1-58243-311-0; ISBN 1-58243-311-9 (hc)
 1. Sontag, Susan, 1933-2004. 2. Women and literature—United
States—History—20th century. 3. Criticism—United States—
History—20th century. 4. United States—Intellectual life—20th cen-
tury. 5. Film criticism—United States—History. 6. Kael, Pauline. I.
Title: Sontag and Kael. II. Title.
PS3569.O6547Z88 2004
818'.5409—dc22
 2003023878
ISBN-13 978-1-58243-312-7; ISBN 1-58243-312-7 (pbk)
DHSB 06 07 10 9 8 7 6 5 4 3

Printed in the United States of America

COUNTERPOINT
2560 Ninth Street, Suite 318
Berkeley, CA 94710

www.counterpointpress.com

To Silvana Nova

Sontag & Kael

1

I DIDN'T WANT TO WRITE A BOOK with a hero and a villain, but Sontag kept making it hard for me. She is not a likable writer—but then she doesn't intend to be. She's elitist and condescending toward those less informed than she is (i.e., everybody) and gratingly unapologetic about it. Intimidation, which I'll grant is an indispensable critical weapon, she uses remorselessly. So does Kael. The difference is that Sontag uses it charmlessly—but then she doesn't intend to be charming. (Charm, she almost seems to feel, is for pipsqueaks.) All that erudition impresses me, though there's a big difference, as anyone who's hung out with academics can tell you, between erudition and insight, erudition and taste. But my quarrel with Sontag isn't about her generally impeccable taste, and you would have to be crazy to say she lacks insight—her criticism is brilliant. I'm getting off on the wrong foot by even using the phrase "my quarrel with Sontag." She is a critic I revere, a magnificent critic.

When I complain about her, you should keep in mind the caveat Nietzsche proffered once at the end of a (much more bitter) attack on Wagner: "When I use harsh words against the cretinism of Bayreuth, the last thing I want to do is start a celebration for any *other* musicians. *Other* musicians don't count compared to Wagner." Obviously I can't be that categorical, since for me there *is* one critic who counts compared to Sontag, and though my aim in putting them side by side is to illuminate the work of each, honesty and ethics command me to admit right here what will be obvious anyway, which is that I don't feel the same way about them. I revere Sontag. I love Kael.

Loved. I met her when I was a young man just out of college who knew her work practically by heart; she was near sixty, and over the twenty-three years she had left, we became close friends. I've avoided meeting Sontag, though I've had the opportunity more than once. Her voice doesn't draw me as Kael's voice did; in fact it frequently puts me off. In my scale of enthusiasms, Kael's humanity and her virtuosity trump Sontag's loftiness, and it's a constant temptation to use Kael as a cudgel to bonk the smirk of self-esteem off Sontag's face with. I hope I can avoid it. It isn't useful, and it isn't—to use an unfashionable term that never fell out of fashion with either of them—honorable. What one achieved doesn't diminish the other's accomplishment. When in this book I place Sontag and Kael next to each other as perfect foils in their approaches, their purposes, and their personalities, the last thing I want to imply is that I'm running a contest. One of the pleasures of being in my position is that I don't have to choose.

A few fundamental parallels sharpen their differences that much more. Both were Westerners who came east, a prov-

enance that shaped Kael more than it did Sontag, since Kael began her career in the Bay Area and wrote for years as an establishment outsider; Sontag was younger and far less formed when she left the West. Both concentrated in philosophy, a background that didn't hurt either one's powers of argument; Sontag's career owes more (or at least owes it more visibly) to her formal education, in that she writes with a less seat-of-the-pants, more philosophical bent. Both were secular (very secular) Jews, heirs to an intellectual intensity that has gotten deflected, in the case of so many modern thinkers, from sacred works to cultural ones; both exemplify what Sontag sometimes calls Jewish moral seriousness. (Kael would have hated the phrase, but she wouldn't have disputed it.) Both were single mothers, and there's nothing like the need to support a child, as Kael once said, to jump-start one's ambition. A final parallel they share only with each other. Though they barely knew each other, they were the two most widely discussed and influential critics in the United States from the amazing era of cultural and political exuberance in the 1960s to the era of ossification that set in during the 1980s. After that, Kael stopped writing and Sontag shifted most of her attention to her fiction.

I'm using *critic* here to mean "commentator on art." Sontag objects to the term and doesn't consider herself a critic in the sense of "evaluator of art," since she generally avoids taking on work she dislikes. This is one of their major differences. Kael was happy in the role of evaluator, and evaluation is how she gets to insight. She never lost her excitement about the this-weekness of this week's movie, and while it may provide some enlightenment about last week's movie or next week's movie, this week's movie—the work at hand—is what she's

there for. For Sontag, the work at hand (which is nearly always a great or important one—the evaluating is finished before she sits down to write) is a stepping stone: she's eyeing bigger fish, using individual works to reach larger conclusions. Kael is a reviewer down to her toes; her responses are specific. Sontag is an aesthetic theorist, if not always a systematic one.

You can see the contrast easily in their approaches to the chestnut about what's appropriate to theater and what's appropriate to film. Kael is a pragmatist, and the question of domain doesn't interest her much: "Filmed plays," she writes, "are often denigrated, somewhat dishonestly, by people who learn a little cant about what is said to be proper to the film medium and forget about the pleasure they've been getting from filmed plays all their lives." She deals with the issue brusquely, impatient to move on, in her 1962 "Is There a Cure for Film Criticism?" an evisceration of Siegfried Kracauer's *Theory of Film* that is also one of her funniest attacks on theory in general. The whole debate about domains strikes her as misguided, since "what motion picture art shares with other arts is perhaps even more important than what it may, or may *not*, have exclusively." Responding to Kracauer's notions about what is "genuinely cinematic" (big objects, for example), she snaps, "Who cares whether the objects on the screen are accessible or inaccessible to the stage, or, for that matter, to painting, or to the novel or poetry? Who started this divide and conquer game of aesthetics in which the different media are assigned their special domains like salesmen staking out their territories—you stick to the Midwest and I'll take Florida?"

"Who cares?" may be a rhetorical question, but in this case it's one with an answer: aesthetic theorists—specifically,

Sontag, who devoted a substantial essay to the subject in 1966. Sontag's own views aren't any more prescriptive than Kael's ("there is no reason to insist on a single model for film . . . it is no more part of the putative 'essence' of movies that the camera must rove over a large physical area than it is that the sound element in a film must always be subordinate to the visual"), yet the question "What *is* the difference between theater and film?" so needles her that she has to spend twenty-three pages worrying it out—doggedly, cogently, and, whatever Kael might think of the effort, fascinatingly. Kael is down-to-earth, and she likes it there. Sontag heads off on a quest in the other direction. With an impulse that borders on the religious, she's searching for truth.

Consider their use of a single word, *serious* (and its derivatives *seriousness, seriously*). In 1988 Sontag told an interviewer, "Sometimes I feel that, in the end, all I am really defending— but then I say all is everything—is the idea of seriousness, of true seriousness." She has no higher term of praise. It encapsulates everything that most affects her in art and in thought, and it recurs in her writing over and over: "No one who loves life would wish to imitate her dedication to martyrdom. . . . Yet so far as we love seriousness, as well as life, we are moved by it, nourished by it" ("Simone Weil," 1963). "Still another use for silence: furnishing or aiding speech to attain its maximum integrity or seriousness" ("The Aesthetics of Silence," 1967). "Artaud changed the understanding of what was serious, what was worth doing" ("Approaching Artaud," 1973). "When I denounced . . . certain kinds of facile moralism, it was in the name of a more alert, less complacent seriousness. What I didn't understand . . . was that seriousness itself was in the early

stages of losing credibility in the culture at large. . . . Thirty years later, the undermining of standards of seriousness is almost complete" ("Thirty Years Later . . . ," 1996). As Lionel Trilling observed of the Princess Casamassima, "Seriousness has become her ruling passion." (And, as he added, it's also "her fatal sin, for seriousness is not exempt from the tendency of ruling passions to lead to error.")

Kael is no foe of the serious, but you wouldn't know it from her vocabulary. Seldom does she use the word any way but ironically, as a term of derision—not serious but "serious." "I couldn't persuade friends to go see *Charade*. . . . The word had got around that it isn't *important,* that it isn't *serious*." "*Faces* has the kind of seriousness that a serious artist couldn't take seriously." Of Jack Nicholson: "When he tried to give a quiet performance in *The King of Marvin Gardens,* he was so self-effacingly serious that he was a dead spot on the screen." Of *The Hindenburg*: "[Robert] Wise brings all his flatulent seriousness to this endeavor. One gasbag meets another." An emblematic usage occurs in one of her earliest essays, the 1956 "Movies, the Desperate Art": "Representations of Americans in foreign films always feel wrong to an American audience. It is true we are shallow, but we are not carefree and irresponsible, we are shallowly *serious*." And *solemn,* which Sontag uses as a commendation ("the Great Work . . . proposes satisfactions that are immense, solemn, and restricting"), on Kael's tongue becomes a withering insult.

Or take *vulgar* and its derivatives. Sontag uses the word as you'd expect her to, pejoratively. "I do find much promise in the activities of young people. . . . And I include, not least of all, their interest in taking drugs—despite the unspeakable vul-

garization of this project by Leary and others," she wrote in "What's Happening in America (1966)." (A special-case exception occurs in "Notes on 'Camp'": "The new-style dandy, the lover of Camp, appreciates vulgarity.") To the extent that vulgarity is the opposite of self-seriousness, Kael is willing to give it the benefit of the doubt. "How can you embrace life," she demands of Woody Allen's somber *Another Woman,* "and leave out all the good vulgar trashiness?" "There's no vulgar life in *Silkwood,*" she complains. And: "Vulgarity is not as destructive to an artist as snobbery, and in the world of movies vulgar strength has been a great redemptive force, canceling out niggling questions of taste."

Kael might have been talking about Sontag when she wrote, "I don't trust critics who say they care only for the highest and the best; it's an inhuman position, and I don't believe them." Her own appetite for what she called trash was, according to her, half of what made her (and makes each one of us) a critic. "I think the sense of feeling qualified to praise and complain in the same breath is part of our feeling that movies belong to us," she wrote. "Going to the movies was more satisfying than what the schools had taught us was art. We responded totally—which often meant contemptuously, wanting more, wanting movies to be better." Next to Kael's catholicity, Sontag's high-mindedness—her horror of the vulgar and the low—makes her look thin-skinned and finicky, a kind of modernist Margaret Dumont.

That's a little unfair to Sontag (and to Margaret Dumont), since the truth is that Kael is just as fixed on standards as Sontag is. Both are, preeminently, lovers of literature whose enthusiasm for cinema—a secondary enthusiasm, they both avow

(Kael more insistently, as a matter of fact)—left them feeling seduced and abandoned as the art collapsed late in the century. True, Kael enjoyed trash, and enjoyed saying she enjoyed it, but she also fiercely upheld the distinction between trash and art. (This was one of her beefs with the auteurists: "How can they, with straight faces, probe for deep meanings in these products? Even the kids they're made for know enough not to take them seriously.") Sontag generally avoids having to make the distinction at all by restricting her writing (especially after *Against Interpretation*) to art she esteems; for her, what she esteems and what's great are one and the same. From all the evidence, she abhors trash (though she seems to have sat through a lot of it at the movies). The upshot is such a puritanical view of art—"I'm an incorrigible puritan," she freely admits—that for years it overshadowed her commitment to pleasure.

Would she have found Kael vulgar? It's hard to imagine her surrendering herself to Kael's style, which is everything hers isn't—exuberant, excessive, intimate, emotional, and, of course, funny. (According to Leland Poague and Kathy A. Parsons's *Susan Sontag: An Annotated Bibliography, 1948–1992*, though, she did once express admiration for Kael's criticism, in a 1980 interview with a Polish periodical.) Sontag's own critical style is such a model of detachment that at its most extreme it can suggest intelligence uninflected by personality. Something has been left out of these essays, you may feel; something's missing. And it's true, something is: the phenomenal world, the world that bursts forth in all its "good vulgar trashiness" in Kael's criticism—Sontag has saved it for her fiction. Film, though, wallows in the phenomenal world; it's a journalistic medium

by nature. Not even the most world-embracing art—not even Shakespeare—can give you the vista of the world that you get through a movie (though obviously it can give you something more). This journalistic side was fuel for Kael. Movies, she was fond of pointing out, show us how we live our lives and, by providing models of behavior (social, professional, erotic), how *to* live our lives. "And if it be said that this is sociology, not aesthetics," she wrote early on, "the answer is that an aesthetician who gave his time to criticism of current movies would have to be an awful fool." Ideas alone weren't enough for her. Critical prose can't survive on ideas alone. It needs something more to give it traction (or to give *you* traction), some poetry or some journalistic observation or at least some humor. Otherwise it dries out and turns into scholarship—which is fine and useful in its own right, but it doesn't reward the general reader. (Insofar as it does, it's something more than scholarship.)

Fortunately, Sontag provides it. Her meticulously worked sentences give off a soft glow. I don't blame her for getting peeved at all the attention profile writers have paid to her rather lunar beauty, but what isn't often enough remarked is the lunar beauty of her prose. Every word is *the* word, chosen with fanatical care and unvarying elegance. This kind of beauty—the beauty of precision—tends toward quietness, self-effacement, but occasional patches are stunning, even showy. Consider the eighteenth-century balance of this aphorism from "The Imagination of Disaster": "Ours is indeed an age of extremity. For we live under continual threat of two equally fearful, but seemingly opposed, destinies: unremitting banality and inconceivable terror." Or her definition of beauty as "a glad-

ness of the senses." Or the one-sentence précis of the S&M aesthetic that closes "Fascinating Fascism": "The color is black, the material is leather, the seduction is beauty, the justification is honesty, the aim is ecstasy, the fantasy is death." Mmmm. Kael's sentences, in general, weren't beautiful, though she was capable of lyrical flights and of a lovely quiet lyricism; it permeates her 1967 "Movies on Television," the first essay she published in *The New Yorker*.

For the most part, though, beauty isn't the gratification uppermost in your mind when either of these critics has you under her spell. The thrill is different, almost erotic—though I know the word is loaded. What I mean is that your intellect responds to their writing in a manner that's so overpowering, so encompassing, and so concentrated that it's *like* an erotic experience. Sontag has pointed out that ideas can become "sensory stimulants," "sensuous material," and she loved the way Roland Barthes linked thinking with eros. Stimulated the right way, the intellect turns into a sensual organ, fully focused, just as in good sex, on the single activity: reading. Or activities: reading and thinking.

PAULINE KAEL. Born 1919, the youngest of five children of Polish immigrants—"a bookish girl from a bookish family"—and raised on a chicken farm in Petaluma, California. (When I moved to San Francisco in 1982, the groceries there still sold Kael eggs.) Resettled, with her family, in San Francisco in the late twenties. Entered Berkeley 1936, majoring in philosophy and working for left-liberal causes; felt her lack of wealth acutely and spoke of this aspect of her college years with

bitterness for the rest of her life. Brilliant academic record. Moved during the following decade with a bohemian, largely gay crowd that included the poet Robert Duncan, the painter Jess, the poet Robert Horan (her lover, with whom she lived for a time in New York), and the poet and filmmaker James Broughton, who in 1948 became the father of her only child, Gina James. Worked at menial jobs (seamstress, cook, nanny) while trying out various kinds of writing, including memoirs, plays, and book reviews; didn't write her first movie review— of Chaplin's *Limelight*, which she disliked—until 1953, when she was thirty-three. ("When I started doing movie pieces, all this interest in the arts clicked together, as if I'd found my medium.") Marriage to the owner of a Berkeley movie house led to her writing film notes; from 1955 to 1962, she also broadcast reviews, unremunerated, on the listener-sponsored radio station KPFA. Many of these radio reviews appear, together with longer pieces written for various journals (*Sight and Sound, Partisan Review, Film Quarterly*), in her first book, *I Lost It at the Movies*, published 1965, the year she finally picked up and moved to New York. ("San Francisco is like Ireland. If you want to do something, you've got to get out.") Wrote for glossies, where she was a bad fit (*McCall's* famously fired her), and *The New Republic*, which she quit over issues of editorial tampering. "I had come to the conclusion that it was just about impossible making a living as a movie critic. I was lying in bed with the flu, I was busted, when a telephone call came from William Shawn of *The New Yorker*."

Shawn made an astute hire. For the next two decades, Kael got talked about and argued about and certainly sold more magazines than any of *The New Yorker*'s other fixtures. Initially,

both sides were wary. "The first few years I got very hostile responses from the readers and from a lot of the staff because the writing was colloquial and direct and deliberately so and deliberately crude in many ways," she recalled. "I remember getting a letter from an eminent *New Yorker* writer suggesting that I was trampling through the pages of the magazine with cowboy boots covered with dung." Before she got there, the magazine had irritated her the way it irritated lots of people—"It is 'knowing' about everything," she'd complained. Its air of light irony toward popular culture demonstrated what she called, in a 1971 essay, "the trap of condescension," and without citing *The New Yorker* specifically she elaborated, "This used to take the form of that horrible debonair style which was once the gentleman-critics' specialty. They were so superior to the subject that they never dealt with it." Kael dealt with it. Hers was not the usual moralist's warning that the movies are corrupting us. It was the cry of a frustrated movie lover that, through greed and timidity, they were corrupting *themselves*.

She believed, with an intensity that all but flattened readers, that a great deal was at stake in the movies—and not just the art movies that Sontag and Dwight Macdonald, among others, were championing. Macdonald, who was born in 1906, belonged to a generation of American intellectuals who were intent on segregating high culture from popular culture. His bitterness against mass culture is startling to come upon today— "It doesn't even have the theoretical possibility of being good," he thundered in his widely read 1960 essay "Masscult and Midcult." "It is non-art. It is even anti-art." For a younger generation of critics, this distinction rang false. Kael knew that she experienced mass culture as something more than aesthetic junk

food. So did Andrew Sarris. So did Sontag, who was arguing in 1965 that "the distinction between 'high' and 'low' culture seems less and less meaningful," that for the "new sensibility" she was attempting to define, "the feeling (or sensation) given off by a Rauschenberg painting might be like that of a song by the Supremes." You could love Godard *and* Jasper Johns *and* the Beatles.

Kael didn't have to convince most of her readers that films mattered, but she succeeded better than anyone else in articulating why, and in doing so without either condescending to the medium or granting the industry any more respect than she thought it deserved. From her first review to her last, a span of nearly four decades, she was remarkably consistent; her prose got more intricate, but her approach never changed. She was as sensitive to fraud as some people are to pollen, and this aversion was probably what made her such a natural as a critic. That most movies are vast meadows of fraud didn't faze her (though it often depressed her). Her genius was for separating out what was fake from what was true, zeroing in on the parts of a movie—a performance, a theme, a look, a line—that you could respond to without being had. It was even OK to respond to fraud if you knew what you were responding to, because certain kinds of fraud appeal to something in our natures that isn't fraudulent. Others seek out the goo in all of us. "Whom could it offend?" she asked of *The Sound of Music.* "Only those of us who, *despite the fact that we may respond,* loathe being manipulated in this way and are aware of how self-indulgent and cheap and ready-made are the responses we are made to feel." The shame isn't in responding but in failing to understand what it is we're responding to, and why. Kael, who was often derided

as an anti-intellectual (Sontag was, too, believe it or not), was a champion of the intellect. She understood not just why it didn't need to be quarantined from the street but also how exposure to the street enriched it; she understood the reasons smart people love movies even when movies aren't smart.

Kael made much out of the progress in her writing from the semiformality of her early essays to the unbuttoned exuberance of her late ones, but I think it mattered more to her than it did to her readers, for whom the early writings were already a jolt. The voice was there. That voice became instrumental in reshaping the American critical language, stripping it down and making it colloquial. But between, say, the plummy orotundity of H. L. Mencken and the late Kael's pixilated slang, there were some significant way stations, such as Macdonald and James Agee, both of whom Kael admired. These writers were consciously direct and informal; so was she, but by the end of her career she was so bent on bringing the fizz of the American vernacular into literary usage that her slang took on a plumminess of its own. She said she wanted to talk about movies the way people talk about them leaving the theater, and her prose does seem to replicate the human voice. But this speaking voice is a carefully crafted illusion—"pure literary artifice, carefully, painstakingly constructed, masquerading as ordinary speech," as John Bennet, her last editor at *The New Yorker*, recalled in a talk after her death. "No one has *ever* talked the way Pauline writes," he said. "Balzac, madly revising at his most caffeinated, Proust at his most hypodermically caffeinated, had nothing on Pauline when it came to crossing out, writing all over the margins, taping extra sheets of paper

to the margins to make even more revisions—revisions of revisions, inserts inside inserts."

A label that turns up regularly in articles about Kael—often by detractors, who feel they have to grant her *something* before they start hacking away—is *stylist*. She was, indeed, a major stylist, and she was already one in her first published essays. But the word suggests that the splendor of her writing was a bonus that came packaged with her criticism. No: her writing *is* her criticism. In her case as well as Sontag's—in criticism across the board—style is substance. A critic's words convey her ideas, but her style—her craft—carries the authority of her personality, from which her tastes grow. An anecdote: one summer day not too many years ago, I was on Kael's verandah, staring off vacantly, and seeing me through the screen door, she called, "What are you doing?" "Thinking," I told her. (I wasn't.) She said, "I only think with a pencil in my hand." It was just a small joke, but it got at something. You sit down to review a work you're not sure about your response to, and by the time you get up from your desk, you know what you think. It isn't a matter of taking a stand and then coming up with an argument to defend it; the argument is more organic than that. As you connect your thoughts—as you try to make them coherent by the simple method of fixing your sentences, making the words flow, correcting imprecisions—an argument emerges. There may be beautiful vacant writing, but I can't cite any beautiful vacant criticism. What I *can* cite is a lot of bad critical prose that thinks it can get away with its mediocrity by virtue of the (ostensibly) excellent quality of the thought behind it. "I don't play accurately—any one can play accurately—but I play

with wonderful expression," Oscar Wilde has Algernon say as he rises from the piano, and only the dimmest member of the audience can fail to catch the lampoon. Perceptions that aren't backed up by creditable prose are generally worthless, because writing isn't just a conduit for thinking. Writing *is* thinking.

SUSAN SONTAG. Born 1933, New York City; raised in Tucson and Los Angeles. An alienated, bookish, intensely serious child—"When I was nine . . . I'd lived for months of grief and suspense in *Les Misérables*. (It was the chapter in which Fantine is obliged to sell her hair that had made a conscious socialist of me)"—who looked back on childhood as a "long prison sentence." Undergraduate work at Berkeley (one semester, nine years after Kael left) and the University of Chicago, where she married one of her instructors, Philip Rieff; David Rieff, her only child, born 1952, when she was nineteen. Brilliant academic record. Postgraduate work at Harvard, Oxford, and, most important, the Sorbonne, a landmark in her long love affair with French culture. Divorced Rieff, moved to New York, began publishing essays in *Partisan Review, The New York Review of Books,* and other journals. Notoriety soon followed. *The Benefactor,* a novel (or antinovel), published 1963; *Against Interpretation,* criticism, published 1966.

And then notoriety turned into fame. In a prose that was as colorless, as odorless, and as intoxicating as vodka, she had been mapping out a position that celebrated the senses as a fully deserving partner of the intellect. That was why she was sometimes accused of anti-intellectualism: there was no essential firewall, she argued, between the life of the mind and the

life of the body. Given her taste for austerity, you could hardly call Sontag a hedonist—"If hedonism means sustaining the old ways in which we have found pleasure in art . . . , then the new art is anti-hedonistic," she reported approvingly in 1965—but the interest in pleasure is there, too. Sontag came to prominence in a postfifties culture that was busy getting back in touch with the senses. Sex was in the air (along with drugs and rock and roll), and intellectuals desperately wanted an invitation to the party. Sontag provided it. The credentials she presented were persuasive: in addition to several manifestos of what she called the new sensibility, *Against Interpretation* demonstrated conversance with practically every area of the arts and included masterly essays on literature and criticism, anthropology and psychoanalysis, theater, the avant-garde (happenings and the French new novel), pop culture (science-fiction films and camp), and film, which she once called "*the* art of the twentieth century." Most of those essays haven't aged an hour. The electricity of the perceptions and the evangelist's passion rub up hypnotically against the dry, dispassionate prose. Sontag's style is a model of density without condescension, and her refusal to make things easier for the reader is enormously flattering. You race through Kael, but each of Sontag's sentences you have to wrestle down before moving on to the next one. With Kael you get caught up in the cataract of thought; Sontag you can feel weighing each word. (And in fact Kael was a fast writer and Sontag an agonizingly slow one.)

What's absent, famously, is humor. Her gravity holds the reader at a constant arm's length. But then hard-to-get is a classic element of allure. If I'm eroticizing Sontag's writing (and I don't deny that I am), it's because I find it so deeply seduc-

tive; Garboesque, almost. There's a mystery in Sontag—in her unreachability, her refusal to curry favor, to charm—that *is* her charm. In the imagination of the reading public, to whom she became a prototype of the intellectual, her reserve added piquancy to the fact that, as her photographs told you if her prose didn't, she was an unabashedly sexual being. But her prose *did*. For example, in *Against Interpretation*, she noted,

> A country in which the vindication of so sexually reactionary a book as *Lady Chatterley's Lover* is a serious matter is plainly at a very elementary stage of sexual maturity. . . . The truth is that love is more sexual, more bodily than even Lawrence imagined. And the revolutionary implications of sexuality in contemporary society are far from being fully understood.

That passage probably *has* aged. The openness (or relative openness) with which we talk about sex today has taken the edge off what must have been a liberating lack of coyness. Not that anything she said could be construed as titillating. She didn't even write *as* a woman; but for the photographs, if she had signed her work "George Sontag," nobody would have been the wiser. She didn't, though, and the fact that her name was Susan inevitably affected the reception of her work. A million B pictures have cast a starlet as the female scientist on the expedition, to throw in some sex appeal. Sontag doesn't give the lie to those characters; she *validates* them. The notion that intelligence compromises a woman's sexuality—her "femininity"—is in such ignominious retreat today that it's hard now to appreciate the figure she cut. A man couldn't have captured the imagination the same way, back in the dark ages before we

allowed ourselves to celebrate the eroticism of the male body, too.

The charge that Sontag has used her beauty to further her career is drivel; the essays collected in *Against Interpretation* would have made a warthog famous. But she *has* used her beauty, and in the right way: to make herself interesting photographically. Sontag respects photographs. For four decades, she has made a superb photographers' model. The camera relishes her opaqueness. And age has withered her spectacularly. "Society allows no place in our imagination for a beautiful old woman who does look like an old woman," Sontag complained in her 1972 article "The Double Standard of Aging." "No one imagines such a woman exists." Twenty years later, a profile in *The New York Times Magazine* contained this description of her at fifty-nine: "Wrinkles and creases run wild on her unadorned face. Her skin is as pale as a monk's. Her long, unruly, onyx-black hair is rent by a dramatic slash of pure white that runs like an ice floe over the crest of her head." Could a cover model ask for a more smitten gaze?

(As a beauty, Kael wasn't in the same league, and the photographs of her aren't, either. The one place she didn't know how to be herself was in front of the camera. Part of the problem was that she *insisted* on taking off her glasses when she posed— maybe the only vanity I ever knew her to display. So not only does she not look like her bespectacled self in her jacket photographs; they depict a woman gazing into a blur.)

In 1967 Sontag published her second novel, *Death Kit*, another modernist conundrum, and in 1969 her second collection of essays, *Styles of Radical Will*, which was, if anything, even more overpowering than the first. It opens with

two masterpieces: "The Aesthetics of Silence," a meditation on the uses and implications of difficulty in contemporary art, and "The Pornographic Imagination," a level consideration of French head porn that functions as an investigation into extremes-seeking in contemporary art. There are also lengthy reflections on the Romanian-French aphorist E. M. Cioran, on Godard (a favorite of both Sontag's and Kael's), on Bergman's *Persona*; the aforementioned theater-and-film essay; and two enraged attacks on American culture and politics, both of which would haunt her.

By the end of the sixties, Sontag seems to have gotten her fill of the senses; thereafter her critical approach is more traditionally literary. But by then literature wasn't the only iron she had in the fire. In the following decade, she made two narrative films, *Duet for Cannibals* and *Brother Carl*, in Sweden, and a documentary, *Promised Lands*, in Israel. She wrote essays in support of feminist goals. She published, over several years, a series of disquieted meditations on problems in photography and collected them as *On Photography* in 1977. The ordeal of cancer led to *Illness as Metaphor* in 1978; the same year, she collected eight specimens of her short fiction under the title *I, etcetera*. In 1980 came the six portrait-essays in *Under the Sign of Saturn*.

Her work in the eighties varied even more: stories and short (for the most part) essays; directing in both the theater and film; the American presidency of PEN, the international writers' organization, in which role she labored furiously in defense of persecuted writers (hers was one of the strongest voices raised in support of Salman Rushdie after the Iranian government leveled its *fatwa* against him in 1989); and *AIDS and Its Metaphors* and the celebrated short story "The Way

We Live Now" on the same theme. After that, mainly fiction: *The Volcano Lover,* a novel, in 1992; *Alice in Bed,* a play, in 1993; *In America,* her fourth novel, in 2000. In 2001 she brought out *Where the Stress Falls,* a hodgepodge of (mainly) reviews, prefaces, program notes, and occasional pieces from the past two decades, and in 2003 the substantial essay *Regarding the Pain of Others.* But she's made it very clear that she considers fiction her vocation now.

Kael discovered that in writing about film she could write about everything. Sontag's ambition to write about everything seems practically unbounded. But this isn't just a difference in fields of concentration. It has to do with consistency—consistency as an attribute of personality. Notwithstanding her stylistic growth, Kael's approach stayed much the same. Sontag's changed. Mutability has, in fact, been one of the defining motifs of her career. Her political shift from the hard left to reformist liberalism is the most obvious instance. Another is her shift from advocate of the antinarrative to author of plush narrative novels. Another is a change in the direction of her essays. In the earlier ones, she was contending with the tumultuous arts scene around her as it teetered on the edge of bewildering; her mission was to explain and also to promote, insofar as she was championing an antiliterary art that was an extension of the senses. But she also made it clear that the art she was talking about was, to use her word, anti-hedonistic. She hadn't fully envisioned the *popularization* of her ideas. When the difficulty disappeared from this kind of art, and it became lunkheaded and hedonistic and sweepingly popular, she got the horrors at what she saw going on in the culture—"the levelling of all taste so that everything is made equivalent to everything else, a kind of

relativism which you have to call cultural nihilism"—and she retreated with a Prufrockian that-is-not-what-I-meant-at-all, casting her lot with the old-style literary intellectuals she'd once sought to outrage. Thus her mission changed: "I find myself moved to support things which I did not think would be necessary to support at all in the past. Like seriousness, for instance." The troubled early essays, written in attack mode against conservative naysayers, give way to portraits and appreciations written increasingly in defense mode against philistine blockheads.

But the reality is that Sontag's emphases are always shifting, her positions subtly or not so subtly readjusting themselves. Part of the reason is that, where Kael is a natural iconoclast, Sontag takes the next step and defines herself frankly as a contrarian. "The very nature of thinking is *but*," she has declared:

> If the mainstream changes, the criticism of it has to change too; which is to say that the oppositional or ironic attitude, the counter-attitude, must change. I am very interested in counter-attitudes. They are absolutely necessary ingredients in culture. If those attitudes are not present, any culture becomes a form of lobotomization.

All of her writing, she's said, has come out of opposition to mainstream attitudes, and this was as true at the beginning as it is now. She embraces change. In her late work, she acknowledges—and celebrates—this aspect of herself, which she calls self-transcendence. A passage in *The Volcano Lover* even suggests that mutability is an aspect of superior natures: "The poet

was always—would always be—in the process of being reborn. Definition of a genius?"

Sontag appeared in the 1966 *Against Interpretation* just as fully formed as Kael had the previous year in *I Lost It at the Movies,* and the two of them came at culture from such discordant positions that Kael was already blasting away at Sontag in the opening pages of her book. The conflict oozed paradox. Here was the ostentatiously intellectual Sontag chastising American culture for fostering "the hypertrophy of the intellect at the expense of energy and sensual capability" and beating the drum for a greater sensual openness to art. And here was Kael, the unembarrassed pleasure lover who had climbed on a soapbox for *The Manchurian Candidate* and *Charade,* declaring herself intellectually appalled. Citing Sontag's defense of Jack Smith's *Flaming Creatures,* a messy, queeny underground movie that had been in the news because it was having problems with the police—"Thus Smith's crude technique serves, beautifully, the sensibility embodied in *Flaming Creatures,*" Sontag had written in *The Nation,* "a sensibility based on indiscriminateness, without ideas, beyond negation"—Kael snorted, "I think in treating indiscriminateness as a *value,* she has become a real swinger."* Kael regarded attempts to elevate what she called trash (and appreciated as trash) into art—the auteurists were the worst offenders—as a betrayal of the standards the critic is supposed to be laboring to uphold. Alluding to the ride astride

*Maybe Kael's jab shook her, because when Sontag collected the piece in *Against Interpretation,* she changed the phrase to "a sensibility which disclaims ideas, which situates itself beyond negation."

the H-bomb at the end of *Dr. Strangelove,* she wrapped up her attack: "Miss Sontag is on to something and if she stays on and rides it like Slim Pickens, it's the end of criticism—at the very least."

By calling Sontag a swinger, Kael zeros in, with malicious accuracy, on what must have already been recognizable as her adversary's Achilles' heel: her straightness. Her stylistic straightness, I mean; Sontag was having a considerably wilder time in New York during this period than Kael was having in California. But as an arguer, Sontag comes across as something of a square, especially in her fixation on moral issues. Her mother once horrified her by calling her a Goody Two-Shoes, and her mother was right. For all her talk about sensual openness, Sontag almost never relaxes in the presence of a work of art and just has a good time. She's nervous unless she's justifying her pleasure. She does somersaults explaining how art designed to stimulate the senses is really moral, and while she's far too much of a formalist to claim that art is supposed to impel anybody toward moral behavior, she gets into church through the back door by arguing that our aesthetic vision shapes our moral one. "The moral pleasure in art," she wrote in "On Style" (1965), "as well as the moral service that art performs, consists in the intelligent gratification of consciousness." Mm-hmm. And, more touchingly:

> Our response to art is "moral" insofar as it is, precisely, the enlivening of our sensibility and consciousness. For it is sensibility that nourishes our capacity for moral choice, and prompts our readiness to act. . . . Art performs this "moral" task because the qualities which are intrinsic to the aesthetic

experience (disinterestedness, contemplativeness, attentive-
ness, the awakening of feelings) and to the aesthetic object
(grace, intelligence, expressiveness, energy, sensuousness)
are also fundamental constituents of a moral response to life.

Compare her eagerness to believe here with her coolly skep-
tical citation, nearly forty years later in *Regarding the Pain
of Others*, of "the canonical example of the Auschwitz com-
mandant returning home in the evening, embracing his wife
and children, and sitting at the piano to play some Schubert
before dinner." Although I don't buy (and I don't entirely get)
Sontag's early argument for linking art and morality, I under-
stand, and I share, the impulse behind it. We experience great
art, or certain kinds of great art, as ennobling; when Schubert's
piano music moves us, we can feel that something worth nur-
turing in us, something *good*, is responding. The later Sontag
writes off the commandant's response as sentimentality, but that
dismissal isn't any more satisfactory than her earlier attempt
to find something moral in the effects of art. Not that I expect
answers from her. These are maddeningly thorny questions,
and my point isn't that she hasn't thought about them enough
but that she thinks about them all the time. This is a matter
of temperament. Moral beauty is a large part of what draws
her to Robert Bresson and Danilo Kiš and Adam Zagajewski,
and it graces her own work. What bugs her about camp is its
aspect of pure aestheticism, free from ethical worries and cares;
conversely, her arguments promoting Antonin Artaud and her
favorite pornographers, Pauline Réage and Georges Bataille,
pivot on the heroism they show in "making forays into and
taking up positions on the frontiers of consciousness (often very

dangerous to the artist as a person) and reporting back what's there." Her early defense of Leni Riefenstahl's Nazi extravaganzas on aesthetic grounds in "On Style" sat with her so sourly that she finally had to go back a decade later in "Fascinating Fascism" and make it clear that she thought the woman was a worm. And *On Photography* is a revealing investigation into a medium whose ethical blankness throws something of a damper on her passion for it. Morality, not aesthetics, is the motor of her quest; throughout the book she's asking, "Is it OK to love photography?"

The question begins with Diane Arbus's impassive vision of life as a freak show. What spooks her about Arbus's photographs is their morally numbing quality—their capacity "to suppress, or at least reduce, moral and sensory queasiness." But her discomfort extends from there to the whole enterprise of picture-taking. "Life is not about significant details, illuminated in a flash, fixed forever. Photographs are," she worries, with the puritan's mistrust of images as false representations. The appetite for collecting that goes with photographic appreciation makes her uneasy, too, because it takes the order, the hierarchy, out of reality. The relative importance of things gets jumbled in a democracy of images, "a garbage-strewn plenitude" that, by confusing or erasing values (e.g., a picture of litter can outshine a picture of the Parthenon), degrades reality into kitsch. That's what she's getting at in her closing remarks on the need to establish "an ecology not only of real things but of images as well," quixotic though the desire may be (she has a high regard for quixotry), as a means of preventing a general devaluation, if not an outright falsification, of the real world. What nags at her—the sore spot she comes back to prod again and again—is

the implacable aestheticizing tendencies that compromise even socially conscious photography. "The best writing on photography," she says at one point, "has been by moralists—Marxists or would-be Marxists—hooked on photographs but troubled by the way photography inexorably beautifies." And she should know.

But having deftly painted herself into this corner, she turns elusive. Sontag's knottiness is part of her style, but the difficulties of *On Photography* are more than stylistic. She lays out her discomfort with the medium and then tiptoes away from it—an evasion that left some readers thinking her discomfort was the whole story, that she was saying it's *not* OK to love photography. Although Sontag is dealing here with paradoxes, instead of just acknowledging her ambivalence and going on from there, she allows it to erode into a vagueness, a shudder of obfuscation. A haze clouds her argument. As I read the book, her solution to the dilemma she's posed is to give in with a kind of antihumanist fury, returning to her early campaign to rout the humanist view of art in favor of the formalist one. (In *Against Interpretation,* she dismissed humanism on aesthetic grounds as "an ideology that, for all its attractiveness when considered as a catalogue of ethical duties, has failed to comprehend in other than a dogmatic and disapproving way the texture and qualities, the peculiar vantage point, of contemporary society.") Rejecting the notion that photography can improve you (or the world), she downplays the political effectiveness of even the most horrifying photojournalistic calls to action, partly because their proliferation hardens us and partly because time will inevitably lay a patina of pathos—of art—on them, too. In other words, she responds to her moral discomfort with photography by dismiss-

ing its moral potential; she stakes her claim to connoisseurship on purely aesthetic grounds, just as she'd once done (and then undone) in the case of Leni Riefenstahl. But this later effort to outflank humanism didn't agree with her any more than her defense of Riefenstahl had. Her relationship to aestheticism was always troubled; although she dedicated "Notes on 'Camp'" to Oscar Wilde, her own attitude she'd described as "a deep sympathy modified by revulsion." Eventually the revulsion won out, and she went from lobbing bombs at humanism to carrying its flag.

True to form for someone who believes that the nature of thinking is *but,* in *Regarding the Pain of Others* she quarreled with some of the notions she'd developed decades earlier in *On Photography*. By then she'd grown more relaxed about the aestheticizing tendencies of photography, since "transforming," as she simply says, "is what art does"; and she could frankly admit, "There isn't going to be an ecology of images. No Committee of Guardians is going to ration horror, to keep fresh its ability to shock." Most significantly, she questioned the idea that image saturation makes us callous. Probably as a result of fraternizing with photojournalists during the siege of Sarajevo in the early nineties, and of recognizing their importance in bringing the siege to international attention, she saluted the moral—the humanistic—effects of their work: "Let the atrocious images haunt us. Even if they are only tokens, and cannot possibly encompass most of the reality to which they refer, they still perform a vital function. The images say: This is what human beings are capable of doing—may volunteer to do, enthusiastically, self-righteously. Don't forget."

The equanimity of those words, with a lifetime of thought and experience behind them—she wrote them close to her seventieth birthday—lies some way from the moral quandaries of *On Photography*. And not only moral. Running through the earlier volume is a nagging aesthetic question, too, namely: Is it OK to call such a promiscuous medium an art at all? Which, as it happens, is the same question Kael was confronting in "Trash, Art, and the Movies," the 1969 essay that comes as close to a manifesto as anything she ever wrote. As usual, their differences in approach are characteristic. For Sontag the question is almost as moral as it as aesthetic: Is it *just* to call photographs art? For Kael it's something else entirely: Is it *sane* to call movies art? Sontag is posing the question to herself, and to come up with answers she searches deep within. Kael has the answers sewn up before she writes her first word (which is why she's at her desk), and she comes out swinging. Consider *her* response to Riefenstahl: "one of the dozen or so creative geniuses who have ever worked in the film medium. Out of the Nuremberg Rally of 1934, she made the most outrageous political epic of all time, the hypnotic *Triumph of the Will* (the outrage is that she could make a great film of it)." The need to distance herself from Riefenstahl's politics never occurs to her—who in the world could think she endorses them? She's superbly, genuinely untroubled.

And that may be the fundamental difference between these two personalities. Sontag has described the hell she goes through when she writes criticism, stopping after every sentence to submit it to a thorough frisking before going on to the next one. ("I am perfectly prepared to spend an hour thinking

is the word 'fast' or 'rapid'?") You can feel that painstaking-
ness as you read: behind every line she writes, she's asking,
"Is this true?" In every line Kael writes, she's saying, "This
is *true*." Kael is the rare (literary) example of the untroubled
consciousness. Her sentences get their nervous agitation not
from self-doubt, of which she had none, but from impatience,
the arguer's impatience with those who *don't get it*. The gold-
en serenity of Sontag's prose is, by contrast, not really serene
at all; it's the enforced calm of someone who's throttled her
doubts—for the moment. Sontag is a supreme example of the
troubled consciousness, always questioning and never still. No
wonder she's so drawn to the mind in agony; for her, as she's
constantly declaring, thought *is* agony. Hence her attraction
to Cesare Pavese ("as a man, he suffers; as a writer, he trans-
forms his suffering into art"), to Michel Leiris ("a man flogging
himself just in order to make his lungs consent to draw air"),
to Georges Bataille ("a consciousness in an acute, unrelenting
state of agony . . . an erotics of agony"), to E. M. Cioran ("phi-
losophy becomes tortured thinking"), and to those tortured
thinkers in *Under the Sign of Saturn* whose portraits are really
self-portraits. This quality of excruciation makes her prose riv-
eting even when the thought itself is less than solid. Consider,
as probably the best example, her 1968 political essay "Trip
to Hanoi," in which she wills herself into a sympathy with
Vietnamese Communism that she would later repudiate. Not
many documents provide as gripping a record of the agonized
mind in high gear, doubling back on itself, challenging itself,
questioning its assumptions, even questioning its perceptions,
asking itself, again and again, "*Is this right?*" However confused
or self-deceiving or just plain *wrong* Sontag's thinking is, it's

never shoddy. It's never lazy. It stands bravely if a bit self-consciously in a spotlight that makes it, as it's fully aware, a sitting duck—unapologetic, obstinate, and deeply honorable.

Kael wasn't lazy either, or self-deceiving, and God knows she wasn't tortured. "I'm temperamentally incapable of getting into the mind-set of those who agonize over sentences," she said—which doesn't mean that she wasn't exacting but that she wasn't (as Sontag described herself) obsessional. Moral questions interested but didn't trouble her, partly because she had such a low opinion of the medium she wrote about that a picture had to be truly vile for her to waste much space exposing its moral confusions. ("It's very difficult to talk in moral terms when you're dealing with incompetents.") Where she does show some qualms is around the issue of violence. Her ardor for *Bonnie and Clyde,* the first two *Godfather*s, and the work of Peckinpah, De Palma, and the early Scorsese gave her a reputation as a violence buff, but that's a malicious distortion of her views. She loathed movie violence, except (and it's a crucial exception) in the hands of masters. The Clint Eastwood "Dirty Harry" pictures revolted her. So did the "sheer pounding abrasiveness" of *The French Connection,* which had been a huge hit. ("It is, I think, what we once feared mass entertainment might become: jolts for jocks.") She accused critics who didn't speak out against excessive violence of "implicitly saying that no brutality is too much for us," of implying by their silence that "only squares and people who believe in censorship" were in her camp.

And nobody ever called Kael a square. As far as the quality of her prose is concerned, *she's* the swinger. Tone is perhaps the most obvious area where these two writers are at odds. Kael's

hipness leads straight to her verbal bebop; Sontag's puritanism makes her criticism formal and rather icy. Slogging through Sontag can be difficult, as I've already observed, and she *means* it to be difficult, to slow you down, to stymie you—that's how she sinks her points in. As a critic, she has never sought a large audience. Kael wants to reach as many readers as she can: hence the speaking-voice style it took her so long to perfect. A telling peculiarity of her career is that her voice didn't arrive at its full conversational timbre until some years after she'd stopped broadcasting—until she got hired by *The New Yorker,* in fact. Financial security freed up something inside her. Kael's writing after 1968 shows a new lyricism and a new puckishness, a new delight in craft, and, not least, a new informality. Sontag achieved success far earlier; the freedom to write what she wanted and *as* she wanted was never at issue for her, and her prose is less prone than Kael's is to preen and enjoy itself (until her later novels, when she felt free in a different kind of way).

Not that the two of them necessarily got *better.* The truth is, they did their best work, if not their most handsomely crafted writing, in the first half of their careers. Kael's later reviews don't have the amplitude of her early ones. In the seventies, as she went, in her phrase, deeper into movies, the aesthetician shouldered aside the sociologist who'd been ascendant in the fifties and the sixties. Once the aftershocks of Vietnam and Watergate had died down and the country grew complacent again, there was less to say in the way of social analysis; meanwhile, the flood of outstanding films in the seventies called for the added aesthetic scrutiny. And "as the seventies gave way to the eighties," she wrote in her introduction to her late omnibus collection *For Keeps,* "the excitement I had earlier found

in the movies gave way to the pleasure I found in writing"; in other words, as the movies died, the stylist shouldered aside the aesthetician. You can savor those reviews without seeing the movies, and in most cases you probably should. But there's a downside, which is that they often offer greater satisfactions as literary performances than as criticism. As criticism they're suspect. In her late phase Kael lost some readers and forfeited the indulgence of many more through what she ultimately admitted was "my worst flaw as a writer: reckless excess, in both praise and damnation." She got pushy. On the question of violence, for example, she had complained in 1976, in the introduction to *Reeling*, that many moviegoers

> react to the incineration of characters in *The Towering Inferno* as marvelous entertainment. That indicates one of the problems of movies: they can be effective on shameless levels. Who isn't terrified of burning to death? . . . It's almost impossible to persuade people that a shallow, primitive work can give them a terrific kick.

But only a couple of years later, in a belligerent essay she titled "Fear of Movies," she argued that the yearning for tameness, for "the placidity of *nice* art," is "a rejection of the particular greatness of movies: their power to affect us on so many sensory levels that we become emotionally accessible, in spite of our thinking selves." She recognized that what was happening on the streets had soured some viewers on violence: "They've lost the hope that things are going to be better—that order will return." But this understanding didn't flower into sympathy. "What does it mean when someone says to you in a prissy,

accusing tone that he 'doesn't like' violence?'" she demanded. "Obviously, he's implying that your ability to look at it means you *like* it. And you're being told that you're made of coarser stuff than he is." The squeamishness of the educated middle class made her see red—but anger is always the lot of the critic frustrated by the audience's indifference or hostility to art that has moved her. Sontag shares it; every critic does.

Sontag, meanwhile, went deeper in her own way. The wide-ranging, high-stakes inquiries of the early essays gave way to appreciations of specific artists, specific works. The polemicism went south, a development that sometimes makes her writing even harder to follow. Argument gives the essays in her first two collections an inherent drama. A critical essay without an argument is like a story without a plot, and while plot, as Sontag will be the first to tell you, is no more indispensable to fiction than figure is to painting or melody to music, dispensing with it has a price. An argument creates suspense: it keeps you turning pages to see where it leads. Without this armature, an essay can seem amorphous, inchoate, as Sontag's later essays sometimes do. The chiseled sentences seem to float free of one another, unmoored. The intelligence is evident, the observations are striking, but the purpose is obscure. What's she driving at? What's her *point?*

But then directness is as foreign to her temper as it is basic to Kael's. Open a book of Kael's to any page, and the verbs jump out at you. She isn't trying on arguments, she's hurling them. (When Renata Adler brought out her furious attack on Kael in 1980, one of her primary charges was the coarse aggressiveness of Kael's language.) Open one of Sontag's books, and you'll soon come upon the passive voice, as in this rather egregious

example (slightly compressed, italics added) from *AIDS and Its Metaphors*:

> The sexual transmission of this illness, *considered by* most people as a calamity one brings on oneself, *is judged* more harshly than other means—especially since AIDS *is understood as* a disease not only of sexual excess but of perversity. (I am thinking, of course, of the United States, where people *are currently being told that* heterosexual transmission is extremely rare . . .). . . . True of syphilis, this is even truer of AIDS, since not just promiscuity but a specific sexual "practice" *regarded as* unnatural *is named as* more endangering. Getting the disease through a sexual practice *is thought to be* more willful, therefore deserves more blame. Addicts who get the illness by sharing contaminated needles *are seen as* committing (or completing) a kind of inadvertent suicide. Promiscuous homosexual men practicing their vehement sexual customs under the illusory conviction, *fostered by* medical ideology with its cure-all antibiotics, of the relative innocuousness of all sexually transmitted diseases, *could be viewed as* dedicated hedonists—though it's now clear that their behavior was no less suicidal. Those like hemophiliacs and blood-transfusion recipients, *who cannot by any stretch of the blaming faculty be considered* responsible for their illness, *may be as ruthlessly ostracized by* frightened people. . . .

What's the meaning of all this passivity? What's going on? There's nothing hesitant in Sontag's position—the grammar doesn't bespeak a chink in her confidence. She's passionate about what she's saying. But all those twisted-around constructions

have a muting effect, like wall-to-wall carpeting. Even at her most fervent, Sontag holds herself emotionally aloof. Although passion smolders underneath her sentences, she won't let you look at it directly—that might be vulgar. There's a hint of snobbery in this reserve; it serves as a kind of tonal bouncer, keeping out anyone who's not on the guest list. Sontag the puritan writes for the elect, the *truly interested*, stamping out spectacle and sweeping her argument clean of anything that might be construed as entertaining—entertainment is suspect. What she's iterating, again and again, is: the hymn, not the singer. The meaning, not the writer. The truth, not the messenger.

But this reticence isn't the whole story. It isn't even real reticence. Sontag leads a kind of double life in her essays, like Catherine Deneuve in *Belle de Jour*: under her aloofness, she harbors a yearning to undress—by which I mean an impulse toward autobiography so strong that it isn't an exaggeration to call it confessional. And here again she forms a perfect reverse image with Kael, who *seems* to be terribly intimate and forthcoming and yet turns out, when you peer more closely, to be surprisingly guarded.

Neither Sontag nor Kael would object to Wilde's proposition that criticism is autobiography. Sontag characterized the essays in *Against Interpretation* as, in part, "case studies of my evolving sensibility," and Kael, at the end of her career, said it bluntly: "I'm frequently asked why I don't write my memoirs. I think I have." The autobiographical passages are high points in Kael's first two books: the sardonic recollection of her father's promiscuity ("I was very proud of my father for being the protector of widows") in the essay on *Hud*, the plangent memory of gazing down from an airplane circling the Bay Area at the

beginning of "Movies on Television," and—my favorite—the first paragraph of her retrospective review of *Shoeshine*:

> When *Shoeshine* opened in 1947, I went to see it alone after one of those terrible lovers' quarrels that leave one in a state of incomprehensible despair. I came out of the theater, tears streaming, and overheard the petulant voice of a college girl complaining to her boyfriend, "Well I don't see what was so special about that movie." I walked up the street, crying blindly, no longer certain whether my tears were for the tragedy on the screen, the hopelessness I felt for myself, or the alienation I felt from those who could not experience the radiance of *Shoeshine*. For if people cannot feel *Shoeshine,* what *can* they feel? My identification with those two lost boys had become so strong that I did not feel simply a mixture of pity and disgust toward this dissatisfied customer but an intensified hopelessness about everything . . . Later I learned that the man with whom I had quarreled had gone the same night and had also emerged in tears. Yet our tears for each other, and for *Shoeshine* did not bring us together. Life, as *Shoeshine* demonstrates, is too complex for facile endings.

By sharing these very personal memories, Kael pulls you into an intimacy that she doesn't follow through on. If you used to read her regularly, you knew a lot of stuff about her—that she grew up in California, went to Berkeley, had a daughter, loved dogs, and so forth—and it made you feel as though you knew her. Yet as powerful a part as the first person plays in her reviews, there's nothing confessional about them. Something you can

often say of a writer is "He's really writing about himself."
But, except in those patently autobiographical passages (which
became fewer as the decades passed), you can almost never
justly say it of Kael. She identifies with the audience, not with
what she sees of herself in the artist, and it's the audience that
has her strongest allegiance. Sontag doesn't care about the
audience. She identifies much more deeply than Kael with her
subject, and in most cases her subject's outlook more or less
reflects her own.

In other words, she writes self-portraits. You see the seed
of the impulse in the emphasis on tormented thinkers in *Styles
of Radical Will*. It ripens eleven years later in *Under the Sign
of Saturn*, four of whose seven essays—on Paul Goodman,
Roland Barthes, Walter Benjamin, and Elias Canetti—amount
to records of self-scrutiny. (The exceptions are Riefenstahl—
obviously; Hans-Jürgen Syberberg—"not a true melancholic
but an *exalté*"; and Artaud, whose madness, for all its reso-
nance, puts him out of reach: "One can be inspired by Artaud.
One can be scorched, changed by Artaud. But there is no way
of applying Artaud.")

Walter Benjamin, the influential German essayist who died
in 1940 and whose career as a freelance intellectual provided
Sontag with an inspiration (if not, in its haplessness, a model),
is the one she feels closest to. "I came into the world under the
sign of Saturn," Benjamin wrote, referring to his native melan-
choly, and in her title essay Sontag lays out the temperament
they share:

Slowness is one characteristic of the melancholic tempera-
ment. Blundering is another, from noticing too many possi-

bilities, from not noticing one's lack of practical sense. And stubbornness, from the longing to be superior—on one's own terms. . . . The mark of the Saturnine temperament is the self-conscious and unforgiving relation to the self, which can never be taken for granted. The self is a text—it has to be deciphered. . . . The self is a project, something to be built.

Slowness: the fastidious questioning of every word one sets down. Blundering: intellectual trial and error, the continual *"Is this correct?"* demanded of one's positions and the continual discarding of those (support of authoritarian regimes, promotion of popular culture, rejection of narrative) that no longer look tenable or wise. The self as a project: "That idea of surpassing oneself is the deepest theme in my work," Sontag has said. Hence the unremitting guilt: "The process of building a self and its works is always too slow," she observes in the Benjamin essay. "One is always in arrears to oneself." (Compare Kael, who was maddeningly fast, maddeningly sure, content with herself and pitiless toward guilt, especially liberal guilt.)

"If this melancholy temperament is faithless to people"— coolly analyzing the intellectual's vexed social relations, Sontag may give one pause—"it has good reason to be faithful to things. Fidelity lies in accumulating things." "Things" covers a lot of possibilities. For Benjamin, "learning was a form of collecting" whose tangible twin was book hunting. Both pursuits link him to another of Sontag's heroes, Elias Canetti—whose goal, she writes in the book's closing essay, "Mind as Passion," was "to learn everything," and whose personal library stood for

"an obsession whose ideal is to put the books inside one's head; the real library is only a mnemonic system." Sontag likes that; it's her ideal, too. "I remember what I read. All the references in *On Photography* and *Illness as Metaphor* are to books I have on my shelves," she told Wendy Lesser in 1981, the year after she wrote the Canetti essay. "I didn't do any research for either of those books."

Some of what Sontag sees mirrored in Benjamin's image is more problematic. E.g., "He liked finding things where nobody was looking . . . he didn't like to read what everybody was reading." In Benjamin's case this meant, among other passions, German baroque drama; for Sontag it's led to the many masters, Benjamin among them, she's had a hand in introducing to the American public. A service, definitely; yet sometimes something in this zeal for pioneering rubs me the wrong way. In *Against Interpretation*, Sontag was a scout bringing back news from territories we would all (she was sure) eventually visit. But in her later books, she came to resemble one of those travel insiders who's anxious to reach the pristine beach before the tourist hordes find out about it. There's a little too much satisfaction in having gotten there first. And this satisfaction applies not just to artists but to ideas, too. "Benjamin's propensity is to go against the usual interpretation," she writes. "Precisely because he saw that 'all human knowledge takes the form of interpretation,' he understood the importance of being against interpretation"—noted—"wherever it is obvious." Is this contrariness so different from Kael's "Was there ever a good movie that everybody was talking about?" I think it is. "When I see something acclaimed by the whole press," Kael once said, "I almost know that I'm not going to like it."

She thought critical consensus often just signaled the triumph of hype. She didn't trust the judgment or the taste of her colleagues and believed they could be bulldozed by advertising if not bought off outright by the studios. But she's a long way from going against the crowd *because it's the crowd*—she loved plenty of hits. Sontag loathes the crowd. The modernist critic, she asserted in a 1982 essay on Barthes,

> will tend to avoid those [texts] that everyone has handled, the meaning that everyone knows. . . . For it is, finally, the exercise of taste which identifies meanings that are familiar; a judgment of taste which discriminates against such meanings as too familiar; an ideology of taste which makes of the familiar something vulgar and facile.

If the culture had neglected psychological approaches to art, she told a TV interviewer in 1969, she would have defended them. They bored her "not because they're not true, but because they're not very useful, because they're so obvious. Why not think about it in some other way?"

Why not? Because this is a response not to the work but to the culture around it—a response to context, a response, in essence, to the audience. I respect (and share) Sontag's view that "writers are professional adversaries." But it's one thing to find yourself constantly disagreeing with the crowd and another to *will* yourself into separateness in order to have a *jump* on the crowd. Keying your reactions to what others are saying (or have said) is an insult to the artist, egotistical and, worse, disingenuous. And so it's no surprise to find Sontag pointing out that "what is most foreign to Benjamin is anything like ingenuous-

ness" and quoting his assertion that, for the intellectual, "ambiguity displaces authenticity in all things. . . . The 'unclouded,' 'innocent' eye has become a lie."

Maybe for Benjamin, and maybe for Sontag and the vast majority of modernist intellectuals. But I would argue that Kael's eye remained innocent in Benjamin's sense, by which I mean that she trusted her responses and they remained unswayed by the context they occurred in; she never feared they were facile even when she was falling for a *Tootsie* or an *E.T.* (In the terms Schiller devised for unself-conscious and self-conscious creators, Kael is a naive critic, Sontag a sentimental one.) "We're not only educated people of taste," Kael argued in "Trash, Art, and the Movies," "we're also common people with common feelings. And our common feelings are not all *bad*." The unclouded eye Benjamin speaks of is probably available only to an intellectual who doesn't abhor vulgarity, who at some level relishes it and the way it ties her to the crowd. Kael would have been repelled by Sontag's use of taste to put the critic above the crowd, since for Kael, criticism is a democratic art (which is not to say an egalitarian one—she never pretended to represent the mass audience). Sontag's discriminations are a way of cordoning the great work off from the public. Kael is out to bring the public to the work, when it *is* great, and when it's not to puncture its pretensions and bring it back down where it belongs—to the level of the crowd.

But then Sontag and Kael are engaged in very different tasks. Kael is a born polemicist—a puncturer—but as I've already noted, Sontag, who knows how to argue when she needs to, isn't always sure she wants to. Neither was Benjamin, who, as

Sontag reports approvingly, considered polemic "beneath the dignity of a truly philosophical style." Her much admired friend Roland Barthes similarly moved away from his early "debunking forays" as he got "more interested in bestowing praise, sharing his passions"—more "celebratory." The same adjective applies to Canetti: "So wholehearted is Canetti's relation to the duty and pleasure of admiring others, so fastidious is his sense of the writer's vocation, that humility—and pride—make him extremely self-involved in a characteristically impersonal way. He is preoccupied with being someone *he* can admire." For him, too, the self is a project.

Although he isn't quite the mirror for her that Benjamin is, Sontag's essay on Canetti is still "self-involved in a characteristically impersonal way," in one respect in particular. "All of his work," she says, "aims at a refutation of death. A refutation seems to mean for Canetti an inordinate insisting. Canetti insists that death is really unacceptable." The thirst for longevity that she so admires, and the long passages she quotes from *The Makropulos Affair*, Karel Čapek's 1922 play (now better known through Janáček's opera) about a woman who has passed her 337th birthday, become suddenly moving when you hold them up against her life at the time. Five years earlier she had been informed that she had breast cancer and that it was, in all probability, terminal. Those were the circumstances under which, in 1978—two years before the Canetti essay—she had published another obliquely confessional work, the quietly enraged *Illness as Metaphor*. As she relates in that essay's 1989 pendant, *AIDS and Its Metaphors*, her prognosis had filled her with "evangelical zeal," and the result was a polemic (Benjamin notwithstand-

ing) of a very quirky kind: an exposé of cancerphobic bigotries wrapped up with an attack on literary ornamentation in the innocuous person of metaphor.

Metaphor is the single-cell unit of everything that requires interpretation, and thus it makes sense that a writer so famously against interpretation should have a problem with it. Lucid as her critical prose is, it isn't rich in decoration; she has the puritan's suspicion of adornment. As she explained in a 1978 interview, "Somebody says: 'The road is straight.' Okay, then: 'The road is straight as a string.' There's such a profound part of me that feels that 'the road is straight' is all you need to say and all you *should* say." No wonder that, as soon as she witnessed firsthand how cruelly certain metaphors can afflict the afflicted, she jumped at the chance to attack a device she was allergic to by temperament, and to do it from high moral ground. It wasn't even a drawback that the campaign was, as she conceded, "quixotic"—that was exactly the word she had used, admiringly, for Canetti's campaign against death. There was something ennobling about battling so hopelessly, like a doomed resistance fighter. And since the flip side of aversion is fascination, she could now exploit the device as she'd never let herself before—she could run amok, chasing metaphor into every last corner. Like the bluenose whose fulminations against licentiousness turn into a specimen of what he's attacking, Sontag goes on a metaphorical bender, starting with her dryly delirious, Janet Malcolm–like opening sentences: "Illness is the night-side of life, a more onerous citizenship. Everyone who is born holds dual citizenship, in the kingdom of the well and in the kingdom of the sick. Although we all prefer to use only the

good passport, sooner or later each of us is obliged, at least for a spell, to identify ourselves as citizens of that other place."

She then proceeds to root out offending metaphors with the zeal of a bloodhound, not sparing herself. She includes a mea culpa for her famous insult "The white race *is* the cancer of human history." And, without exactly singling herself out by name, she condemns "romanticizing" improprieties of the type she'd committed in such earlier essays as "The Aesthetics of Silence," "The Pornographic Imagination," and "Approaching Artaud," in which she'd roped another illness metaphor, this one drawn from insanity—"The exemplary modern artist is a broker in madness"—into the service of criticism.

But the anger she's drawing on in *Illness as Metaphor* goes deeper than moral outrage. It's personal. "The view of cancer as a disease of the failure of expressiveness condemns the cancer patient: expresses pity but also conveys contempt," she writes in prose that can fairly be said to seethe, and it's not hard to guess why: she had been pegged as an expressiveness suppressor long before her doctors noticed anything funny in her blood work. There's justice both in the label and in her resentment. Sontag is a writer with a highly romanticized self-image ("I don't write because there's an audience. I write because there is literature") who recoils from Romantic notions of self-expressiveness. Her personality and her convictions equally dictate the coolness of her style. In high school, as she relates in the memoir "Pilgrimage," she was already aching to express her feelings *indirectly*—"by focussing feeling away from myself onto something I admired or felt indignant about." Her passion is right there in her prose, if you know where to look, and it

infuriates her that the great unwashed should mistake her, out of ignorance (of her character) and superstition (about illness), for a victim of repressed or depleted or otherwise insufficient passion. In interviews, she goes out of her way to insist she has passion to burn.

Yet the passion in *Illness as Metaphor* doesn't burn as scorchingly as she intended. Yes, this is engaged and angry criticism. "The metaphors and myths, I was convinced, kill," she wrote retrospectively. "I wanted to offer other people who were ill and those who care for them an instrument to dissolve these metaphors, these inhibitions." I'll buy that. What I can't fully buy is her claim for the essay's larger ambitions: "*Illness as Metaphor* is not just a polemic, it is an exhortation. I was saying: Get the doctors to tell you the truth; be an informed, active patient; find yourself good treatment, because good treatment does exist (amid the widespread ineptitude)." She was? *Where?* I'm not being facetious when I say can't locate that passage. As criticism *Illness as Metaphor* is riveting, but as a piece of agitation it's a head-scratcher; not until *AIDS and Its Metaphors* did she clarify the essay's aims (in an essay whose own aims puzzled a lot of readers). Once again, as in *On Photography,* she seemed to be backing away from the case she was making. Did her refinement hinder her? Could plain speaking and earthbound activism have struck her, as so much else does, as vulgar? Was she conflicted about the autobiographical sources of her argument?

If she was, she got over it, because in the following decades her confessionalism came out of the closet. Her short stories had always had autobiographical elements. Now she turned up with the charming and surprisingly self-mocking memoir

"Pilgrimage" (published in 1987 in *The New Yorker* and as yet uncollected) and injected the central characters of her third and fourth novels, *The Volcano Lover* and *In America,* with her own DNA. Once she loosened up in this regard, so did her prose. It got warmer, more hospitable. The novels, with their surging romance, suggest a new receptiveness to the popular culture she had seemed to disown after her early writings; as it turns out, she'd never slammed the door. "If I had to choose between the Doors and Dostoyevsky," she wrote in the same 1996 jeremiad that bewailed the decline of seriousness, "then—of course—I'd choose Dostoyevsky. But do I have to choose?"

Her soft spot for pop culture is more significant than the slender space she allots the topic might suggest. It's also a taste she shares with Kael, and it differentiates the two of them from the older (in Kael's case, not that much older) generation of New York intellectuals, who sneered at pop. Sontag may be the last writer you'd expect to hear declaring "Rock & roll really changed my life," but there it is, in a 1978 interview in the pages of *Rolling Stone.* "I think it was Bill Haley and the Comets and Chuck Berry," she went on, "that made me decide I had to get a divorce and leave the academic world." She's speaking here for a generation, and rock and roll was the dividing line: it was rock and roll that marked the ascendancy, and eventually the triumph, of pop culture. In the late fifties, Sontag recalled, "there was this total separation between the people who were tuned into the popular culture and those who were involved in high culture." By the mid-sixties, that division had disappeared, and today the young intellectual who's impervious to rock and hip-hop is an anomaly, not least because rock and hip-hop claim some of the best young artists. Sontag could be acute

on pop culture. "The Imagination of Disaster," her 1965 analysis of low-budget science-fiction movies and what they tell us about ourselves, is one of the two or three finest things she ever wrote—or at least it's one of my two or three favorites, partly because the grade-Z material she's dealing with brings out an affectionate humor that seldom pokes through elsewhere. That same year, she nodded affably at the Supremes, Dionne Warwick, and the Beatles in "One Culture and the New Sensibility," the final essay in *Against Interpretation*. But after that she pretty much turned her back on pop, and it's our loss. The culture has changed, for better or (as critics always think) for worse, and today pop reflects the state of the society in ways that high culture doesn't and probably no longer can. By ignoring it, she constricted the scope of her vision, not to mention the size of her audience. She always claims to be interested in everything, so what happened to this very winning side of her enthusiasm? I can't help feeling (and I know it's a paradox) that while Sontag on Cioran or on Canetti is moving, engaging, often brilliant, Sontag on the Gang of Four, Sontag on Prince—*that* would have been for the ages.

Meanwhile, Kael took off in the other direction. She had started from a position of self-aware skepticism. "Who at some point hasn't set out dutifully for that fine foreign film and then ducked into the nearest piece of American trash?" she asked in "Trash, Art, and the Movies." "You hoped for some aliveness in that trash that you were pretty sure you wouldn't get from the respected 'art film.'" There's nothing misty in her candor. Disaffection with the movies, as the word *trash* implies, acidulated her outlook from the start—a circumstance that casts her choice of career in a slightly odd light. (The end of "Trash, Art,

and the Movies" is all about this disaffection.) In her view, the negativity was necessary, a demonstration of critical good faith; any other relation to the movies—fandom, boosterism, or the auteurist program of rehabilitating studio product as consciously achieved art—would have been too silly to countenance. Her skepticism shifted, though, when the brilliant run of American movies in the seventies raised the possibilities of mass art, in her eyes, to a new level. In the eighties, Kael talked less about trash and more about pop. The latter word had fewer pejorative connotations for her, and those it did have it gradually shed—so thoroughly that not long before she died she could declare that "culture without pop," borrowing a phrase from *McCabe and Mrs. Miller*, "freezes my soul."

Well, that leaves out an awful lot of culture. Late in Kael's career, her interest in high culture, especially European high culture, declined. Not that philistinism ever threatened (she treasured Bergman's *The Magic Flute* and Louis Malle's *Vanya on 42nd Street* and plenty of other highbrow triumphs, and her devotion to Hardy and Proust never dwindled), but her taste for looseness lost its own looseness. Philip Kaufman, she wrote, had rescued *The Unbearable Lightness of Being* from Milan Kundera by cutting down on the "pastry pensées" and adding some of his own "adventurous spirit" to the movie. I love Kaufman's movie, but I also love Kundera's novel, so I wince at her swipes. ("Kundera was more cultivated—more elegantly European—than a great writer needs to be. He was too conscious of his themes, his motifs, his paradoxes.") A couple of years before her death, we watched a tape of *The Life of O-Haru* together, and afterward she wondered if it would have killed Mizoguchi to crack a few jokes; I bit my tongue. On the

other hand, where once her skepticism had extended well into the reach of the magnificent—"I don't think *The Conformist* is a great movie," she had written cautiously in 1971 while still citing it as easily the best film of the year—in the eighties she became notorious for her deliriums over far more disposable pictures.

But whether she deflated it as trash or embraced it as pop, Kael's attraction to the art of the mass audience—the audience that includes our family and our neighbors—is about as far as you can get from Sontag's prostration before the exalted and the disaffection from the mass audience it entails. Kael was wary of anything as humorless as exaltation. She was wary of anyone who took himself too seriously—such as Sontag's adored Bresson, whom she charged with "inhuman pride." Literary-patrician bearing of the kind that Sontag exemplifies appalled her; "great lady" is a term that, in her writing, drips with contempt. (Her own lack of glamour was almost a trademark.) Actors, especially, got nailed on the self-seriousness watch. Overly apparent technique struck her as ostentatious and ridiculous. ("He keeps us conscious that he's acting all the time. His toes act in his shoes.") Her skepticism about Meryl Streep distressed many of her readers (including Streep). "She has no natural vitality," Kael griped, trying to explain why she couldn't swallow Streep's performance in the 1983 *Silkwood*. A scene in which Streep's Karen Silkwood swoops down to take a bite out of someone else's sandwich struck her as *all* technique: "Meryl Streep imitates raunchiness meticulously—exquisitely. . . . But she hasn't got the craving to take that bite. If the young Barbara Stanwyck had grabbed the sandwich, we'd have registered that her appetite made her break the rules; if Debra

Winger had chomped on it, we'd have felt her sensual greed. With Streep, we just observe how accomplished she is."

That kind of virtuosity—empty virtuosity, she would have argued—gave her no pleasure, and it all comes down to pleasure. But definitions of pleasure differ. Even Sontag at her severest concedes that "the purpose of art is always, ultimately, to give pleasure." For Sontag, who once pointed out that an orgasm is more like an epileptic seizure than like a conversation or a meal, pleasure is obviously something more than just a good time. She bristles at the equation of aesthetic pleasure and entertainment, since for her the decline of seriousness has gone hand in hand with "the ascendancy of a culture whose most intelligible, persuasive values are drawn from the entertainment industries." Show-business values are closer to Kael's heart, naturally. "If art isn't entertainment," she once asked, "then what is it? Punishment?" Sontag is prepared for that one. "Having one's sensorium challenged or stretched hurts," she explains blandly. It should come as no surprise that a critic who regards modern art as "an instrument for modifying consciousness and organizing new modes of sensibility" expects audiences looking to have their minds expanded to be ready to bear some pain. "The seriousness of modern art precludes pleasure in a familiar sense," she argued in 1965. "The new serious music hurts one's ears, the new painting does not graciously reward one's sight, the new films and the few interesting new prose works do not go down easily." She's perfectly willing to administer castor oil in the service of progress, and she believes in progress. "Art is the army by which human sensibility advances implacably into the future," she argued, with a straight face (and a martial metaphor), in "Nathalie Sarraute and the Novel." And when, a

couple of decades later, modernism showed signs of throwing
in the towel before the easier pleasures of postmodernism, at
just around the time that the rise of AIDS was leading a lot of
people to backtrack on the sexual freedoms they had fought for
so hard in the sixties, she got snippy and sarcastic:

> The behavior AIDS is stimulating is part of a larger grateful
> return to what is perceived as "conventions," like the return
> to figure and landscape, tonality and melody, plot and char-
> acter, and other much vaunted repudiations of difficult mod-
> ernism in the arts. . . . The response to AIDS, while in part
> perfectly rational, amplifies a widespread questioning that
> had been rising in intensity throughout the 1970s of many
> of the ideals (and risks) of enlightened modernity; and the
> new sexual realism goes with the rediscovery of the joys of
> tonal music, Bouguereau, a career in investment banking,
> and church weddings.

What's remarkable about this dig (from *AIDS and Its Meta-
phors*) is that she made it in 1989, at just around the time she
was embarking on *The Volcano Lover*—her own repudiation of
modernist perplexity. In 2000, on the publication of the even
more approachable *In America*, she really got into repudiating.
"I thought I *liked* William Burroughs and Nathalie Sarraute
and Robbe-Grillet, but I didn't," she confessed breezily. "I
actually didn't." Her own earlier novels and stories, which had
been forbidding enough to satisfy the most draconian modern-
ist, she simply shrugged off. "I didn't like what I wrote that
much. That's why I stopped."

Kael never repudiated anything. She didn't have to—that's one of the benefits of consistency. "Samson Raphaelson is a giver of pleasure," she once said, putting in a nutshell everything she loved about one of her favorite screenwriters. "What man can ask more of himself?"

2

THE LOCUS CLASSICUS OF SONTAG'S case against humanism, and her nerviest brief for an art that appeals directly to the senses, is the 1965 "One Culture and the New Sensibility," the final essay in *Against Interpretation*. High on the cockiness of an era that saw itself as revolutionary, she spurned the nineteenth century's loftiest proponent of humanism as an emblematic stuffed shirt: "The Matthew Arnold notion of culture defines art as the criticism of life—this being understood as the propounding of moral, social, and political ideas. The new sensibility understands art as the extension of life"—by which she meant the extension of the senses, *life* being understood as the life of the body. "For we are what we are able to see (hear, taste, smell, feel) even more powerfully and profoundly than we are what furniture of ideas we have stocked in our heads." Sontag's turn as a bad girl didn't last much longer than a cultural moment. But in the eyes of some of the "outraged humanists" (her phrase) she had mocked with her conviction that an over-

cerebral society needed a little rock and roll (and a little Boulez) to get in touch with its nerve ends, it damned her forever.

Another polarity: Sontag, unlike Kael, has had to eat a lot of crow. She became one of those outraged humanists—"It is humanism or suicide," she declared flatly three decades later, after she decided culture was really in a mess. In reevaluating "the freedoms I espoused, the ardors I was advocating" on the occasion of a 1996 reissue of *Against Interpretation,* she sounded both condemnatory and defensive: "The judgments of taste expressed in these essays may have prevailed. The values underlying those judgments did not." Or, as Kael put it late in her life, "When we championed trash culture we had no idea it would become the *only* culture." In other words, be careful what you wish for. Poor Matthew Arnold, who'd looked so decrepit when Sontag was ragging him back in 1965, got the last laugh when Sontag turned *into* him. She became our Arnold. Seriousness, after all, is a primary Arnoldian value. It was Arnold's carefully considered definition of criticism—"a disinterested endeavour to learn and propagate the best that is known and thought in the world"—that drew him to foreign literatures, because sticking to home shores "would be making criticism lend itself just to one of those alien practical considerations, which, I have said, are so fatal to it." Does something in that statement ring familiar? The aim of what Sontag has called her wisdom project—*admiration project* would do as well—is celebrating Arnold's best that is known and thought in the world, and in her view, her homeland seldom measures up. The tone here isn't Arnoldian, but the sentiment is: "If I must describe what Europe means to me as an American, I would

start with liberation. Liberation from what passes in America for a culture. The diversity, seriousness, fastidiousness, density of European culture constitute an Archimedean point from which I can, mentally, move the world. I cannot do that from America."

But Arnold wrote with the optimism of his era, an optimism that seasoned his vision of the blessings culture would bring to the Britain he genially mocked. No one writing on this side of Hitler and Stalin can share that optimism, and Sontag doesn't share his geniality, either. Where Arnold gazed with serenity on the inevitable spread of social equality, Sontag regards the same phenomenon, from the other end, with a Nietzschean shudder at what the masses are doing to culture. She has always been an elitist, unembarrassed and, to me, abrasive. Arnold wrote with the aim of edification, but Sontag, appalled at "what passes in America"—and, increasingly, in the rest of the world—"for a culture," sees no hope for edifying the larger audience and has never even wanted to reach it. After "Notes on 'Camp'" gained such notoriety, she cringed at "the speed at which a bulky essay in *Partisan Review* becomes a hot tip in *Time*"; the ten thousand readers of *Partisan Review*, she once joked to a student audience, "were all the readers I ever wanted to have—until I was dead, of course." But the sentiment underneath was no joke. Her writing churns with bitterness toward the mass audience, and this bitterness sits uncomfortably with her egalitarian politics.

Every democratically inclined reader who can remember falling for the passion and the brio of Nietzsche ("*NIETZSCHE—my hero!*" Sontag's friend Richard Howard once saw scrawled on her lecture notes) will recognize the

conflict. No writer has ever articulated more forcefully than Nietzsche how much is at stake in the work of art. But his aesthetics is conjoined with a politics that is, any way you cut it—and those of us who love him keep on trying to find new ways—chillingly antidemocratic. Anyone on the left will find Nietzsche's endorsement of a two-tier society of masters and servants untenable (no matter how firmly rooted on the planet it actually is), but the only place I'm aware of that Sontag faces the problem squarely is the passage in "Trip to Hanoi" in which she concedes that what's salubrious for a truly egalitarian society might not be such a party for her: "Of course, I *could* live in Vietnam, or an ethical society like this one—but not without the loss of a big part of myself." That part of herself was the best part: the thinker, the aesthete, the critic. But if the intellect can, as she argues, dull the aesthetic sense, the aesthetic sense can also elbow ethical preoccupations out of the way. The same year as "Trip to Hanoi," 1968, she wrote, in the grips of a different mood, "Someday perhaps a demystification of the myth of 'art' (as an absolute activity) will be possible and will take place, but it seems far from that moment now." It wasn't as far as she thought. That very demystification was taking place in the writing of Kael.

Spend your whole life thinking about art, and it's possible to forget that art isn't everything—and, specifically, that art isn't ethics, that the choice between saving the old man or the old master from the burning museum is, ethically, no choice at all. That's one reason I'm grateful for Kael's insistence on "not taking the arts too seriously," as she once put it. And this was a woman who *lived* for art. That passion was the barb on the

hooks that she and Nietzsche both sank into my youthful heart. For Kael art was the supreme happiness. But for Nietzsche art was life itself. I'm not cracked enough to argue that her thinking rivaled his, but as I've grown older I've come to prefer the easygoing skepticism of her aesthetic as more humane and far less toxic. Kael titled one of her uncollected articles "It's Only a Movie," and if pressed she'd have applied that scruple not only to her favorite films but to the work of Matisse and Monteverdi, too. It's *only* art. And while art may seem to stand for everything you and I hold dear, *standing for* isn't the same as *embodying*. Art takes a distant second place to life. As Henry James demonstrated in his portrait of Gilbert Osmond, and Sontag in her example of the Auschwitz commandant who plays Schubert, a cultivated person isn't a better one. Nor is there a necessary conflict—a favorite theme of Tolstoy's—between goodness and plodding ignorance. I hope I'm not insulting you. As elementary as this stuff may seem, it's all too easy for aesthetes and intellectuals to lose sight of it, as the contempt for the vulgar public that mars so much of Sontag's writing demonstrates. Kael didn't forget it, and while she drew the (obvious) distinction between the mass audience and the educated audience, she neutralized whatever discomfort this insight may have brought her by fricasseeing them both.

Sontag points out, in discussing the "priestly" aims of modern art in "The Aesthetics of Silence," that "as long as art is understood and valued as an 'absolute' activity, it will be a separate, elitist one. Elites presuppose masses." No problem there (apart from that "absolute"). Nor can I object when she takes the next step, into the "familiar double standard" of modern philosophy:

upholding one standard (health) for the culture at large, another (spiritual ambition) for the solitary philosopher. The first standard demands what Nietzsche called the sacrifice of the intellect. The second standard demands the sacrifice of health, of mundane happiness, often of participation in family life and other community institutions, perhaps even of sanity. The philosopher's aptitude for martyrdom is almost part of his good manners, in this tradition of philosophizing since Kierkegaard and Nietzsche.

These notions call to mind the astute description, in "The Pornographic Imagination," of the modern artist as "a freelance explorer of spiritual dangers."* All of the foregoing observations seem eminently fair; nor is there any reason to blanch when she observes, "The republic of letters is, in reality, an aristocracy." The modern notion of art is inherently elitist.

But Sontag's elitism has an exclusionary malevolence that goes well beyond the notion of a priestly caste of artists and thinkers. As early as 1964, she attributed the cinema's relative security from hordes of interpreters in part to "the happy accident that films for such a long time were just movies; in other words, that they were understood to be part of mass, as opposed to high, culture, and were left alone by most people with minds." That use of "people with minds" as a synonym for *literary intel-*

*Compare Kael's observation "In primitive societies, and in this country until quite recently, a man proved his courage by exposing himself to a dangerous test. If there's any equivalent to that now, it's exposing himself to the danger of going crazy."

lectuals has always ruffled me, since the unavoidable corollary is that people who aren't literary intellectuals don't have minds. And that's offensive. Are scientists who don't share my interest in the arts short on intelligence? Are the members of my family? (They could make a pretty good case that most of the art I subject myself to pegs me as the dimwit.) Sontag is noticeably reticent on the subject of her own family, and the few spots where she does refer to it give off a whiff of contempt. Not that Kael isn't a virtuoso of contempt herself. But she directs it differently. Sontag's contempt is for the mass audience—the paying public. Kael is a more consistent small "d" democrat, and though her tastes are nothing like mass tastes, her respect for show business leads her to scorn not the audience (her attitude toward the audience comes closer to exasperation) but the artists who insult it with second-rate efforts: "As soon as an artist ceases to see himself as part of the audience—when he begins to believe that what matters is to satisfy the jerk audience out there—he stops being an artist."

It's easy enough to laugh off Sontag's snottiness as a holdover from high school, but on occasion it suggests a more worrisome set of attitudes. In her 1974 anti-Riefenstahl polemic, "Fascinating Fascism," she offered second thoughts on her earlier endorsement of camp. (It had only been a semi-endorsement, anyway.) I agree with her that the rise of camp taste was disastrous to a lot of pop culture, and though I don't buy her ascription of Riefenstahl's rehabilitation to that phenomenon—*Triumph of the Will* strikes me as too accomplished, and too upsetting, to satisfy an appetite for failed seriousness—that's beside the point. The point is the assertion her argument leads to:

Art that seemed eminently worth defending ten years ago, as a minority or adversary taste, no longer seems defensible today, because the ethical and cultural issues it raises have become serious, even dangerous, in a way they were not then. The hard truth is that what may be acceptable in elite culture may not be acceptable in mass culture, that tastes which pose only innocuous ethical issues as the property of a minority become corrupting when they become more established.

Note the slight hesitation—agenbite of inwit?—in the conditional "may be," "may not be." Note also that here she's no longer making provision for a priestly caste of artists and thinkers; she's talking about an upper class of educated intellectuals. How very Madame Mao, ensconced in her screening room with the Garbo movies that were considered too louche for the public. In contravening the notion that the free exchange of even the most dangerous ideas amounts to a lesser threat than the repression of ideas, the passage is antidemocratic in the profoundest sense. No, I don't think Sontag is for the suppression of speech—but her *posture* suggests that it might not be such a bad thing. The existence of an elite who can decide which ideas are safe for general consumption is one of the cornerstones of repression, and for Sontag to put it forward, even with a million qualifiers—and she doesn't offer *one*—makes me gulp.

But then Sontag has always had a low opinion of her fellow citizens, predicated on the embarrassing robustness of American bad taste. For her, vulgarity is a mortal sin rather than a venial one. "Today's America," she scowled in 1966, "with Ronald Reagan the new daddy of California and John Wayne chawing spareribs in the White House" (as a South-

erner, I resent that), "is pretty much the same Yahooland that Mencken was describing." Then she got *really* high-handed: "After America was 'won,' it was filled up by new generations of the poor and built up according to the tawdry fantasy of the good life that culturally deprived, uprooted people might have at the beginning of the industrial era. And the country looks it." That's some fairly supercilious class bias to be issuing from the granddaughter of immigrant Jews, not to mention from a radical (at that point) leftist. In the 1969 "Some Thoughts on the Right Way (for Us) to Love the Cuban Revolution," one of several political essays she must be glad she never collected, she tried to link this revulsion directly to her politics—i.e., to make an ethical case for it:

An integral part of the adversary culture developed by American radicals is the cultivation of good taste. Imperialist America is also Babbitt America. To us, it is self-evident that the *Reader's Digest* and Lawrence Welk and Hilton Hotels are organically connected with the Special Forces' napalm-ing of villages in Guatemala this past year.

It's instructive to set next to this twaddle a nearly contemporaneous passage from Kael's 1967 essay on *Bonnie and Clyde*. Far from holding herself above American vulgarity, she hailed "the honesty to see ourselves as the Yahoo children of yokels" as "a good part of American popular art": "We are bumpkins, haunted by the bottle of ketchup on the dining table at San Simeon. We garble our foreign words and phrases and hope that at least we've used them right. Our heroes pick up the wrong fork, and the basic figure of fun in the American theatre

and American movies is the man who puts on airs." Or this, from "The Man from Dream City," her 1975 profile of Cary Grant: "When we in the audience began to sense the pleasure he took in low comedy, we accepted him as one of us. . . . Cary Grant's romantic elegance is wrapped around the resilient, tough core of a mutt, and Americans dream of thoroughbreds while identifying with mutts."

Kael had no patience with snobbery on the left. "John Schlesinger in *Midnight Cowboy*, Tony Richardson in *The Loved One*, Antonioni in *Zabriskie Point*—liberals all, but aesthetes first—spin a new baroque out of the grotesqueness of American bad taste," she protested. "They lose their socially conscious moorings when they treat American culture." Years later, she directed the same vitriol at Michael Moore for his sardonic documentary *Roger & Me*: "The camera makes brutal fun of a woman who's trying to earn money as an Amway color consultant, and it stares blankly at a woman who's supplementing her government checks by raising rabbits. . . . *Roger & Me* uses its leftism as a superior attitude. Members of the audience can laugh at ordinary working people and still feel that they're taking a politically correct position." Sanctimony and self-satisfaction on the left, where she was situated herself, revolted her probably even more than they did on the right. "The left can be really good haters," she lamented (and she was speaking as one who knew), "aristocrats of hatred."

For me, Sontag's best writing on politics and society occurs not in the dryish articles she devoted to those topics but in the same place Kael addressed them: the asides, swipes, and off-the-cuff observations that crop up constantly in her essays on aesthetic themes. That's largely because her thinking about

society, like that of her inspirations the Surrealists, takes off from and entwines with her thinking about art. These asides are so cogent and confident that they seem to reflect positions she's worked out fully elsewhere—only there's no such elsewhere. They are, in fact, a stratagem, a way of saying "This is obvious, this has been dealt with, and there isn't the space to go into it here," when the truth is they're ambushes dressed up to look more formally worked out than they really are. Which isn't to say I don't find them convincing.

A few examples. Notwithstanding her objections to Arnold's definition of art as the criticism of life, that definition has always been implicit in her assumption that the creations of the avant-garde represent a response to (often a revulsion against) the society around it. This goes even for the art she was against interpreting—the art that was supposed to appeal directly to the senses. "Ours is a culture based on excess, on overproduction," she declared in the 1964 manifesto that gave her first collection its title; "the result is a steady loss of sharpness in our sensory experience. All the conditions of modern life—its material plenitude, its sheer crowdedness—conjoin to dull our sensory faculties. . . . What is important now is to recover our senses. We must learn to *see* more, to *hear* more, to *feel* more." This position wasn't just about individual gratification; it was a matter of *social*, of *cultural* convalescence. The art she was defending could save us from what society was doing to us, and any art that aims at salvation is by definition a criticism of what it's salvaging us *from*. In writing about art (and about illness, too), Sontag has offered an ongoing critique of consumer capitalism—of what she calls, in "Notes on 'Camp,'" "the psychopathology of affluence."

A culture based on excess, on overproduction: these features of modern capitalist society have always shocked the puritan in her. Nothing in North Vietnam charmed her more than the country's enlightened frugality: "To observe in some of its day-to-day functioning a society based on the principle of total use is particularly impressive to someone who comes from a society based on maximal waste." Her puritanism also underlies the magisterial pessimism with which she reviews the photographic endeavor at the end of *On Photography*, in a summation that's equally censorious of excess and of what I'm tempted to call graven images:

> A capitalist society requires a culture based on images. It needs to furnish vast amounts of entertainment in order to stimulate buying and anesthetize the injuries of class, race, and sex. And it needs to gather unlimited amounts of information, the better to exploit natural resources, increase productivity, keep order, make war, give jobs to bureaucrats. . . . Social change is replaced by a change in images. The freedom to consume a plurality of images and goods is equated with freedom itself. The narrowing of free political choice to free economic consumption requires the unlimited production and consumption of images.

She continues this critique in *AIDS and Its Metaphors*, with the instinctual recoil from extravagance that some gay critics would misread (despite the caveat she clearly offers) as homophobia:

> One set of messages of the society we live in is: Consume. Grow. Do what you want. Amuse yourselves. The very

working of this economic system, which has bestowed these unprecedented liberties, most cherished in the form of physical mobility and material prosperity, depends on encouraging people to defy limits. Appetite is *supposed* to be immoderate. The ideology of capitalism makes us all into connoisseurs of liberty—of the indefinite expansion of possibility. . . . Hardly an invention of the male homosexual subculture, recreational, risk-free sexuality is an inevitable reinvention of the culture of capitalism, and was guaranteed by medicine as well.

Advertising disgusts her as a tool designed "to incite people to buy more, to consume and throw away faster. People let the direct awareness they have of their needs, of what really gives them pleasure, be overruled by commercialized *images* of happiness and personal well-being."

Kael, too, grimaced at the vacancy of "a commercialized society that nobody believes in." In the sixties, she saw her antipathy reflected in the nausea of the disaffected kids who "want some meaning, some honesty, some deeper experience" and find, instead, that "they're surrounded by selling, and they tune out." Advertising appalled her every bit as much as it appalled Sontag, and she thought that movies were turning into a form of it. There was no part of her portfolio she took greater pride in than razzing hype—because, as she frequently said, "without a few independent critics, there's nothing between the public and the advertisers."

But while her values resemble Sontag's, her outlook is from another psychic planet. She's not puritanical; she's not ascetic; she's not *guilty*. "What Marxists and other puritans have never

wanted to allow for," she once wrote, "is the fun to be had with the material goodies that capitalism produces (such as entertaining movies)." Can you imagine Sontag writing a sentence like that? In content it's not so different from her self-flagellation before the North Vietnamese: "Those who don't enjoy (in both senses) my pleasures have every right, from their side, to regard my consciousness as spoiled, corrupt, decadent. I, from my side, can't deny the immense richness of these pleasures, or my addiction to them." Except that in Kael there's no flagellation. Nothing repelled her like guilt—an uncommon aversion for a Jew, even a nonbelieving one. At the end of one of several broadcasts on which she attacked the management of KPFA, the listener-sponsored station that ran her show, for its high-handedness, its cheapness ("They didn't even pay my way into the movies," she was still grousing years later), and its interminable panhandling, she turned on her listeners disgustedly:

> And you, I suppose, will go on guiltily turning over your dollars to this station, feeling with each contribution that you're a better person for it. You're paying off the liberal debt. You feel as if you're really doing something, even if nobody will tell you exactly what. It's all a big union of self-sacrificing, dedicated staff and self-sacrificial listeners—a kind of osmosis: they give you guilt, you give them money. And the more guilt they give you, the more you need to assuage your guilt by giving them money.

(She didn't last much longer on the radio.) Similarly, her take on the bankruptcy of American imperialism isn't nearly as different from Sontag's as her emotional response is. In reviewing

the 1982 *Four Friends,* she pointed to the "deeply conserva-
tive" assumptions of Steve Tesich's screenplay—"There's
a flag-waving underlayer to this picture's love affair with
America the melting pot"—and then laid out the reasons they
dismayed her: "This foursquare optimism is much harder to
take than cynicism or disillusion, because we're supposed to
learn from it, and what we're supposed to learn is how lucky we
are to be Americans. We'd have to be terrible fools not to know
that. And we'd have to be moral idiots not to be disturbed by
what is entailed in our good fortune."

There's something liberating in this guilt-free acknowledg-
ment of the compromises underneath our comfort. It was, I
suspect, a matter of disposition: the serenity with which Kael
accepts the ugly truth would be cynicism in others. Reviewing
the 1983 *Under Fire,* she wrote, "The United States has been
setting up or knocking down Nicaraguan governments since
1909; the movie can hardly pretend to be showing us things we
don't—at some level—already know. *Under Fire* is about how
you live with what you know." Sontag finally can't live with
what she knows. She has to *do* something. Kael doesn't suffer
the same compulsion.

One place their outlooks do predictably converge is around
issues regarding women. Both of them were producing mature
work well before the contemporary feminist movement ignit-
ed in the late sixties, and while they shared most of the move-
ment's assumptions (if not most of its rhetoric), they were both
exceptions: women who hadn't faced all that many obstacles *as*
women. Sontag admits she had it easy: "Now and then, people
I met would allude to the supposed difficulties of being both
independent and a woman; I was always surprised—and some-

times annoyed, because, I thought, they were being obtuse.
. . . I was conscious of being an exception, but it hadn't ever
seemed hard to be an exception; and I accepted the advantages
I enjoyed as my right. I know better now."

Kael was angrier earlier, no doubt because, unlike Sontag,
she had to really struggle for recognition. She griped about
"how difficult it is for a woman in this Freudianized age, which
turns out to be a new Victorian age in its attitude to women
who *do* anything, to show any intelligence without being
accused of unnatural aggressivity, hateful vindictiveness, or
lesbianism." She also anticipated by several years some of the
movement's major themes. Readers with memories of the later
Kael's practically smacking her lips over her favorite actresses
(Jessica Lange: "when this woman gets to shake her chassis it's
some chassis"; Anjelica Huston: "*oooee*—she's a harlot, she's
a princess"; Annette Bening: "a stunning actress and a superb
wiggler") may be surprised at the rage she brings to a denunci-
ation of the "degradation of the female image" early in *I Lost It
at the Movies*. Referring to the photos in two modish coffee-ta-
ble volumes on sex in the cinema (Kenneth Anger's *Hollywood
Babylon* was one of them), she charges, "This female image is
a parody of woman—lascivious face, wet open mouth, gigan-
tic drooping breasts. She has no character, no individuality."
And, gathering steam, she continues, "I don't believe that these
photographs are erotic in any ordinary sense. I think that the
grotesqueness of this female image is what people enjoy." But
why? In large part because "these spongy, subhuman sex imag-
es reduce women to the lowest animal level. And in the modern
world, where women are competent, independent, and free and
equal, the men have a solid, competitive hostility—they want to

see women degraded even lower than they were in the Victorian era." This specimen of protofeminist consciousness-raising comes from an essay first published in 1961. It was only later, as she became alarmed by the widening streak of prudery in feminism, that she made such a point of standing up for female sexiness.

Several years after she retired, Ray Sawhill asked her how her career might have been different if she'd been Paul Kael; she laughed and answered, "I don't know who can say, because I very specifically took a woman's point of view." ("And I used bitchery as a tool," she added, in case anyone was wondering.) Kael never lets you forget you're listening to a woman's voice, informed by a woman's sometimes harsh experience. For example: recalling a scene from *Christopher Strong,* "an arch, high-strung, sickeningly noble Katharine Hepburn movie back in 1933" in which the man the aviatrix heroine has just gone to bed with asks her, out of love and genuine concern, to give up her career, she commented, "There are probably few women who have ever accomplished anything beyond the care of a family who haven't in one way or another played that scene. Even those who were young girls at the time"—she would have been thirteen or fourteen—"recognized it, I think, if only in a premonitory sense. It is the intelligent woman's primal post-coital scene."

Exhilarated by Lonette McKee's brazen performance as Sister in the 1976 *Sparkle* ("You look at the sheer taunting sexual avidity . . . and you think 'What man would dare?'"), she probed in ways that never occurred to the filmmakers. "The subject that's passed over—why the thug wants to possess and destroy Sister, who so obviously has everything it takes to

become a star, and why she's drawn to him—is a true modern subject," she observed, then speculated as to why Sister might want to be possessed and destroyed: "The stronger a woman's need to use her energy, her brains, and her talent, the more confusedly she may feel that she has a beating coming." What Kael found phony wasn't Sister's doom, which she could make sense of, but the "docile, unassertive" title character's steady rise to stardom—"because, given the social and biological circumstances of women's lives, a woman who isn't called a hard-driving bitch along the way is not likely to reach any top. A movie can show us the good girls winning the fellas, mothering the kids, succoring those who have met with adversity, but a good-girl artist is a contradiction in terms." That's experience talking.

Sontag made precisely the same observation in her author's note to *Alice in Bed*: "The obligation to be physically attractive and patient and nurturing and docile and sensitive and deferential to fathers (to brothers, to husbands) contradicts and *must* collide with the egocentricity and aggressiveness and the indifference to self that a large creative gift requires in order to flourish." Yet in the tone she brings to discussing these matters, she is, as usual, Kael's opposite number. The feminist critic Angela McRobbie nailed it, I think, in an ambivalently admiring 1991 article: "The sensibility of literary modernity which Sontag explores, enters into and shapes her own critical style of writing. So deeply impersonal is this mode that Sontag's enthusiasm is always tempered and constrained. There is hardly a trace of her own personal voice, not a trace of gender, of place, or of preference. Sontag's modernity is stripped bare." Exactly.

Even when Sontag is arguing from a specifically feminist stand-point, her voice remains stylistically neuter. Or it did until recently. She narrates *The Volcano Lover* and *In America* in what is unmistakably a woman's voice—which must be one of the reasons she feels so much freer, as she's stated, when she's writing fiction—and this freedom carries over into *Regarding the Pain of Others,* in which she argues, if not exactly in a woman's voice (the familiar timbres haven't changed), certainly from a woman's point of view.

There are other spots, too, where you find Sontag and Kael drawing on their common experience as women to make the same observation. In 1973, Sontag admonished the liberated woman against "betraying her sisters":

> Most women who pass as being "liberated" are shameless Uncle Toms, eager to flatter their men colleagues, becoming their accomplices in putting down other, less accomplished women, dishonestly minimizing the difficulties they themselves have run into because of being women.

Kael had offered the same admonition seven years earlier in "The Making of *The Group*":

> Mary McCarthy has always satirized women. We all do, and men are happy to join us in it, and this is, I think, a terrible feminine weakness—our coquettish way of ridiculing ourselves, hoping perhaps that we can thus be accepted as feminine, that we will not be lumped with those imaginary gorgons who are always held up as horrible examples of

competitive, castrating women. We try to protect ourselves
as women by betraying other women.

Kael's "we" versus Sontag's "they" is characteristic—another
example of the personal versus the impersonal voice.

Since movies are constantly (if not always scintillatingly)
raising women's issues, Kael could address them the same way
she addressed other social issues, in the course of her regular
reviewing. Perhaps because Sontag didn't have this natural
platform—and perhaps, too, because she wrote from such a
gender-neutral standpoint—in the early seventies she devot-
ed two lengthy articles, "The Double Standard of Aging" and
"The Third World of Women" (both as yet uncollected), to
feminist topics.

"The Double Standard of Aging" is a protracted kvetch
about the unfair conditions that reduce women to dumb narcis-
sism ("a woman who spends literally *most* of her time caring for,
and making purchases to flatter, her physical appearance is not
regarded in this society as what she is: a kind of moral idiot")
while men get away with barely paying attention to their looks.
Today it reads like a period piece, a time capsule from that same
bygone era of male insensibility when Kael could account for
Bob Dylan's allure by concluding that "his narrow shoulders
were appealing to all those hunched-up kids who show their
opposition to war by not developing their muscles." It's angry
and cogent, but it doesn't have the shock of discovery and
self-discovery that electrifies Sontag's critical essays.

"The Third World of Women" is less of a slog. It offers some
ideas that can still make you sit up—e.g., "In a nonrepressive

nonsexist society, . . . sexual relations will no longer be hysterically craved as a substitute for genuine freedom and for so many other pleasures (intimacy, intensity, feeling of belonging, blasphemy) which this society frustrates." It has a political hardheadedness that distinguishes it from a lot of other feminist writing of the era. ("The liberation of women is a necessary preparation for building a just society—not the other way around, as Marxists always claim.") And I love to picture Sontag carrying out her proposals for female subversion, which include storming beauty parlors, establishing makeup withdrawal centers, collecting pledges to renounce alimony and giggling, and wolf-whistling at men. Still, the Sontagian excitement is missing here, too—one indication of which is the article's stylistic parsimony. When Sontag gets revved, flourishes glamorize her sentences, as in "The modern 'nuclear' family is a psychological and moral disaster. It is a prison of sexual repression, a playing-field of inconsistent moral laxity, a museum of possessiveness, a guilt-producing factory, and a school of selfishness": you can tell from her metaphors that the subject has hooked her.

For the most part, these articles yearn for that kind of exuberance. There's something dutiful in them, as Adrienne Rich suggested in a 1975 letter to *The New York Review of Books*— though Rich was complaining that Sontag wasn't being dutiful *enough*. She wondered how the same thinker who two years earlier had produced "The Third World of Women" could have written the recent "Fascinating Fascism," which, for all its brilliance, didn't identify fascist values as "masculinist, virilist, patriarchal" explicitly enough to suit Rich. Accusing Sontag of "aesthetic compromise with the representatives of oppression,"

she speculated that Sontag's excursion into feminism had been "more of an intellectual exercise than the expression of a felt reality—her own—interpreted by a keen mind."

I do think Rich was on to something, but it wasn't a matter of "a felt reality." The fact that art pierces Sontag more deeply than politics does is hardly an indictment of her entirely admirable decision to pitch in and do her part for sisterhood. In any case, her reply was so withering that Rich probably wound up wishing she hadn't mailed the letter. Sontag aimed straight at the anti-intellectualism of feminist rhetoric. "Like all capital moral truths, feminism is a bit simple-minded," she said dryly. She accused Rich of devaluing the complexity of history, pointing out that since "most of history, alas, is 'patriarchal history,'" it's "not possible to keep the feminist thread running through the explanations all the time." Sontag has never been more at one with Kael than in the impatience she showed with "this demand for an unremitting rhetoric, with every argument arriving triumphantly at a militant conclusion."

The enemy, in other words, was cant. Sontag and Kael both recognized that nothing is ever simple, not even justice. ("The very nature of thinking is *but*.") The protofeminist Kael tore into pop sisterhood gleefully. "I dislike *The Stepford Wives* for reasons that go beyond its being a cruddy movie," she wrote in 1975, about a science-fiction picture in which male chauvinists turn their wives into obedient droids:

> As a statement—a text for our times—with the slave-wives parading somnambulistically in the aisles of the Stepford supermarket, stacking canned goods in their carts, it's really a crock. If women turn into replicas of the women in

commercials, they do it to themselves. Even if the whole
pop culture weighs on them—pushing them in that direc-
tion—if they go that way, they're the ones letting it happen.
. . . What is the danger represented by robotization but giv-
ing in to commercialism and letting the advertising society
set the models for one's own behavior?

Observing that "the most salable part of the women's-liberation
movement is the idea that women have been wronged by
men," she called the movie "a guilt provoker for men," and
guilt provoking nauseated her even more than guilt did.
"There's so much of this in the air now that men are proba-
bly beginning to accept the guilt. . . . This sentimentality is
degrading."

Because of the clumsiness with which moviemakers tend to
ladle lessons over a subject, Kael actually preferred naive or
misguided politics to soggy ones. Thus in 1971 she observed of
The Last Picture Show,

Though the older women in the town are dealt with sympa-
thetically, the young girls are not; I hope no one tries to make
a Women's Lib hanging case out of this. The girls are seen
only from the boys' point of view; this is perhaps an indica-
tion of [Larry] McMurtry's and [Peter] Bogdanovich's limited
understanding rather than a deliberately chosen perspective,
but truth to one's experience is far more important in a writer
and a director than a hollow "fairness" doctrine.

And she despised the sentimental self-mystification with
which women could deck themselves out. "The affectation

of *Lumière*," she said of a 1976 picture Jeanne Moreau had written, directed, and starred in, "is that its heroine is closer to the earth than men are, and yet has higher, more spiritual feelings than men. Which is where many men, too, have wanted to place women—leaving them out of the middle range, where the action is." Structurally, this complaint resembles her objection to the treatment of the aborigines in the 1979 Australian film *The Last Wave*:

> A few generations ago, whites saw the victims of white civilization (as racist bigots still do) in terms of sexuality and savagery; now the victims are seen in terms of magic, dreamspeak, nobility, intuition, harmony with nature. The white bigots saw them as mentally inferior; the modern, guilt-ridden whites see them as spiritually superior. In neither case are they granted what is their plain due: simple equality.

The calls for balance, for the reasoned approach of the middle way, mark Kael as the Aristotelian she was. Sontag was a Platonist from the start. (Compare with the preceding quotation Sontag's "The white race *is* the cancer of human history.") This elementary method of classifying philosophical personalities applies neatly to their (actually rather similar) politics. Sontag is a born radical, a utopian, a quester after the impossible—a writer who uses *quixotic* as a term of praise. Kael's pragmatism vis-à-vis politics isn't so different from her approach to the cinema, which is another instance of the art of the possible. The earliest piece she included in *I Lost It at the Movies,* the 1954 "Morality Plays Right and Left," pummels extremists at both ends of the

political spectrum. Her anti-McCarthyism apparently didn't raise too many hackles among the readers of *Sight and Sound,* where the article originally ran, but her denunciation of *Salt of the Earth* (which had been independently made by blacklisted filmmakers) as Communist propaganda drew outraged letters, and *I Lost It at the Movies* ends with her response to them, which articulates the church-state divide between art and politics that she would find herself having to rehash many times over the years: "*Salt* wasn't a strike, it was a movie; but the confusion goes to the heart of the propagandistic aesthetic—you're considered a strike breaker if you didn't like it." She regarded this divide as a principle, even though politics enthralled her almost as much as movies did. She always had the news or C-SPAN on at home, she inhaled *The New York Times,* and she once told me that if her career hadn't taken the turn it did, she might have enjoyed writing a political column. (What a prospect: with her finely tuned bullshit detector and—what may be the same thing—her phobia of sanctimony, especially in her own voice, she had the makings of a spectacular pundit.) It wasn't that she thought politics had no place in films. What was anathema to her was letting one's politics affect one's critical judgment.

In practice she was more circumspect about her own views than she thought she was. "I tried to put my background and predilections right out on top, so that the reader could know what my responses came from," she explained in an interview a few years after her retirement. It's true that on KPFA she once described herself as "an honest atheist anti-Communist," and that in praising *L'Avventura* she said of the Marxist Antonioni, "Although he may believe in the socialist criticism of society,

he has no faith in the socialist solution. When you think it over, probably more of us than would care to admit it feel the same way." But these two small position statements are both early and rare. As astute a reader as Jed Perl could observe, in a 1993 appreciation of *For Keeps*, "It is one of the interesting things about Kael's writing that, after all this time and all the controversial topics that she's dealt with, one cannot really say where she stands politically save that she's a kind of liberal spirit."

To make things murkier, she spilled more ink attacking cant on the left than on the right. After disemboweling *A View from the Bridge* in 1963, she told her radio audience, "I expect I'll get some letters saying, 'Why are you always so hard on the liberals? Why don't you attack the reactionaries?' I'd be happy to, but in the arts where are they? Our drama and films are a thick sludge of liberal sentimentality." When she had the opportunity, she gladly went after stupidity on the right: the vapid anti-Communism of the 1954 *Night People* (the "Right" of "Morality Plays Right and Left"), the savagery of John Milius, the paranoia of Clint Eastwood, the "narcissistic jingoism" of Sylvester Stallone. But in Hollywood the bilge tends to collect on the left, and she loved ripping into liberal smugness. "There's a strong element of self-admiration in the film's anti-Vietnam attitudes," she clucked in 1978 over *Coming Home*, in which a paraplegic antiwar veteran not only leads the wife of a gung-ho Marine to enlightenment but also gives her her first orgasm. "Are liberals really such great lovers?"

In 1953, in her very first published review, "Some Notes on Chaplin's *Limelight*," Kael was already using politics as a way of getting a handle on the makeup of the mass audience,

defining it as "let us say roughly the people who voted for
Eisenhower." Her feelers for grassroots attitudes helped make
her a master psychopathologist of American society. When
there was disquiet, it showed up in the popular culture, and for
purposes of diagnosis, as she once explained, "sometimes bad
movies are more important than good ones just because of those
unresolved elements that make them such a mess. They may
get at something going on around us that the movie-makers felt
or shared and expressed in a confused way." So it was that in
her 1955 essay "The Glamour of Delinquency," she used three
films she had severe reservations about—*On the Waterfront,*
East of Eden, and *Blackboard Jungle*—to decry the "prosper-
ous, empty, uninspiring uniformity" of a culture whose rewards
for the line-toeing citizen amounted to "a dull job, a dull life,
television, freezers, babies and baby sitters, a guaranteed annu-
al wage, taxes, social security, hospitalization insurance, and
death." (It was a period, she later said, "when everybody was
Eisenhower-gray.") The blandly attractive protagonists of
most new movies, she wrote elsewhere around the same time,
"represent the voice of adjustment, the caution against indi-
viduality, independence, emotionality, art, ambition, person-
al vision. They represent the antidrama of American life." In
a nation stricken with the blahs, the sudden rise of sociopathic
young protagonists had real meaning: "When the delinquent
becomes the hero in our films, it is because the image of instinc-
tive rebellion expresses something in many people that they
don't dare express." At the time, Kael was still a Berkeley bohe-
mian herself, and her disdain strikes some of the same anties-
tablishment notes the Beats would soon hit:

Our economic system, our social order, are accepted, not
with respect, but as facts, accepted almost at the same level
on which "regular" films are accepted—a convictionless
acceptance which is only a hair's breadth away from violent
negation. . . . Why care about acquiring the millionaire's
equipment of the middle-class home; does anyone really
enjoy a power-driven lawn mower? Everything in America
makes life easier, and if Americans are not really happy,
they're not really unhappy either. If they feel some pangs
of dissatisfaction, what can they blame it on? Only them-
selves—guiltily. . . . What a relief to go to the movies and
hear mixed-up kids say it out loud. They don't always say
it in attractive ways, but it is a no and *somebody* has to say it.

If these pictures raised crucial issues, though, their phony
optimism, with the delinquents cleaning up and growing up
for the upbeat finales, let her down. "It's a social lie to pretend
that these kids are only in conflict with themselves or that they
merely need love or understanding. Instinctively, the audience
knows better."

But social lies are what Hollywood manufactures—a theme
she explored the following year in a landmark essay, never
collected, called "Movies, the Desperate Art." In a section on
pressure groups, she addressed the question of stereotyping,
positive as well as negative: "The morally awakened audience
banished the early subhuman racial stereotypes from the screen;
they developed their own stereotypes—which they must know
to be lies and yet feel are *necessary* lies." Lies are lies, though.
As Sontag once wrote, "When a choice (between truth and jus-
tice) is necessary—as, alas, it sometimes is—it seems to me that

an intellectual ought to decide for the truth." Kael wouldn't
have limited the obligation to intellectuals. "How effective,
one wonders, are the 'necessary' lies of well-meaning people
when the mass audience lives in a world full of the very people
that the movies tell us are figments of prejudiced thinking—
the Negroes of Harlem or the Fillmore, the Jews of Broadway
and Central Park West, and the Hollywood producers of the
Hillcrest Country Club." Being a Jew herself may have bol-
stered her sense of impunity in making that statement, but she
was far less alarmed by the dangers of negative stereotyping
than by the "real democratic disease" that well-intentioned
counterattempts had produced: "a mass culture made up of
[positive] stereotypes, models, whitewashes, smiles and lies."
She took up the theme again in her 1973 review of *Mean Streets*,
Martin Scorsese's breakthrough account of petty Mafiosi in
Little Italy:

> Some editorial writers like to pretend this is all a matter of
> prejudice; they try to tell us that there is no basis for the pop-
> ular ethnic stereotypes—as if crime among Italians didn't
> have a different tone from crime among Irish or Jews or
> blacks. Editorial writers think they're serving the interests
> of democracy when they ask us to deny the evidence of our
> senses.

"Films do not suffer from the pressure to do something," she
concluded in "Movies, the Desperate Art"; "they turn into
drivel because of the pressures not to do almost everything.
One may suspect that there is something fundamentally cor-
rupt in a concept of democracy which places safety, harmony

and conformity above truth." She was writing a good two to three decades before the rise of political correctness. When its era arrived, her directness earned her vituperation (often in the pages of *The Village Voice*) as a racist, a homophobe, even an anti-Semite—slanders all.

Like most liberals, Kael opposed the Vietnam War and detested Richard Nixon, but the tenor of her writing in the Vietnam/Watergate period is far less one of protest than of worry over what those debacles were doing to the national psyche. In review after review during the late sixties and early seventies, she pondered the damage, most fully and eloquently in a 1973 essay, written shortly after the Watergate hearings, called "After Innocence":

> The movies of the thirties said that things would get better. The post–Second World War movies said that villainy would be punished and goodness would triumph; the decencies would be respected. But movies don't say that anymore; the Vietnamization of American movies is nearly complete. Today, movies say that the system is corrupt, that the whole things stinks, and they've been saying this steadily since the mid-sixties. The Vietnam war has barely been mentioned on the screen, but you could feel it in *Bonnie and Clyde* and *Bullitt* and *Joe*, in *Easy Rider* and *Midnight Cowboy* and *The Last Picture Show*, in *They Shoot Horses, Don't They?* and *The Candidate* and *Carnal Knowledge* and *The French Connection* and *The Godfather*. It was in good movies and bad, flops and hits, especially hits—in the convictionless atmosphere, the absence of shared values, the brutalities taken for granted, the glorification of loser-heroes.

For Kael, though, the *whole* thing didn't stink, and the national self-laceration sickened her. She fretted maternally about this self-loathing tone in popular culture, which an endemically corrupt industry had turned into a profit-making formula for celebrating violence and brutality. (Sontag—the later, politically matured Sontag—was acknowledging the same phenomenon, and with the same recoil, when she noted that Diane Arbus's photographs amassed their power via the "cut-rate pessimism" of "making equivalences between freaks, mad people, suburban couples, and nudists." Arbus's method, she wrote, constituted "a very powerful judgment, one in complicity with a recognizable political mood shared by many educated, left-liberal Americans"—the judgment that there's no difference between run-of-the-mill Americans and monsters; everything is corroded, has always been corroded.) For Kael, it was as though pop culture had turned on its audience:

> When movie after movie tells audiences that they should be against themselves, it's hardly surprising that people go out of the theaters drained, numbly convinced that, with so much savagery and cruelty everywhere, nothing can be done. The movies have shown us the injustice of American actions throughout our history, and if we have always been rotten, the effect is not to make us feel we have the power to change but, rather, to rub our noses in it and make us accept it. In this climate, Watergate seems the most natural thing that could happen. If one were to believe recent movies, it was never any different in this country: Vietnam and Watergate are not merely where we got to but where we always were.

And yet, and yet . . . the situation held a deep, strange irony. An extraordinary number of the movies that were making Kael so uneasy were, she recognized, superb: "We will never know the extent of the damage movies are doing to us, but movie art, it appears, thrives on moral chaos." In this tormented era she discerned a great age, possibly *the* great age, of American filmmaking. "A few decades hence," she wrote in the introduction to the 1976 *Reeling,* "these years may appear to be the closest our movies have come to the tangled, bitter flowering of American letters in the early 1850s." She never changed her mind.

If there was something motherly in Kael's concern, Sontag played the opposite part: the impossible teenager she'd never been. She admitted it. "I had a very enjoyable adolescence from the age of 27 to about 35, which coincided with the '60s," she told one interviewer. ("I was practically thirty, and I learned to dance, and I became a dancing fool," she told another.) Kael, who had identified herself as a Trotskyist during her college years, had the good fortune to play out the drama of her political adolescence before she made her way into print. Sontag wasn't so lucky. If she took her professional model from the buttoned-up New York Intellectuals, of whom she was too young to be a bona fide member, she got her political style from the New Left, which was younger than she was and tempera-mentally far more rabid. In the sixties, she was widely regarded as a radical across the spectrum—the apostle of the new in art and politics both. But her critical stands have worn better than her political ones have. In her politics, she sometimes reminds me of Katie Morosky, the "frizzy-haired Jewish girl from New

York with a chip on her shoulder," as Kael described her, that Barbra Streisand played in that 1973 soap opera *The Way We Were*. For Kael, Katie incarnated "the spirit of the hysterical Stalinist workhorses of the thirties and forties—both the ghastly desperation of their self-righteousness and the warmth of their enthusiasm." Allowing for the difference in eras and temperaments (I know, it's a stretch), her description catches something winning, and touching, in Sontag: "Katie, who has no common sense, cares so much about everything . . . that our feelings go out to her, even when her outbursts are offensive— perhaps most when they're offensive."

Throughout her career, Sontag has made a point of sticking her neck out in public in the attempt to do, and inspire others to do, what's right. Often she's done it gracelessly. In her political writings, the fuses blow and her cool gives way to a pained, neurotic wrath. The essays on aesthetic topics, even with their gauntlet hurling and their pronunciamentos, open the way to debate, but the political essays seek to shout it down. You could argue in Sontag's defense that in politics issues of immense and immediate consequence are at stake, issues of life and death. But in politics more is *always* at stake in terms of human consequence, and so clarity and detachment are never more crucial. Sontag isn't detached even on the surface when she confronts America's maleficence toward the rest of the globe. Her hotheadedness recalls something Kael noted back when she was demolishing *Salt of the Earth* in 1954. *Salt of the Earth* depicted the miserable living and working conditions of Mexican-American miners in the Southwest, a situation Kael knew was anything but trumped up. The trouble, she argued, arises when

people of conscience let propagandists prey on their eager desire to do something about such outrages:

> Communist propaganda takes this desire and converts it into a sense of anxiety and distress by "demonstrating" that all of American power supports this shocking situation and thus uses this situation for a total condemnation of American life. The moral sensibility that has given vitality to American principles is manipulated by these propagandists into a denial that America stands for those principles, and into an insistence that the *real* principles of American life are revealed in the sore spot.

A decade later, the sore spot was Vietnam. "I, for one, feel ashamed of my country," Sontag addressed the crowd at a 1966 antiwar meeting, "ashamed and anguished to be an American at this moment in world history." With her strong morality fixated on the sore spot, she came to fear that "flag-waving Legionnaires and Irish cops and small-town car salesmen who will vote for George Wallace are the genuine Americans, not I." And in her rage, she blundered. She idealized North Vietnam as "a place which, in many respects, *deserves* to be idealized." She declared, "Ever since my three-month visit to Cuba in the summer of 1960, the Cuban Revolution has been dear to me, and Che, along with Fidel, have been heroes and cherished models." In a 1970 survey of Cuban poster art (a brilliant performance, incidentally, even by her standards), she dropped the comment, "The fact that theaters in Havana play Albee as well as Brecht is neither a sign that the Cubans are still hung-up on bourgeois art nor a symptom of revisionist

soft-mindedness (as a similar-looking cultural policy is in non-militant Yugoslavia)"—a remark she's lucky no one dug up during her sojourns in Sarajevo in the 1990s. And that essay ends with a forthright "Viva Fidel." To take a hard line about it: to the extent that Sontag supported these absolutist societies, she participated in some of the conduct she most abhors, the persecution of dissident artists and intellectuals. To put it more generously, she recapitulated the progress of many earlier American Stalinists, from blindness to disillusion—or, more generously still, to enlightenment. I've sometimes wondered whether she views the politically compromised protagonists of *The Volcano Lover* with quite the distance of Eleonora de Fonseca Pimentel, the poet who condemns them in the monologue that closes the novel. It's usually assumed that Sontag's identification with Fonseca as an artist, an activist, and a feminist is complete, but perhaps she regrets her own past errors enough to include at least a part of herself among the objects of Fonseca's curt and final "Damn them all." For the sake of her humility, I hope so—though that doesn't mean I judge her that way myself. Without disregarding her credulity, you can be moved—you *should* be moved—by her quest for a more inspiring way of life. Her lament in "Trip to Hanoi" rings with pain: "I live in an unethical society that coarsens the sensibilities and thwarts the capacities for goodness of most people"—although honesty forced her to add, sheepishly, that it also "makes available for minority consumption an astonishing array of intellectual and aesthetic pleasures." There's an almost comic pathos in her quest. Her political flounderings call to mind Keats's remark about what our reasonings look like from the viewpoint of "a superior being": "though erroneous they may be fine."

Sontag's erroneous reasonings were fine indeed. They were a thousand times finer than the unsearching, unquestioning complacency of those critics, mainly on the right, who have mocked her tortuous path—*they* haven't suffered any moral agony. Yeah, I know what the road to hell is paved with. But I find a profound thinker misguided (for a time) by her conscience a far more admirable figure than a troglodyte *without* a conscience. Giving up the hopes of the sixties wasn't easy for her, but she did it and she acknowledged her mistakes, if not with the wholeheartedness one might wish for. "It was not so clear to many of us as we talked of American imperialism how few options many of these countries had except for Soviet imperialism, which was maybe worse," she eventually conceded in the spotlight glare of *The New York Times*. (But, oh, that "maybe.") "When I was in Cuba and North Vietnam, it was not clear to me then that they would become Soviet satellites, but history has been very cruel." Elsewhere she admitted that intellectuals like her had "played at being egalitarians and zealots, only to discover that they were still elitists and liberals." The time had come, she said, for them to "accept the fact that they're part of the ruling class and use that as a basis for leading specific campaigns on real issues," to accept "the authentic privileges and freedoms that are given to us here in order to fight against the injustices that exist, against things that are harmful in the long run." Acquaintance with some of the celebrated refugees from the Soviet bloc eventually turned her into a committed anti-Communist. She moved from the radical to the less radical left—but never to the right, as she was accused of having done after a controversial speech she gave at Town Hall in Manhattan on February 6, 1982.

A left-wing coalition calling itself American Workers and Artists for Solidarity had convened the rally after the Communist government of Poland, under General Wojciech Jaruzelski, imposed martial law in an attempt to break the back of the popular workers' movement Solidarity. The free world reacted in outrage. The immediate problem for the democratic left was, as Sontag phrased it in the opening of her address, "to stake out a different kind of support for Poland than that tendered by, say, Reagan and Haig and Thatcher"—a conventional enough lead-in. As she continued, though, her words grew increasingly critical of the left itself. Audience members began shifting in their seats, and they sat up straight when she said,

> Imagine, if you will, someone who read only the *Reader's Digest* between 1950 and 1970, and someone in the same period who read only *The Nation* or the *New Statesman*. Which reader would have been better informed about the realities of Communism? The answer, I think, should give us pause. Can it be that our enemies were right?*

This was supposed to be an evening of left-wing *solidarity*. Ronald Reagan seemed invincible and the American left was sunk in depression; now here was Sontag raising the aging

*To confuse matters, Sontag later claimed this remark was off the cuff. Her official version of the speech, which *The Nation* carried, offered a blander formulation: "The émigrés from Communist countries we didn't listen to, who found it far easier to get published in the *Reader's Digest* than in *The Nation* or the *New Statesman,* were telling the truth."

specter of Stalinism to a thoroughly anti-Soviet crowd. *Why?* The audience felt slapped. As she neared the end of her speech, she had to declaim over boos and catcalls:

> Communism *is* fascism—successful fascism, if you will. . . . I repeat: not only is fascism (and overt military rule) the probable destiny of all Communist societies—especially when their populations are moved to revolt—but Communism is in itself a variant, the most successful variant, of fascism. Fascism with a human face.

Uproar. Both *The Nation,* which had cosponsored the event, and the soon-to-be-defunct *Soho News* printed Sontag's speech (the latter without her permission, leading to threats of litigation that touched off a new set of outcries on behalf of freedom of the press) as well as disgruntled responses by a bevy of intellectuals. *The Nation* also carried Sontag's response to the responses. (In a low moment, she dismissed Andrew Kopkind, the gay journalist who fourteen years earlier had accompanied her to Hanoi, as "the noted disco expert of the 1970s.") Articles poured out for months, solemnly pondering whether Communism *was* fascism (no, everybody decided) and in general taking a dim view of Sontag's timing and her grasp of history.

Sontag, as noted, loves playing the contrarian. "I knew what I was doing," she told an interviewer later that year. "I knew I would be booed"—though she probably didn't know to what extent. Reading her speech now, it's hard to tell what everybody was so worked up about. Nothing she said was really all

that incendiary. Mainly, I think, they were worked up about Sontag herself, about her belligerence and her arrogance. As Julius Jacobson put it in one of the few truly thoughtful articles to emerge from the dust-up,

> She clearly had no intention of seeking any rapport with her audience. The torch of her new-found enlightenment was used as a club, its flame emitting more smoke than illumination. Her presentation was predicated on a total misunderstanding of the current state of the left. There was not the slightest suggestion of awareness that the audience at the Solidarity rally was representative of an American left far more conscious of the nature of Stalinism than earlier left-wing movements, as evidenced by its readiness to rally *against* Communist oppression.

Jacobson is right about her tone—Sontag wasn't an innocent party, nor did she claim to be. But the issue of Stalinism was more tangled. Some of Sontag's critics were puzzled as to why a woman born too late to have been sullied by the Stalinist fervor of the thirties and forties should feel so implicated; they probably didn't know how deeply she had dug herself in with Cuba and North Vietnam. They didn't know, in other words, to what extent her *nostra culpa* was in fact a *mea culpa*, and beyond her rather formulaic "and of course I include myself," she wasn't ready to enlighten them. Humility is hard for her. A couple of years after the Town Hall speech, she drew a satirical sketch of intellectuals on government-sponsored tours of Communist countries:

> Led from museums to model kindergartens to the birthplace
> of the country's most famous composer or poet, welcomed
> and given tea and phony statistics by dignitaries in factories
> and communes, shepherded from oversized meal to oversized
> meal, with time off for shopping sprees in stores reserved for
> foreigners, the travelers will complete the tightly scheduled
> trip having talked with hardly anyone except each other.

She was clearly including herself, yet her wised-up tone seems
to set her apart from the other dopes, and so whatever self-
criticism she has in mind vanishes from sight. Sontag isn't thick-
skinned. It's hard for her to hand her enemies ammunition.

That said, most of the responses to her speech were less than
encouraging signs of verve on the left. Literal-minded writers
doggedly spelled out the differences between Communism and
fascism, as though they thought Sontag didn't know them. She
knew them. It's a sign of respect to your audience to assume
they can draw distinctions so obviously implicit in your argu-
ment that to draw them yourself would be insulting. But as
most polemicists sooner or later learn, putting your trust in
your audience is a dicey proposition. (And though I'm rais-
ing this issue in the context of a political speech, it applies to
criticism across the board.) The uncrossed *t,* the undotted *i* are
always vulnerable to attack by the malicious and the plodding.
Much of what gets said in criticism—much of the best—con-
sists of generalizations that either can't be proved or aren't
worth using up the wind to prove. A reader can tell when a
critic is on to something, even if she's stated it hyperbolically—
often *because* she's stated it hyperbolically. When you're nav-
igating in difficult or nebulous areas, hyperbole is sometimes

the only way to make a distinction apparent. At other times, as
at the Town Hall meeting, it may be the only way to wake the
audience up. Pedants think they're scoring a legitimate point
when they snap, "You've overstated the case"; sometimes
even saying "Prove it" is demanding too much. (John Simon:
"Sontag has a trying habit of issuing wonderfully challenging
statements . . . without elaborating and elucidating them.") Not
only are drawn-out, QED-style proofs of the critic's (some-
times intemperate) assertions potentially boring; in most cases
they'll convince only those readers the assertions convinced in
the first place, since mathematical proofs aren't possible outside
mathematics. I *don't* mean—obviously, I hope—that it isn't the
critic's responsibility to back up her claims, or that hyperbole
trumps discrimination; a talented critic can offer nuanced read-
ings without succumbing to logorrhea. (And a different stan-
dard may apply to scholarship that isn't intended for—i.e., that's
too technical or too extended or too soporific for—the general
reader.) But as Kael said, "Criticism is an art, not a science."
Communism clearly *isn't* fascism—or, rather, Communism is
fascism in the same sense that beauty is truth and property is
theft and silence equals death. Would Sontag's detractors have
been happier if she'd gazed with fiery eyes into the faces of the
crowd at Town Hall and declared, "Communism *resembles*
fascism"? Oh, God, some of them probably would have. But
Sontag has too much pride in her craft to let her language turn
into mush. Moreover, after twenty years, who remembers what
anybody *else* said that night, or even who else was speaking?
You can't be a great critic—you can't even be an interesting
critic—without a talent for provocation. An imp of the per-
verse perches on the shoulder of the critic; as she formulates

her sentences, a still, small voice will warn her, "Caution! A statement like that is bound to land you in hot water!" And if she's a genuine critic, her imp will throttle that voice. The aim is to make people think; the means is, much of the time, to make them mad. Judiciousness may be central to all criticism, but judiciousness without provocation of some kind is like nutrition without flavor. Who cares if a boiled turnip is good for you? Though angry responses to something you've written can be unpleasant, they're not nearly so demoralizing as *no* response. At least they're evidence—sometimes the only evidence—that the audience has listened.

Even so, Sontag sometimes appears startled at the havoc the imp can wreak. "I'm still digging my way out of the rubble," she moaned a couple of years after the Town Hall speech. Rubble may be a tasteless metaphor for what she had to dig her way out of after the brief essay she came out with following the September 11, 2001, terrorist attack on the World Trade Center and the Pentagon. Nothing published in the wake of the devastation caused more widespread apoplexy than the 460 words that appeared above Sontag's byline in *The New Yorker*'s Talk of the Town Department as part of a package of responses by writers of note. "The disconnect between last Tuesday's monstrous dose of reality and the self-righteous drivel and outright deceptions being peddled by public figures and TV commentators is startling, depressing," she began. Amid the lamentations and the shrieks of pain that were swamping the media, her disdain was shockingly cool. It had less to do with politics per se than with the level of political discourse that followed the attack, and her message was clear: that we needed to talk about

what had happened *intelligently*. She later explained she'd been in Berlin on September 11th and had been holed up with CNN for forty-eight hours straight when she wrote the piece. She ordinarily avoids TV—she despises it—and her irked astonishment at the banality of what she was hearing came through in her complaints that "the public is not being asked to bear much of the burden of reality," that "the sanctimonious, reality-concealing rhetoric" the country was being fed was "unworthy of a mature democracy." Outraged that leaders and news anchors, in their attempts at "confidence-building and grief management," were treating the public as children, Sontag retaliated as though they had patronized her personally. "Politics," she wrote acidly, "the politics of a democracy—which entails disagreement, which promotes candor—has been replaced by psychotherapy. Let's by all means grieve together. But let's not be stupid together."

The response was thunderous. One columnist charged her with "moral obtuseness," another with "moral idiocy"; another wrote in the *New York Post*, "I wanted to walk barefoot on broken glass across the Brooklyn Bridge, up to that despicable woman's apartment, grab her by the neck, drag her down to ground zero and force her to say that to the firefighters." On the TV news program *Nightline*, where she had agreed to discuss her views ("It's not my thing," she said ruefully afterward, "but I did it"), a guest representing the right-wing Heritage Foundation called her "part of the 'blame America first' crowd" and spluttered that she "should not be permitted, you know, to speak in—in honorable intellectual circles again." For a few weeks, Sontag was something close to the national villainess.

The venom spewed at her struck a fairly moronic level, but though there's little in what she wrote that I disagreed with myself, that's not to say that I think she was any more innocent than usual. "Let's by all means grieve together. But let's not be stupid together"—are these the words of a writer stung by any grief at all? Readers hated her cold logic; they wanted emotion that matched theirs. But, as with the Town Hall speech, she knew what she was doing. The imp of the perverse was perched securely on her shoulder. That's not the whole story, though. A disastrous omission from her *New Yorker* essay forced Sontag to work overtime, once again, protesting her passion in her follow-up interviews. "I cry every morning real tears, I mean down-the-cheek tears, when I read those small obituaries that the *Times* publishes of the people who died in the World Trade Center," she found it necessary to declare publicly. "And I'm genuinely and profoundly, exactly like everyone else, really moved, really wounded and really in mourning." The omission was her failure to aim a single one of those 460 angry and contemptuous words at the terrorists. Reading her prose in a vacuum, you might have thought that she truly did blame America first. "Where is the acknowledgment that this was not a 'cowardly' attack on 'civilization' or 'liberty' or 'humanity' or 'the free world' but an attack on the world's self-proclaimed superpower, undertaken as a consequence of specific American alliances and actions?" she'd written. Was her horror at the slaughter of thousands something that went without saying? Of course it wasn't. Readers needed to hear it before they heard anything else. The imp of the perverse should never be your sole adviser; if you're going to engage in political discourse, one of the basic requirements is a sense of diplomacy.

But then diplomacy is at odds with the critic's compulsion (it really is a kind of mania) to lay bare the truth even if some flaying is involved. Kael wasn't politic. She used to attack KPFA's management on the air. Her effrontery and her blue language drove the decorous William Shawn crazy, and instead of mollifying him, she took a grim pleasure in their battles. After he was forced out of *The New Yorker,* she alienated his successor, Robert Gottlieb, too. And observe Sontag in a very different setting, accepting the Jerusalem Prize for literature in 2001 and making it a point to protest the mistreatment of the Palestinians and the settlement of the Occupied Territories before her Israeli audience. These are not women I would want representing me at the negotiating table. Diplomacy isn't one of their virtues—outspokenness is.

And it *is* a virtue. Sontag, for example, was never more heroically outspoken than she was in standing up for Sarajevo during the vicious Serbian siege of the early nineties. Distraught and enraged over the destruction of the beautiful old city, which in its cultivation and cosmopolitanism she likened to San Francisco, and by American and European apathy toward the devastation, she campaigned for military intervention to save both Sarajevo and Bosnia. She turned out opinion pieces, she gave interviews, she made eleven perilous trips to the besieged city, and, most prominently, she staged a production of *Waiting for Godot* in one of its two still functioning theaters. Few public figures matched her for courage; few, to her mounting chagrin, did anything at all.

And then she wrote about it. In "Waiting for Godot in Sarajevo," which appeared in *The New York Review of Books* in October 1993, she recounted her hesitations over talking to

the press about the project: "To protest the sincerity of one's motives reinforces suspicion, if there is suspicion to begin with. The best thing is not to speak at all, which was my original intention. To speak at all of what one is doing seems—perhaps, whatever one's intentions, becomes—a form of self-promotion." If only she'd listened to her own advice—but, as she explained in the article, she had justifiable reasons for talking to reporters in Sarajevo, as she did for writing the *Godot* article and a related lament for Bosnia that ran in *The Nation* two years later. Her valor had been assailed, unfairly, as an act of self-promotion. And then writing about it turned it into one. Without bringing a great deal of tact to bear on an account of one's own virtue (and tact has never been one of Sontag's strong points), the virtue curdles.

As if it wasn't enough for her to applaud her own gallantry, she also had to chide everybody else—to begin with, all those "morosely depoliticized intellectuals of today, with their cynicism always at the ready, their addiction to entertainment, their reluctance to inconvenience themselves for any cause, their devotion to personal safety" who didn't follow her over. But she didn't stop there. "I can't count how many times I've been asked, each time I return to New York from Sarajevo, how I can go to a place that's so dangerous," she reported. So craven this curiosity, so shallow these people "who don't want to know what you know, don't want you to talk about the sufferings, bewilderment, terror, and humiliation of the inhabitants of the city you've just left." As Kael observed of the screenwriters who made American comedy one of the glories of the thirties and then killed it in the forties, "When they became political in that morally superior way of people who are doing some-

thing for themselves but pretending it's for others, their self-righteousness was insufferable."

Sontag wrote as though her experience put her on another, higher plane: "You find that the only people you feel comfortable with are those who have been to Bosnia, too. Or to some other slaughter—El Salvador, Cambodia, Rwanda, Chechnya. Or who at least know, firsthand, what a war is." A statement like that from a male writer would be laughed at for its machismo. She also trounced those dim acquaintances who questioned the advisability of staging such a pessimistic drama in a city under siege:

> The condescending, philistine question makes me realize
> that those who ask it don't understand at all what it's like
> in Sarajevo now, any more than they really care about lit-
> erature and theatre. It's not true that what everyone wants
> is entertainment that offers them an escape from their own
> reality. In Sarajevo, as anywhere else, there are more than
> a few people who feel strengthened and consoled by having
> their sense of reality affirmed and transfigured by art.

This scathing argument didn't prevent her from using the same "condescending, philistine" justification for lopping the second act off Beckett's drama: "Perhaps I felt that the despair of Act I was enough for the Sarajevo audience, and I wanted to spare them a second time when Godot does not arrive. Maybe I wanted to propose, subliminally, that Act II might be different." Her main reason for truncating the play was more practical, though. She'd had the inspiration of using three pairs of Vladimirs and Estragons (one male, one female, one mixed),

and all the resulting stage business made the first half as lengthy a performance as she felt she could ask Sarajevans to sit through under siege conditions. So she cut it—an act that, like the tripling of the central roles, would have sent Beckett, who was such a purist about his work that he was known to take legal action against productions that strayed too far from his stage directions, through the roof.

Sontag's self-righteousness is grating. I take it personally. I think it's hard for anyone who feels sickened and helpless at the morning's lineup of atrocities in the international pages of the *Times* not to take it personally. ("And we'd have to be moral idiots not to be disturbed by what is entailed in our good fortune.") Her harshness toward others is part of what provokes me into harshness toward her, but there you are: Sontag lives in a glass house. The courage she showed in Sarajevo throws into relief what appears to be a lack of courage closer to home. Or, if not a lack of courage, then a silence that's not so different from the silence of the ostrich-like intellectuals she lashed out at on her return from Bosnia. Sontag, as most of her readers know by now, is gay. She rejects this label, with some justification (in "The Third World of Women," she saw good times coming for "a genuine bisexuality," arguing that "exclusive homosexuality . . . , like exclusive heterosexuality, is learned")—so, if you prefer, Sontag is bisexual. At any rate, for years she refused to acknowledge her sexual leanings publicly, even though in her 1972 eulogy of Paul Goodman, she had extolled his honest writing about his homosexuality, "before the advent of Gay Liberation made coming out of the closet chic." Maybe it was the specter of chic that deterred her. Twenty years later she told a nosy journalist, "I don't talk about my erotic life any more

than I talk about my spiritual life. It is . . . too complex and it always ends up sounding so banal." And in 2000, in another of her attacks on "the new culture ruled by entertainment values," she wrote caustically, "Indiscretion about one's unconventional sexual feelings is now a routine, if not mandatory, contribution to public entertainment."

As put off as I am by her silence, though, I don't believe for a moment that Sontag is really a coward. I can sympathize with a desire for privacy in someone who's spent the past forty years as a celebrity. (And God knows nobody was less forthcoming about her personal life than Kael.) But still: reserve is one thing, the closet another, and for anyone gay, coming out of the closet is a fundamental, *the* fundamental political act. It isn't at all the same thing as indiscretion, and it certainly isn't a contribution to public entertainment. Gay men and women have it so much better today than forty years ago because so many of us *have* come out. When I was younger, and the public visibility of well-known gay figures mattered so much more to me, I desperately wanted Sontag to declare herself. I found her silence painful, and I still find it bewildering. What good could it possibly have done her? She's sacrificed far more, in terms of esteem, by her circumspection. And she did herself no honor in 2000, when, with a hostile (and, as it turned out, inept) biography of her looming, whose single selling point was its documentation of her love affairs, she spoke preemptively to Joan Acocella for a profile in *The New Yorker*: "That I have had girlfriends as well as boyfriends is what? Is something I never thought I was supposed to have to say, since it seems to me *the most natural thing in the world*." Those italics are mine, to emphasize the unseemliness of that disingenuous phrase on the

lips of the woman who'd written only three years previously, "One is an intellectual because one has (or should have) certain standards of probity and responsibility in discourse."

"I suspect there was a nobler human being in his books than in his life," Sontag wrote of Goodman, and that's how I sometimes feel about her. But that reservation requires the instant qualification that no human being could live up to her Platonic standards. Her works, in the depth of their conviction and their commitment to truth-telling—in a word, their seriousness— are, like Arnold's, objects of *moral* beauty. Anything less than the noblest behavior would be inconsistent with them. In a wonderful passage about the novelist Bergotte in the second volume of *In Search of Lost Time,* Proust speculates as to why the greatest writers sometimes fall short of the exquisite morality of their work: "The artist offers a solution in the terms not of his own personal life but of what is for him his true life, a general, a literary solution." Proust smiles at the way such writers (and surely he included himself) capture "the vices (or merely the weaknesses and follies)" they see around them "without, however, thinking to alter their way of life or improve the tone of their household." Maybe that's a bit too hard on Sontag, who throughout her career has publicly tried to live up to her vision of what's right. (As to privately, I have no basis on which to judge.)

Kael was a good citizen: she stayed informed, she debated the issues, she voted. But her single ambition was to be an exceptional film critic, and in that vocation she had no peer. Sontag has *wanted* to have the same fixed focus. "I don't think of the writer, ultimately," she has said, "as having any responsibility except to literature." But she's never been able to limit

her enterprise to literature. Sontag, unlike Kael and most of the rest of us, has actually *done* something about injustice. She's stumbled in the course of engagement; wisdom and judiciousness are much easier at a writerly remove, which is one reason Sontag recognizes that politics is, on some level, a trap for a writer. "Somewhere along the line," she has said, "one has to choose between the Life and the Project." I'm quoting her out of context; what she was referring to was the conflict between marriage and career. But it also applies to her political activity—that, too, is bad for the Project. But that doesn't mean it's *bad*. Whatever damage Sontag's activism may have done her work, you can no more knock her for it than you can a photographer who drops his camera at an accident scene to aid the victims. I've barely mentioned Sontag's ongoing work on behalf of human rights and, especially, of persecuted writers; it doesn't contribute that much to her stature as a writer. But it certainly contributes to her stature as a human being, and if I've focused on passages that seem to put a chink in that stature, simple justice demands that I redress the balance. Besides, in *Regarding the Pain of Others* she made up for some of her missteps of a decade earlier, writing about her time in Sarajevo much more gracefully. And she drew on the experience to produce hortatory prose of a fineness she had never before achieved:

> Compassion is an unstable emotion. It needs to be translated into action, or it withers. The question is what to do with the feelings that have been aroused, the knowledge that has been communicated. If one feels that there is nothing "we" can do—but who is that "we"?—and nothing "they" can do

either—and who are "they"?—then one starts to get bored, cynical, apathetic. . . . People don't become inured to what they are shown—if that's the right way to describe what happens—because of the *quantity* of images dumped on them. It is passivity that dulls feeling.

Someone who read an early manuscript of the book you're holding said, "Even when you criticize Kael, you cast her in a golden light, but you never give Sontag the benefit of the doubt." Another friend was blunter: "Why are you devoting half of a book to a writer you hate?" If, after revisions, it still sounds like I hate Sontag, then my revisions haven't done their job. I don't hate her. In fact, after reading her and thinking about her daily, often hourly, for several years now, I've come to adore her—warts and all. That doesn't mean I want to *meet* her. From the minute I started reading Kael, I thought of her as a funny, acidulous friend. Playing if-you-could-meet-any-body when I was a college freshman, I had no trouble choosing; that was years before she became an actual friend. But I've been reading Sontag for most of my adult life, and I've never felt the same pull from her. Her tone isn't congenial and she exasperates me. You have to be a bit of an asshole to say, "I don't write because there's an audience. I write because there is literature." But the older I get, the more convinced I am that you have to be a bit of an asshole to get *anything* accomplished in this world. Kael and I had the kind of friendship that seldom brought us into conflict; on the few occasions that it did, I encountered a will of granite. It wasn't pretty. When she said that a woman who hadn't been called a hard-driving bitch was unlikely to get to the top, she was talking from the top.

The warts *especially*. Kael sometimes refers to a certain kind of lofty intellectual as inhuman, and Sontag, who hardly ever acknowledges less than the most high-minded feelings, might be the embodiment of her distaste. Thus the importance, to me, of Sontag's foibles. In truth, Kael's unfailing wisdom and her unfailing clarity of vision seem more inhuman. Sontag, for all her self-assurance and her maddening pride, has crashed through the world blindly, tripping and falling. Her arrogance, her remorselessness, her refusal to acknowledge anything low in herself—those qualities are all easy to decipher as the underside of terror: a terror of humiliation. Only an author so panicked for her status would refuse, as she does, to read reviews of her work. I wish she had more humility, and I wish that when she conceded her mistakes she could do it with some humor about herself and without so much recrimination toward everybody else. Her writing is rife with repositionings, about-faces, and plain old errors of judgment. The body of her work is flawed. But fortunately for Sontag, and for everyone else who has ever set pen to paper with an eye toward publication, including Shakespeare, we judge writers by their masterpieces, not by their failures. One measure of her greatness is that those bent on pointing out her flaws (I suppose I'd better amend that to "those of us") look like pygmies beside her. The flaws are just that, flaws—irksome little dings on a magnificent edifice—and those who can't see them for what they are have missed the edifice for what it is.

3

SOMETHING ELSE THEY HAVE in common: they enraged people. And they loved doing it, though neither one ever copped to (or, I suspect, recognized) the extent of her pleasure. While some of this anger can be written off to misogyny, that's a charge I hesitate to level indiscriminately. Their pugnacity, their self-assurance begged for a fight.

They both got called anti-intellectual, first of all for their fascination with popular culture. It's startling to discover Irving Howe—humane, sagacious Irving Howe—attacking Sontag and her "cheerfully eclectic view" with such bitterness in his commanding essay of 1968, "The New York Intellectuals": "Now everyone is to do 'his thing,' high, middle, or low; the old puritan habit of interpretation and judgment, so inimical to sensuousness, gives way to a programmed receptivity; and we are enlightened by lengthy studies of the ethos of the Beatles." He goes on to accuse her of rejecting both puritan and Jewish moral seriousness—Sontag, of all people—"in favor of creamy

delights in texture, color, and sensation." This parody of her views was not Howe's finest moment. But then "One Culture and the New Sensibility," the essay that most fueled it, wasn't Sontag's, either; she had set out, a little too recklessly, to push buttons. Still, Howe was wrong. I suspect that Sontag's radical politics blinded him to her strengths. Elsewhere he had laid out his Old Left revulsion at New Left tactics; now he jumbled up politics and aesthetics in voicing his objections to "the new sensibility":

> It cares nothing for the haunted memories of old Jews. It has no taste for the ethical nail-biting of those writers of the left who suffered defeat and could never again accept the narcotic of certainty. It is sick of those magnifications of irony that Mann gave us, sick of those visions of entrapment to which Kafka led us, sick of those shufflings of daily horror and grace that Joyce left us. It breathes contempt for rationality, impatience with mind, and a hostility to the artifices and decorums of high culture. It despises liberal values, liberal cautions, liberal virtues.

And in this final charge he was right: Sontag and her New Left cohorts didn't use *liberal* as a compliment. (Surely the title *Styles of Radical Will* was, at least in part, a retort to the title *The Liberal Imagination*.)

But in championing pop culture, Sontag and Kael didn't insist that all aesthetic experience is *equivalent*. Actually, Sontag did toy with this possibility in "One Culture and the New Sensibility," but she quickly pulled back with a shudder. While you could argue (and some did) that a critic who saw a crisis in

"the hypertrophy of the intellect at the expense of energy and sensual capability" is not the intellect's best friend, few readers who'd worked their way through Sontag's dense sentences could press this case without a hint of sheepishness. Kael's approachable prose offered her no such protection. She angered cineastes with her insistence that the satisfactions we get from most movies are lesser, coarser than those we get from literature; she angered them with her misgivings about film studies. ("If you think movies can't be killed, you underestimate the power of education.") They reviled her for bashing the kind of picture she called *arty*, that is, sensitive to aesthetic and intellectual values and deaf to entertainment ones. Engaging the audience was, in her view, basic to the artist's job. A work of art that's rich below but thin on top—deep subtext, dull text— was no work of art at all. She would have had choice words for Sontag's early pronouncement that "there is, in a sense, no such thing as boredom. Boredom is only another name for a certain species of frustration," a frustration endemic to "the new languages which the interesting art of our time speaks."

Certain words and notions keep turning up in the early attacks on Sontag (and in many of the later ones). *Humorless*, of course. And *modish*, as in "an obsessive modishness well in keeping with the editorial policies of ladies' fashion magazines," based on the conviction that her devotion to the new was mere faddishness. Another such prejudice, which has dogged her throughout her career, is a disapproval of her portrait photographs—of her beauty, really—that goes hand in hand with disapproval of the shrewdness with which she's managed her career. Thus a 1966 review of *Against Interpretation* states flatly, "The recent appearance of a full-page

photograph of Miss Sontag in *Vogue* symbolizes one of the qualities which make this self-appointed avatar of 'The New Sensibility' so irritating to so many men of good will." A 1983 swipe by Alexander Cockburn begins, "That's a forbidding picture of Susan Sontag on the cover of *Vanity Fair*. She used to look so jolly in the early photographs—frolicsome yet brainy." Cockburn goes on to mock her as "no mean student of the icon." As late as 2001, a writer blaming the collapse of all standards largely on Sontag faulted her for a preoccupation with "cultivating her image as a proponent of the cutting edge." Her *image?* Can there be any doubt, after forty tireless years, that Sontag actually *cares* about the new? This presumption that she's a hollow image, which the principal piece of evidence, her challenging, unwelcoming essays, does nothing to support, is a crude form of professional jealousy, a way of ascribing her brilliant success to something other than her brilliant accomplishments. Kael suffered the same accusations of careerism, though the constant emphasis on Sontag's appearance gives the attacks on her an especially nasty, ad hominem edge. Maybe that's the price of beauty. (So far as I'm aware, Andrew Sarris and John Simon are the only writers who ever mocked Kael for *not* being a beauty.)

Aestheticism was another frequent charge against the early Sontag—"a consistently extreme argument for the separation of aesthetic values from values of all other kinds"; "aesthetic detachment . . . perverted into autistic irresponsibility." Looking back, it's clear that Sontag's attempt to distinguish between moral and aesthetic imperatives was far more troubled and complex than her detractors allowed, but that she attempted to make the distinction at all was enough for them.

In this sphere, her most formidable adversary has been the conservative art critic Hilton Kramer, who can't seem to tear himself away from Sontag's work; it maddens him. I'll sidestep his revulsion at her politics, about which there's not that much to say—it'll cheer readers on the right and annoy those on the left. More pertinent here is his revulsion at her aesthetics. Given Kramer's views, it's not surprising that the one essay of Sontag's that he heartily endorses is the 1974 "Fascinating Fascism," her scathing demonstration that Leni Riefenstahl's work remained ideological down to its toenails long after the Third Reich had crumbled. But Kramer's praise ("one of the most important inquiries into the relation of aesthetics to ideology we have had in many years," etc.) makes for uncomfortable reading, because it's based on an error. When he writes that "Miss Sontag has now completely reversed her position"—on Riefenstahl and on the dichotomy of aesthetics versus morality—he's wrong. He even quotes the passage that proves him wrong, from Sontag's 1965 essay "On Style": "To call Leni Riefenstahl's *The Triumph of the Will* and *The Olympiad* masterpieces is not to gloss over Nazi propaganda with aesthetic lenience. The Nazi propaganda is there. But something else is there, too, which we reject at our loss." It's pretty hard to misread her position—"The Nazi propaganda is there"—but Kramer does, declaring that "in 'Fascinating Fascism' she writes as if she had only just discovered the Nazi content of these films." No: from the beginning, she recognized the propaganda *and* the something else. The beauty and the rot were both, inextricably, there. When she turned on Riefenstahl, it wasn't because she'd changed her mind about the greatness of Riefenstahl's films but because, as she wrote, "the context has changed": by 1974 Riefenstahl

freaks really were glossing over the fascist content with aesthetic (and sisterly) lenience.

Kramer's dudgeon isn't misplaced—Sontag and he truly are ideological enemies—but he allows it to blind him and, thus, to weaken his case. In consistently offering the least sympathetic reading of her work, he *mis*reads her. So, for example, following Howe, he reduces her call for an erotics of art to a quest for "untroubled aesthetic delight: untroubled precisely because it would no longer be burdened by intrusions of moral discrimination," when Sontag has never written an untroubled sentence in her life. Her campaign against interpretation he views as "one case among many in the sixties—a particularly distinguished one, of course—of intellectuals engaging in strenuous flights of cerebration on behalf of ideas that promised deliverance from the tyranny of cerebration." Malarkey: Sontag was against interpretation, not against thought.

Kramer is really raving when he assails Sontag as a late-twentieth-century Oscar Wilde, spreading the gospel of aestheticism because she lacks—of all things—*seriousness*. As he sees it, she came along at a period when "the whole ethos of moral earnestness and finical discrimination that had dominated cultural life in the 1950s, uniting such otherwise disparate endeavors as abstract expressionism in painting and the new criticism in literature, had clearly collapsed," and she capitalized on—and furthered—that collapse. Exhibit A for the prosecution is "Notes on 'Camp.'" "'Notes,'" Kramer writes, "spoke for fun, for frivolity, for wholesale release from the burdens of seriousness. It made the very idea of moral discrimination seem stale and distinctly un-chic." (*Un-chic:* that old canard again.)

Replace "wholesale" with "temporary" in Kramer's obser-
vation, and it might bear some relation to the truth. For, as
Sontag argues in "Notes on 'Camp,'" "one cheats oneself, as
a human being, if one has *respect* only for the style of high cul-
ture, whatever else one may do or feel on the sly." (Kael argued
similarly, citing Gene Kelly and Fred Astaire singing and
dancing in *Ziegfeld Follies* and Elisabeth Schwarzkopf singing
operetta: "Why should we deny these pleasures because there
are other, more complex kinds of pleasure possible?") But
to paint Sontag as a vandal out to destroy the temple of cul-
ture requires ignoring what she actually wrote, namely: "I am
strongly drawn to Camp, and almost as strongly offended by
it." Kramer does ignore it. In his opinion, "This hint of a dis-
claimer, if that is what it was, was not very persuasive when
'Notes' was first published, for in the sixties Sontag's defense
of aestheticism was conducted with an air of stridency and mil-
itancy that brooked no possibility of contradiction." *Hint* of a
disclaimer? To anyone who's read more than a few pages of
Against Interpretation, Sontag's commitment to seriousness
(Weil, Lévi-Strauss, Lukács, Sartre, Weiss, Bresson, Resnais,
et al.) is more than persuasive. What she was espousing in the
sixties wasn't aestheticism, as Kramer keeps claiming, but for-
malism—a distinction that Kramer himself very usefully draws:
"Whereas formalism attempts to sever the connection between
art and life in order to uphold the autonomy of art, aestheti-
cism affirms their ineluctable attachment while at the same time
making experience the principal raison d'être of all aesthetic
endeavor." For a formalist, he goes on to explain, Wilde's boast
about putting his genius into his life and only his talent into his
art would have been a confession of failure.

Sontag is (or was), by Kramer's definition, a formalist. (Wilde's boast on her lips is inconceivable.) The distinction is crucial in clarifying her own brand of moralism. In another passage from "On Style" that left Kramer sputtering, she wrote, "A work of art, so far as it is a work of art, cannot— whatever the artist's personal intentions—advocate anything at all." Again, Kramer lets his temper get in the way of a careful reading. The statement is not, as he thinks, an abrogation of morality. Sontag wasn't saying that a work of art can't advocate anything. She was saying that it can't advocate anything *so far as it is a work of art*. *Triumph of the Will* clearly advocates something—"The Nazi propaganda is there"— but advocacy isn't part of its *aesthetic* function, and we don't judge it *aesthetically* on the level of its advocacy—we judge it *morally*. Kramer never tells us whether he thinks *Triumph of the Will* and *The Olympiad* are any good, but his League of Decency approach suggests that asking him would be pointless. The practice of seeing the aesthetic and the moral merits of a work "in a kind of split level way," as Sontag once put it, is anathema to cultural conservatives, for whom ambivalence means weakness, surrender to the champions of relativism. For Sontag, Riefenstahl is (and always was) deplorable *and* admirable. The very nature of thinking is *but*. Nothing is ever simple.

Kramer doesn't condescend to Sontag (except when he writes about her politics); he takes her seriously as a destructive force. As far as he's concerned, it was "Notes on 'Camp'" that opened the floodgates to the "spiritual bankruptcy of the postmodern era":

It severed the link between high culture and high seriousness that had been a fundamental tenet of the modernist ethos. It released high culture from its obligation to be entirely serious, to insist on difficult standards, to sustain an attitude of unassailable rectitude. . . . "The whole point of Camp," Miss Sontag wrote, "is to dethrone the serious," thereby defining the special temper of postmodernist culture.

Only one problem here: *Sontag never espoused camp*. She defined and, to some extent, defended it, but she never *promoted* it. It wasn't her sensibility—oh, boy, was it not her sensibility. Her identification with camp ("Miss Camp Herself," a hostile review of *Against Interpretation* was headlined) has always made her uneasy; "I haven't allowed that word to pass my lips since 1964," she said some years ago.

But laying the decline of culture at Sontag's door, or at Kael's, is a popular move. Things are bad, it must be somebody's fault, and they both look shady to theoreticians of the slippery-slope school. Kramer linked Sontag to the postmodernist "corruption of standards" in 1982; as recently as 2001 she was still taking the rap for "the pulling-down of critical hierarchies and standards of judgment" that obliterated a superior culture, "the vanished world she would like to have back and that she did so much to destroy." Kael got the same kind of grief. In a 1981 article called "Why Do Critics Love Trashy Movies?" the critic Stephen Farber argued that Kael's "once-provocative argument" for the subversive pleasures of trash had "hardened into a rigid and untenable catechism" that had, in turn, "overpowered all other approaches to movie crit-

icism." A constant worry was that she was lowering the tone. Thus John Simon, in 1973: "She is a lively writer with a lot of common sense, but also one who, in a very disturbing sense, is common." Richard Gilman, in 1976: "Intelligent writing . . . about film art . . . has been put on the defensive.. . .The space between Kael's taste and her public's, as between other leading critics and theirs, has narrowed to the point of invisibility." John Podhoretz, in 1989: "This critical game of searching out art in trash, hoping to come upon a diamond in the dunghill, has been taken up in great boring earnestness by the younger generation of movie critics who have been much influenced by Pauline Kael. . . . With more and more juvenile movies being produced, the low in cinematic art needs no defenders nowadays." Richard Schickel, shortly after Kael's death, in 2001: "Her critical values were really quite simple. She believed that the vitality of American movies derived from their 'trashiness,' from their eagerness to exploit the low, even vulgar, tastes and emotions of their audience and their makers."

If Kael was subject to continual jabs by her colleagues, you couldn't say she hadn't earned them. When she went to work for *The New Yorker* in 1968, she finally retired the shiv she'd become known for using on other critics—a practice that had fewer repercussions when her voice was just a gadfly buzz from out in San Francisco. In those days she scented blood when she read a review, and nobody was safe; thanks to her, we now remember *The New York Times*'s Bosley Crowther the way that thanks to Alexander Pope we remember Colley Cibber. In her acknowledgments to *I Lost It at the Movies,* she felt obliged to express her "admiration and

respect for Dwight Macdonald, who despite my hectoring him in print has, personally, returned good for evil." Reviewing the book, Macdonald tried to be gallant, but she had stung him—"Movies are, happily, a popular medium (which makes it difficult to understand why Dwight Macdonald with his dedication to high art sacrifices his time to them)" was one of several gibes—and he wound up losing his temper and snapping, "The hell with that 'respect and admiration.'" Stanley Kauffmann, another target (and then, as now, the film critic for *The New Republic*), winced as he allowed Kael a few merits—"some comprehension, disdain for fashion, questing humanism, fine enthusiasm"—gnarled up with "slovenly logic," "flabby glibness," "intellectual disorder, personal display, and the very tastelessness she campaigns against." He, too, felt stung. "I hope that readers will proceed past the cheap title of her collected articles and broadcasts to discover her virtues," he primly advised, clearly hoping that they wouldn't.

But by far her most battered victim was the unfortunate Andrew Sarris, with whom she deftly wiped the floor after his "Notes on the Auteur Theory in 1962" provided her with the occasion for her great, savage 1963 polemic, "Circles and Squares." The auteur theory, as Sarris was then espousing it, embraced precepts far more complicated and controversial than the elementary notion it's most often reduced to: that a film bears the stamp of its director. That was obvious, as Kael pointed out—"just simple discrimination." Sarris went much further, claiming that "the ultimate glory of the cinema as an art" lies in the "interior meaning" that can be "extrapo-

lated from the tension between a director's personality and his material," and here Kael squawked, convinced that this criterion gave Sarris and his young allies at the British journal *Movie* a resource for glorifying hacks:

> Poor misguided Dostoyevsky . . . tackling important themes
> in each work (surely the worst crime in the *auteur* book) and
> with his almost incredible unity of personality and material
> leaving you nothing to extrapolate from, he'll never make
> it. If the editors of *Movie* ranked authors the way they do
> directors, Dostoyevsky would probably be in that almost
> untouchable category of the "ambitious." . . . Their ideal
> *auteur* is the man who signs a long-term contract, directs any
> script that's handed to him, and expresses himself by shov-
> ing bits of style up the crevasses of the plots. If his "style" is
> in conflict with the story line or subject matter, so much the
> better—more chance for tension.

The claim often made later in Kael's career that her passion for certain directors put her over on the auteur side ignored (or was ignorant of) the theory. Part of what incensed her about the auteurists was their conviction that a pantheon director's greatness infuses even his most negligible work. "It is an insult to an artist," she wrote, "to praise his bad work along with his good; it indicates that you are incapable of judging either." Kael's detractors later accused her of doing just that. E.g., Sarris, in 1976: "She certainly seems to have given blank checks to Altman, Coppola, Scorsese, Peckinpah, Mazursky, and De Palma." Stephen Farber, reviewing *5001 Nights at the Movies* in 1982: "She can outdo any auteurist in her unflagging loyalty

to her favorite directors." Kael never had unflagging loyal-
ty to any director: witness her appraisals of *Images, Quintet,
One from the Heart, The Cotton Club, Raging Bull, The King of
Comedy, Straw Dogs, The Getaway, Alex in Wonderland, Willie
and Phil, Sisters, Body Double* . . . the list goes on.

Furious over "Circles and Squares," the young men of *Movie*
struck back in a letter to *Film Quarterly,* where the essay had
appeared. Unfortunately, they ignored the central issues. "The
main argument of Miss Kael's article," they wrote rather bewil-
deringly, "can be left to fall by itself." What had really miffed
them was her concluding paragraph, which they regarded as a
slur on their masculinity. Kael had written, in reference to their
enthusiasm for Howard Hawks and Raoul Walsh,

> Isn't the anti-art attitude of the *auteur* critics, both in
> England and here, implicit also in their peculiar emphasis
> on virility? . . . Can we conclude that, in England and the
> United States, the *auteur* theory is an attempt by adult males
> to justify staying inside the small range of experience of their
> boyhood and adolescence—that period when masculinity
> looked so great and important but art was something talked
> about by poseurs and phonies and sensitive-feminine types?

The *Movie* group took these remarks very hard. "She seems
to think that she can discredit us as critics," they complained,
"by characterizing us implicitly as homosexuals of the rugged
all-male variety." They must have heard something in her tone,
since their indignation presages the accusations of homophobia
that would bespatter Kael a couple of decades later. But after
reading that paragraph dozens of times, I'll be damned if I can

locate what they were talking about, and I don't *think* I've left out anything incriminating.* Neither could Kael—but, with awesome viciousness, she took advantage of their apoplexy to twist the knife deeper. "If I had wished or intended to 'discredit' you as homosexuals," she replied (notice that she puts "discredit" in quotation marks), "it would never have occurred to me to suggest that you were of 'the rugged all-male variety.'"

Sarris's response, a sixteen-column treatise cobbled together from earlier articles (one in its entirety), didn't address the central issues, either. In fact, except for its title—"The Auteur Theory and the Perils of Pauline"—it made no mention of Kael's broadside at all. (Her name must have pained him, because when she came up in the introduction to his 1968 book *The American Cinema,* he veiled her as "a lady critic with a lively sense of outrage.") "I was no match for her in a straight-on polemic," he admitted, rather pitifully, some years later. "All I could do was lick my wounds."

That meekness doesn't exactly buttress one's confidence in his views. It would have been far better for him to bite back, hard—better, that is, than what he did do, which was spend the next forty years seething and sniping at Kael whenever he got the chance. "I've always been a little surprised he took it so personally," she said late in her life. (I'm not. "Circles and

*In a footnote, Kael regrets she can't put the auteurists to the test of detecting a director's signature in his minor films. "I can only *suspect* that many *auteur* critics would have a hard time seeing those telltale traces of the beloved in their works," she wrote. Could this be what set them off? Did the editors of *Movie* think her joke meant they were lovesick over Hawks and Walsh?

Squares" is humiliating.) In fact, she'd made friendly overtures to him almost as soon as the article was set in type. Sarris tells the story himself:

> The phone rang in the Queens apartment I shared with my mother. A woman identifying herself as Pauline Kael invited me to meet her for drinks. She had just popped into New York from San Francisco, she said, and wanted to get acquainted. The tone of her voice was aggressive, insinuating, crackling, if not cackling, with good cheer. . . . Noting my hesitation, Pauline asked me laughingly if my "lover" would object to her invitation, and in those days the word "lover" had an exclusively male connotation. The gall of the woman!

He, too, was convinced she'd been making "homophobic innuendoes," and though Sarris is clearly straight, when he writes about Kael his tone is so bitchy ("assiduous self promotion . . . critical insincerity . . . moral superiority . . . lapdog of the literati") that goading him does start to look irresistible. Forty years is too long to spend nursing your bile. He couldn't lighten up even when he found out Kael had died: "I can't say I was as saddened as I had been a few days earlier by the death of Jane Greer," he wrote in a tasteless obituary. "Truth to tell, we never much liked each other."

Sarris mounted his snarkiest attack in "Citizen Kael vs. *Citizen Kane*," his response to the longest and arguably the finest piece of writing she ever published, the 1971 essay "Raising Kane." Commissioned to contribute an introduction to the *Citizen Kane* shooting script, which was coming out in

book form, she'd begun looking into the circumstances of its composition; what she found was that Herman J. Mankiewicz, who had shared the screenplay credit with the director, Orson Welles (and who, since his death in 1953, had dwindled to a footnote in film history), had contributed far more than Welles had acknowledged. Welles was still living and still giving interviews, and Kael, who was conversant with them, steered clear of the director himself. "I felt there was nothing to talk with him about," she explained. "I know what he has to say." From a journalistic standpoint, she screwed up, since much of the debate around "Raising Kane" turned on the accusation that she'd had it in for Welles. Her accusers generally didn't mention the essay she'd written four years earlier, "Orson Welles: There Ain't No Way," in which she'd called the director "the one great creative force in American films in our time, the man who might have redeemed our movies from the general contempt in which they are (and for the most part, rightly) held"— might have, if he hadn't been prevented by the studios, by the businessmen she hated. "Raising Kane" does not demonstrate, as Sarris claimed, a "blatant bias against Welles," and it's certainly not "an excuse to lower the boom" on him. Sarris comes closer to the mark when he bewails Kael's "malignant anti-auteurism"—though "malignant" falls wide of the buoyancy of "Raising Kane," which is above all a celebration of a movie Kael adores.

But "Raising Kane" also functions as a practical demonstration of the limitations of auteur criticism, although Sarris's insistence that as a result of it "Orson Welles is not significantly diminished as the *auteur* of *Citizen Kane*" wouldn't have gotten much of an argument from Kael. "Though Mankiewicz pro-

vided the basic apparatus for it," she stated very clearly, "that magical exuberance that fused the whole scandalous enterprise was Welles'." Her argument was about the writing credit, not the artistic credit. What she wanted to challenge was a recent remark of Welles's that abbreviated Sarris's theory into the statement that "cinema is the work of one single person": "The director should be in control," she wrote, "not because he is the sole creative intelligence but because only if he is in control can he liberate and utilize the talents of his co-workers. . . . [*Citizen Kane*] is a superb example of collaboration; everyone connected with it seems to have had the time of his life because he was able to contribute something." Welles, she said, "had a vitalizing, spellbinding talent; he was the man who brought out the best in others and knew how to use it." But a hero isn't the same thing as a saint, or as Kael put it, "There are monsters, and there are also sacred monsters." The movie business has more than its share of them. She once observed that "a director who cares about the rhythm and texture of his imagery," that is, who isn't a journeyman or a hack, "is likely to turn into a mixture of pompous bore, master strategist, used-car salesman, maniac, and messiah—in short, a major artist." She wasn't one to back off from hard truths—she *relished* delivering hard truths—and there was no question in her mind that Welles was embellishing his legend. Even Sarris conceded that "Welles often shows a tendency to swallow up subordinate credit and thinner egos. . . . This is the monstrous side of his personality." "Raising Kane" was her unflinching attempt to honor the artist without denying the monster.

It was too unflinching for a lot of people. In the words of one scholar, "Raising Kane" "set off the most impassioned

debate in American film circles in the first half of the 1970s."
Kael's principal antagonists were Sarris and the director Peter
Bogdanovich, who years earlier, as an energetic young critic,
had been one of the targets of her antiauteurist scorn in "Circles
and Squares." Bogdanovich was a friend of Welles's, whom
he'd spent years interviewing for a projected book, and in a
long rebuttal that appeared in *Esquire,* he quotes an epistolary
remark by the older director that was clearly also an instruc-
tion: "Cleaning up after Miss Kael is going to take a lot of
scrubbing."

Obviously I'm in no position to criticize Bogdanovich for
partisanship. He mounts an impressive case for Welles as the
principal author of the script—not impressive enough to con-
vince me Kael was wrong, but I'm not a *Kane* scholar, and any-
way, as Sarris points out, who wrote what is something we'll
never definitively know. What I can say with confidence,
though, is that Sarris's and Bogdanovich's reading of "Raising
Kane" as an attack on Welles and on *Citizen Kane* is skewed
(though I don't think they were wrong in viewing it as an
attack on *them*). The most disconcerting note they strike is their
bitterness, their conviction that Kael acted out of malice toward
Welles and his work. That doesn't jibe with either her earlier
Welles essay (and Kael's steely refusal to revise a view was one
of the traits her critics, Sarris especially, held against her) or
with the tone of "Raising Kane," which ends with her rising to
Welles's defense: "He has lived all his life in a cloud of failure
because he hasn't lived up to what was unrealistically expected
of him. . . . In a less confused world, his glory would be greater
than his guilt." And it begins with her calling *Kane* "perhaps
the one American talking picture that seems as fresh now as

the day it opened." There's no way to miss her pleasure in the movie. But it's an *irreverent* pleasure. What offended Sarris and Bogdanovich even more than Kael's skepticism toward Welles's claim of authorship was her skepticism toward some of the larger claims that had been made for the movie itself. "It isn't," she wrote, "a work of special depth or a work of subtle beauty." It wasn't *King Lear*. "*Kane* is closer to comedy than to tragedy," she went on, "though so overwrought in style as to be almost a Gothic comedy. What might possibly be considered tragic in it has such a Daddy Warbucks quality that if it's tragic at all it's comic-strip tragic."

This insouciance shocked them. "What most other critics take to be a coffin," Sarris wrote, "the irrepressible Miss Kael takes to be a barrel of laughs." Bogdanovich bristled at such phrases as "comic-strip tragic" and "Pop Gothic" and "*kitsch* redeemed," and even though Kael had no hesitation about citing *Kane* as a masterpiece, she'd spoiled it by calling it "a *shallow* masterpiece." This anger gets much closer to the heart of their dispute with her than their disagreements over the writing credit or the role of the director do. They were *believers* and she was an apostate. Actually, of course, Kael believed as fervently in the art of the film as anybody; what she didn't believe was that it had been realized to any significant degree under the studio system. *Citizen Kane*'s greatness she attributed explicitly to Welles's extraordinary freedom from studio meddling, so that "he was free to use all the best ideas offered him"—but the film was still, at heart, a product of the system. In her earlier Welles essay, she had noted, "Welles has the approach of a *popular* artist," and she had praised him for that; his showmanship, she said, was "part of an earlier theatrical tradition that Welles carries over into

film, it's what the theatre has lost, and it's what brought people to the movies." In "Raising Kane" she went further: "I would argue that this is what is remarkable about movies—that shallow conceptions in one area can be offset by elements playing against them or altering them or affecting the texture." "Raising Kane" is divided between enumerating the ways (built into Mankiewicz's script) in which *Citizen Kane* isn't profound—

The mystery in *Kane* is largely fake, and the Gothic-thriller atmosphere and the Rosebud gimmickry (though fun) are such obvious penny-dreadful popular theatrics that they're not so very different from the fake mysteries that Hearst's *American Weekly* used to whip up—the haunted castles and the curses fulfilled.

The assumption of the movie was much like that of the yellow press: that the mass audience wasn't interested in issues, that all it wanted was to get "behind the scenes" and find out the dirt.

It is both a limitation and *in the nature of the appeal* of popular art that it constructs false, easy patterns. . . . In popular art, riches and power destroy people, and so the secret of Kane is that he longs for the simple pleasures of his childhood before wealth tore him away from his mother—he longs for what is available to the mass audience

—and showing how Welles transcended them. It was his touch that transformed the shallowness; "he took the Mankiewicz

material and he played with it, he turned it into a magic show."
Sarris and Bogdanovich seem to think that suggesting the mate-
rial *needed* transforming—that *Citizen Kane* is different either
in kind or in quality from *King Lear*—is to belittle the film,
when what Kael is doing is the opposite. Years later she told
Francis Davis, "One of the great things about movies is they
can combine the energy of a popular art with the possibilities of
a high art. What's wonderful about someone like Altman is that
mixture of pop and high art." Welles was an earlier instance of
the same phenomenon. What Kael was expressing in "Raising
Kane" wasn't derision. It was love.

Sontag went through something oddly similar when she
brought out *On Photography*. Though the book was (and
remains) widely admired, it was also attacked in some quar-
ters as bitterly as "Raising Kane" had been. Kael's opponents
thought she had it in for a masterpiece; Sontag's thought she
had it in for a *medium*. "Sontag's real motive for writing the
book is to scuttle photography as an art," one of them wrote,
lamenting "how damaging to new interest in photography the
book is intended to be." Another declared that she was out "to
refute photography as meaningful." These snippets are from
thoughtful, serious reviews that nevertheless badly mistake
the thrust of her writing. "She has spent four years of her life
concentrating on photography . . . with the purpose of con-
vincing [her readers] that photography isn't worth their atten-
tion": that's a critique that contains its own counterargument.
For why would Sontag, a writer with an aversion to demoli-
tion work, steep herself so totally and for so many years in a
medium she can't stand? Is she a glutton for punishment?

She's not; she's a glutton for photographs, as her brief introductory note suggests and the text substantiates. To find something problematic isn't the same as finding it abhorrent. (I find Sontag intensely problematic, and I can't get enough of her.) For all Kael's derisiveness, few of her critics ever questioned her passion for the movies; they recognized, even if they disagreed, that what frustrated her was how few individual films lived up to the medium's vast potential. Sontag, a very different kind of critic, doesn't spend much time discussing individual works, an omission for which more than one detractor took her to task. ("She doesn't see photographs as individual works in the same way that a bigot doesn't think of blacks or Italians or Jews as individual people," one of them actually wrote.) The critics who contested her commitment to the medium because of her probing are another version of the critics who assailed her patriotism because of the anguish about her country that infused "Trip to Hanoi." Sontag is not dismissing—or even dissing—photography. She's profoundly troubled by certain ethical and aesthetic issues arising from the mechanical nature of the medium, such that a more accurate title for the book might be *On Some Problems in Photography*. And I'm far more swayed by her troubled questing than I am by the question-free, doubt-free boosterism of either the photography mavens who hated the one work or the hawks who hated the other.

But questing, doubt, irresolution are offensive to boosters of all stripes. "It is only in the cold light of the translation of the articles into prosaic language that the magnitude of Sontag's rejection of photography can be discerned," one opponent asserts, before going on to paraphrase them at stupefying length. But what such "translation" accomplishes is the

opposite: he's trying to clarify her conclusions when she hasn't reached any. Sontag isn't selling a thesis. She's conducting an investigation, raising hard questions, pointing up paradoxes built into the medium itself, much as Janet Malcolm did in *The Journalist and the Murderer,* and Sontag is no more *against* photography than Malcolm was *against* journalism. Sontag wrote of Walter Benjamin: "It was important for him to keep his many 'positions' open: the theological, the Surrealist/aesthetic, the communist. One position corrects another; he needed them all. Decisions, of course, tended to spoil the balance of these positions, vacillation kept everything in place." As usual with Benjamin, her gaze pierces inward as well; intellectually, she's far less adamantine than her customary tone suggests. Like Benjamin—and unlike Kael—she tries on stances, especially (because she considers them tonic) contrarian ones. Her *rhetoric* is strong—for example, when she sees interpretation running amuck and takes a stand against it. But her critics are always trying to nail her to Procrustean beds she's designed as more temporary resting places. Sontag hovers above her subject, and to pin her down is to misread her. She offers paradoxes that by their nature (by the nature of paradox) can't be resolved; to resolve them, by "translating" them, is to misrepresent, to *mis*-translate them.

Am I saying that a critic shouldn't be held responsible for the stands she takes? No, of course not. On most issues, Sontag has firm positions; even where her attitudes have evolved (as in her views on Communism), the underlying consistency is usually evident. Criticism is more than a series of value judgments, though, and often ambivalence is inescapable in the face of moral and aesthetic problems. That's why they're problems.

All of which is to underline what any intelligent reader should recognize in the first place, which is that a responsible critic can be of two minds about a work, an artist, or a problem—in this case, the problem of photography—and that there's no contradiction between considering photography symptomatic of ominous cultural trends and loving photographs.

Among the other kinds of criticism leveled at the book, some were old-hat and predictable—for example, that Sontag wrote with "the authority of high fashion," that she was "a prisoner of literary chic." This is a slur on her independence, a claim that she's writing not what she thinks but what the crowd thinks, and, put in these terms, it quickly disintegrates. It was also predictable that specialists would attack her as a generalist. Thus Michael Lesy (toward whose *Wisconsin Death Trip* she'd been rather ungracious): "There is no evidence in the book that its author has ever used a still camera, engaged in research in a photographic archive, or interviewed any practitioners of the medium." Compare John Gregory Dunne on Kael: "Reading her on film is like reading Lysenko on genetics—fascinating, unless you know something about genetics." Turf-guarding insiders (Dunne wrote screenplays) are always jealously claiming that outsiders lack the credentials to criticize; this is the same argument that scorched artists have always made, and always will, against critics. C. S. Lewis shot it down years ago when he wrote, in response to an obnoxious comment of T. S. Eliot's, "Only the skilled can judge the skilfulness, but that is not the same as judging the value of the result. . . . For who can endure a doctrine which would allow only dentists to say whether our teeth were aching, only cobblers to say whether our shoes hurt us, and only governments to tell us whether we were being well

governed?" Or, as Kael replied to an insult from a listener back
in her radio days, "There is a standard answer to this old idi-
ocy of if-you-know-so-much-about-the-art-of-the-film-why-
don't-you-make-movies. You don't have to lay an egg to know
if it tastes good."

Another enticing, and frequently specious, way of coun-
tering a critic is with the imputation of bad faith. E.g., "Does
Sontag actually expect to palm off the very special case of
Muybridge's work as typical of the case for all photographers?
Apparently she does. . . . She is making her real argument on
the sly, by misrepresentation." Bogdanovich's whole brief
against "Raising Kane" rests on his assumption that Kael knows
better, that what she's written is, in his word, "fiction," that
she *made it up*. The very seriousness of this charge speaks to
its improbability. Not that the literary politics of *Lost Illusions*
don't still flourish in corners of New York. But the writers who
turn out puff pieces and hatchet jobs to order seldom advance
their careers in criticism much, probably for the simple reason
that in any criticism worthy of the name, brilliance and integ-
rity are twin faces of the same thing—and if I'm overlooking
a special case, it certainly isn't that of Sontag or Kael, who
continually got burned for saying what they thought. In gen-
eral, the argument from bad faith amounts to a sleight-of-hand
attempt to distract attention away from the issues and onto the
honor of the writer who's raised them: it's paranoid at best and,
more often, just low.

But when you're up against an adversary that tough, even
the most dangerous weapons in the arsenal can start to look
good. It takes a master, for instance, to wield a bomb. The
attempt to go beyond censure and annihilate an opponent

utterly, to blow a record of solid achievement to smithereens, can leave the thrower looking like Wile E. Coyote—crisped himself. That's how practically all the attempts I've seen to firebomb Sontag have turned out. The most professional of them, and the most ruthless, was Marvin Mudrick's review of *A Susan Sontag Reader,* which ran in *Harper's* in 1983 under the headline "Susie Creamcheese Makes Love Not War." If nothing else, it's gripping as a display of pure bile. The charges spew out, scattered with chunks of Sontag's phrasing, at the very beginning:

> Susan Sontag, refusing to settle for English, writes a sort of demotic culturese: the "intellectual thrust" of something or other, the "lifestyle" of somebody or other, "the naked power of art" ("Art is seduction, not rape"), "artistic norms," "frontiers of consciousness," "the alienation produced by historical consciousness," "total seriousness." A writer who writes this way can go on forever, and Sontag does, she almost never pauses to quote beyond a phrase or two of the book or author she purports to be writing about, she's usually winging it in unstoppable speculation on the topic of more or less everything—life's bitter mystery; style; the naked power of art. And don't imagine she's writing for you or you, mister; she's writing for "person[s] possessing some training and aesthetic sensibility," for "the better-educated inhabitants of modern mass society," for "people with minds." She seems to think of any essay of hers as rather like a Wall Street or Washington insider's newsletter, aimed at people (with minds) whose ambition is to be in the know.

Most of these accusations are familiar: that Sontag pays too little attention to individual works (though as I pointed out at the beginning, she's not a reviewer; she uses individual works as a way to get to wider territory); that she's elitist (I'll say, but even the democratic Kael wrote for "the better-educated inhabitants of modern mass society," and so, of course, did Mudrick; and though I've already aired my own gripe about that "people with minds," his contention that she isn't "writing for you or you, mister"—"you or you" meaning, in this context, readers of *Harper's*—is wrong: "you or you" is the educated audience they're both writing for); that she's a literary fashionista (but has anyone ever claimed that the artists and writers she's brought to our attention don't merit it?). He thinks she overworks "exemplary" and he hates her italics.

Mudrick's principal objection, though, is anything but trivial. He thinks that Sontag writes gobbledygook, that everywhere she "dithers and bungles on with exactly the same aversion to intelligibility." But he muffs his case by lifting much of his evidence from "The Aesthetics of Silence"—an essay that illuminates certain difficult strains in modern art so astutely, and so profoundly, that I don't have any qualms about calling it a masterpiece. "The Aesthetics of Silence" is slow going, but it's not obscure: any educated reader can follow Sontag's argument, but Mudrick, to his discredit, yanks phrases out of context, where they really don't make sense. Anyway, subsequent developments have come to Sontag's defense. Mudrick was writing, it was apparent even then, as a tsunami of gobbledygook was engulfing scholarly criticism. Compared with what's standard in the academy today, "The Aesthetics of Silence" reads like a study in plain speaking.

Sontag offered Mudrick an irresistible opening, though, by reprinting in the *Reader* a (generally fine) 1975 interview she'd given *Salmagundi,* which leads off with a question about her shift in perspective on Leni Riefenstahl in the nine years between "On Style" and "Fascinating Fascism." Mudrick quotes nearly a column's worth of her long-winded answer, but her opening gambit is enough to suggest its tone: "Both statements illustrate the richness of the form-content distinction, as long as one is careful always to use it against itself." Auggh. Couldn't she have just said she felt the need to temper her admiration, or contextualize her view, or *something* reasonably clear and maybe even a little bit humble? Instead she comes across as someone who can't admit to even a teensy-weensy error of emphasis, in an avalanche of verbiage that—I have to agree with Mudrick—is unintelligible.

As far as he's concerned, though, Sontag is unintelligible consistently (even if she's consistent in nothing else). He travesties her style, letting the travesty carry much of his argument—but here he goes badly wrong, because his parody doesn't sound anything like Sontag:

I'm afraid you don't understand the richness of the form-content distinction. When I'm talking form Riefenstahl is a great artist whose work, being great art, cannot *ipso facto* and *prima facie* be political. When I'm talking content, she's a disgusting fascist every image of whose bold and complex art is saturated with her "noxious political ideology." . . . Besides or otherwise, I have studied the form-content distinction as far as it goes (though where it stops nobody

knows) under Robert Maynard Hutchins* or (speaking strictly) somebody who from the modern aesthetic position looked like him, and consider it the most erotic problem I'm exemplary enough to be thinking about at the moment.

And so forth. Maybe the rising wave of hysteria cracked up Mudrick's audience; it doesn't do much for me. OK, I can accept that Sontag's cerebral style puts some readers off. (Kael was one of them—"It took me many dutiful bursts of effort over a two-week period to get through Susan Sontag's essay on pornography, and when I finally thought I'd grasped it, it evaporated," she groused in what I don't mind calling a lapse of taste. For me, "The Pornographic Imagination" is right up there with "The Aesthetics of Silence.") What I can't accept is Mudrick's contempt. Sontag hasn't earned it, and when Mudrick smears her integrity—when he makes the claim that "she's usually winging it," that a typical Sontag insight is "something that hits her at the moment she's writing this particular piece and she says it because what matters isn't truth or sincerity or consistency or honesty or reality; what matters is 'style' or getting away with it"—the accusation is so rash, so unfair, so ugly, and so irresponsible that it deserves to be called what it is, a lie.

I'll tread more cautiously around the most sensational attempt on Kael's reputation. Renata Adler's poisonous assessment of *When the Lights Go Down* appeared in *The New York Review of Books* in the summer of 1980. The world loves a catfight, though this wasn't much of a fight, since Kael wouldn't respond. Given

*President of the University of Chicago when Sontag was there.

my feelings for her, I'm unlikely to have much sympathy with a review that describes four years' worth of her work as "piece by piece, line by line, and without interruption, worthless." A lot of people still take it seriously, though; recently a university professor told me that when he teaches Kael in his criticism course, he gives his students Adler "for balance."

Adler opens with two propositions, which she presents as axioms: that "no art can support for long the play of a major intelligence, working flat out, on a quotidian basis"; and that "no serious critic can devote himself, frequently, exclusively, and indefinitely, to reviewing works most of which inevitably cannot bear, would even be misrepresented by, review in depth." If you accept those propositions (and the assumptions behind them), that's it for Kael. But is it fair—or even sane— to demand that Kael be Sontag? At a lecture I heard Kael give in the early seventies, a questioner asked why she didn't settle down and write a book, and she responded (sweetly), "I would like to make an obscene gesture." As the audience cackled, she explained that weekly reviewing suited her temperament and her experience of the movies. She wouldn't have challenged Adler on the shallowness of Hollywood product—that was precisely her objection to the grade inflation of the auteurists—but how many readers would have been content with her covering only films of great merit or significant bad ones? Asking a critic to restrict her attention to important work is like telling a novelist the quotidian events of a life don't bear scrutiny. Kael took an almost palpable joy in the weekly challenge, and negligible movies elicited some of her finest and funniest writing. Besides, she would have been the first to acknowledge that she functioned partly as

consumer guide—which is how Adler functioned, too, when she served as a film critic for *The New York Times*. Adler's second point seems to be that popular culture won't support analysis at all: "The simple truth—this is okay, this is not okay, this is vile, this resembles that, this is good indeed, this is unspeakable—is not a day's work for a thinking adult." The truth, however, is *never* simple, and as Kael's work demonstrates, aesthetics is only the first layer of what we talk about when we talk about films. Even a piece of junk, she pointed out, can redeem itself with the surprise of "an actor's scowl, a small subversive gesture, a dirty remark that someone tosses off with a mock-innocent face." Kael's fervency Adler boils down to "holding too many very strong opinions about matters of minor consequence." Ouch—but were the movies of the period truly minor? *The Mystery of Kaspar Hauser; The Story of Adèle H.; Distant Thunder; The Magic Flute; One Flew over the Cuckoo's Nest; Next Stop, Greenwich Village;* and *Taxi Driver* are all in the first season that *When the Lights Go Down* covers. What's major? Kael's ardor for good movies and her fury at bad ones—especially moneymaking bad ones—grew out of the fear that a depraved business culture could *allow* movies to become matters of minor consequence. Well, look at them now. Was her fervency misplaced?

It had nettled Sarris that Kael "disdains the good manners (however teeth-clenched) of the scholarly community," and Adler takes up this complaint, accusing Kael of trying "to coerce, actually to force numb acquiescence, in the laying down of a remarkably trivial and authoritarian party line. . . . She has, over the years, lost any notion of the legitimate borders of polemic. Mistaking lack of civility for vitality, she now substi-

tutes for argument a protracted, obsessional invective." Much of Kael's work amounts to "bullying, presuming, insulting, frightening, enlisting, intruding, dunning, rallying," and Kael's often-invoked first-person plural "becomes a bandwagon, a kangaroo court, a gang, an elite, a congregation, which readers had better join, or else be consigned to that poor group of deviants, sissies, aesthetic and moral idiots who comprise 'some people,' 'many people,' 'a lot of people,' 'those people,' 'they.'"

Umm . . . how many readers of your acquaintance did Kael actually *frighten* into taking a party line? (*What* party line? If there was one, it changed from movie to movie, since she wasn't faithful to Altman or De Palma or even her beloved Renoir.) There may be excellent reasons to hold your tongue through the tirades of an obnoxious dinner-party guest, or to acquiesce to the views of a professor who's giving out grades at the end of the term, or to stammer, "OK, OK, I *love* Arnold Schwarzenegger" to the goon who's got your lapels in his fists. But a writer? Adler is arguing that the most potent tools of polemic are something nice people shouldn't use. Kael addressed this sentiment in a 1992 interview with *The Oxford American*:

> O A : I've heard a few people say that they have stopped reading you because you have made them feel stupid at times for liking something they shouldn't. Have you ever—
>
> K A E L : Tough.

However, I shouldn't play innocent. I understand what Adler is talking about. Skillful invective is one of criticism's nasty pleasures, but unfortunately there's no authority issuing invec-

tive licenses to qualified practitioners. Kael knew what she was doing, and "it wasn't being cruel to be kind, either," she said. She gets away with what she does because of her talent, and, unfair as unlevel playing fields are, talent isn't available to everyone. I'm not sure I can justify the meanness of put-downs like "Gere is to De Niro and Brando what the singers in *Beatlemania* are to the Beatles" or "If Woody Allen finds success very upsetting and wishes the public would go away, this picture should help him stop worrying." But I love those lines—their deftness, their ruthlessness, their *wit*. They justify themselves.

Like Mudrick, Adler impugns her subject's integrity, painting Kael as a careerist who's deserted the altar of Truth for the mansions of Success. After joining *The New Yorker,* she "still seemed to feel extremely strongly about most films she reviewed"—implying that she didn't really. Her slangy prose amounted to "an affectation of straightforwardness"—implying that her real motives lay hidden, that her ardor was a mask: "It is overwhelmingly clear . . . that one thing Ms. Kael has ceased to care about is films." Some of Adler's attempts to sling mud are grotesque—for example, "She has, in principle, four things she likes: frissons of horror; physical violence depicted in explicit detail; sex scenes, so long as they have an ingredient of cruelty and involve partners who know each other either casually or under perverse circumstances; and fantasies of invasion by, or subjugation of or by, apes, pods, teens, bodysnatchers, and extraterrestrials." (Evidently that final clause refers to favorable reviews of *King Kong, Invasion of the Body Snatchers, The Warriors, Invasion of the Body Snatchers*—again?—and *Close Encounters of the Third*

Kind.) The prissiness is embarrassing, and it hardly feels like the work of a thinking adult to point out that while, yes, Kael certainly did applaud a number of movies that included scenes of horror, violence, and sex, she despised a far greater number of them. Horror, violence, and sex were not criteria of value, and I don't believe for a minute that Adler seriously thought they were (though they may have been sufficient criteria for her to *dismiss* a movie). She's grandstanding.

This kind of defense, though, is largely beside the point. Despite the occasional shoddiness of Adler's tactics, I wouldn't accuse her of the bad faith she imputes to Kael. She isn't lying; she's responding to something that really does appall her. Her attack demonstrates a fundamental clash of sensibilities. When Adler winces at "an undercurrent of irrelevant, apparently inadvertent sexual revelation"—I assume she means the Rabelaisian humor that, she's right, is everywhere in Kael—she offers a revelation about herself. When she grows agitated at the surfeit of tropes in Kael that smack of "sexual conduct, deviance, impotence, masturbation; also of indigestion, elimination, excrement," she's telling us something about her own aversions and fears. I have no doubt that her nearly half-column-long list of offending examples contains only a fraction of what she might have quoted. It includes three instances of "manure," "a little gas from undigested Antonioni," "just a belch from the Nixon era"—turns of phrase I'd call delightful—"and elsewhere, everywhere, 'flatulent,' 'gaseous,' 'gasbag'"—that's the one-liner about *The Hindenburg* and its director I quoted earlier, "One gasbag meets another"—and even "makes you feel a little queasy," which I'd think would pass muster on any pulpit. Quibbles aside, though, Adler isn't being devious; she's

giving honest voice to the sensibility dissonance that is her experience of reading Kael. Although the actual Kael had a delicate frame and a refined, silvery speaking voice, to the kind of Eastern Seaboard stiff whom the sedate old *New Yorker* tone fit like a glove, the Kael who comes flying off the page must have appeared raucous and lewd and as mortifyingly demonstrative as the worst scenery chewer in the Yiddish Theatre. The critics Adler admires, she tells us, work "quietly," while Kael is "shrill" and "strident," "overbearing," "hysterical"; instead of writing with "quiet authority," she presents the "somewhat violent spectacle" of an authorial "frenzy." To Adler, Kael is *loud*. Adler sure isn't. She endorses Kael's early reviews for their "energy" and "good sense." She finds the epochal *I Lost It at the Movies* "interesting." Looking back ruefully, she writes, "There was always the impression, unfounded but widely held (I held it), of liveliness"—an accolade that rivals "energy" and "good sense" and "interesting" for its pallor, for its *lack* of liveliness.

"Let's leave aside her humor," Adler proposes, and she does; she's impervious to it. Thus she observes, "The degree of physical sadism in Ms. Kael's work is, so far as I know, unique in expository prose," and then she backs up her claim with examples of *wisecracks*. Kael's quip about Silvana Mangano's countess in Visconti's 1975 *Conversation Piece*—"She'd crunch your heart to clean a pore"—is one of many instances Adler has collected in which "all the squishing and crunching attributed to characters, actors, anyone, is entirely her own idea." This unsmiling literal-mindedness provides a painfully trivial example of the kind of objection I cited earlier to Sontag's "Communism is fascism." Pushed to the wall, Kael would probably have to admit:

OK, I exaggerated—with your heart clasped in a vise before her, the countess might well choose an alternative method of pore cleansing.* Another "pure Kaelism," from a review of Altman's *Quintet,* horrifies Adler even more. "Having described a scene in which a character 'holds her hand over a fire until it is charred and bursts,' still apparently unsatisfied, Ms. Kael adds this joke: '(Did Altman run out of marshmallows?)'" But far from demonstrating what Adler calls an "infatuation with the more extreme forms of violence," Kael's joke is clearly a put-down of a scene that revolts her. Adler doesn't try to claim otherwise; she seems shocked that Kael mentioned the incident at all and outraged that she *joked* about it. *Nice* people don't joke like that.

Even the most innocent devices drive Adler wild. Assiduously compiling more than a column's worth of rhetorical questions, she draws herself up and asserts, "It is difficult to convey the effect of hundreds of pages of these questions. Those which have answers—Yes. No. What. I don't know, sweetie; you're the one that saw the movie—badger the reader, who is courteously inclined to *think* when addressed with question marks, into a mindless, degrading travesty of colloquy or dialectic." But when Kael asks, "Were these 435 prints processed in a sewer?" what other reader feels put on the spot to provide an answer? The list is characteristic of Adler's method. She quotes and she quotes and she quotes, because, as she

*The line that follows in Kael's review, incidentally, immediately qualifies her barb: "You like her, though, and you like the performer—the way you always like the actresses who play chic, ultra-neurotic witches."

explains at the outset, "a sign of integrity in a critic, as opposed to an opinion monger, is that he tries for evidence; in reviewing prose forms, for example, he will quote." You can't fault her diligence, but for a fan like me, all this quotation keeps sabotaging her argument. Consider this small sampling from Adler's list:

> How can the Count's arrival and his plea for a hasty marriage have any vibrations?
>
> Why then does it offend me when I think about it?
>
> And what is Sally doing when she holds out her arms to her husband?
>
> Where was the director?
>
> Does the cavalry return?
>
> Who—him?

Every time I get to that "Who—him?" I laugh. There it is, in two little words, Kael's voice, funny and jabbing and alert and *alive,* and in the middle of that sea of lockjaw prose it argues for everything blissful that Adler missed—that she couldn't hear and she couldn't see because she simply didn't have the equipment to take it in—when she sat down with a volume of Kael.

S ONTAG'S ADVERSARIES have called her shallow and unpatriotic. Kael's have gone further, especially in reaction to reviews that involved her own version of separating aesthetics

from morality—she was notoriously suspicious of message movies. "Art, perhaps unfortunately, is not the sphere of good intentions," she argued in the 1956 "Movies, the Desperate Art," a notion she developed at some length in "The Intentions of Stanley Kramer," her 1965 poison pen letter to that producer and director of messagey films. The publicity for Kramer's 1959 antinuclear drama, *On the Beach*, had featured encomiums from, among others, the Nobel Prize–winning chemist and peace activist Linus Pauling, who declared, "It may be that some years from now we can look back and say that *On the Beach* is the movie that saved the world." "Six years have passed," Kael noted: "does anyone remember *On the Beach* as anything more than a lousy movie?"

Some detractors have claimed she was biased against political films, but in fact she endorsed such extreme cases as *The Battle of Algiers*, *The Confession*, and *The Battle of Chile* (not to mention *Triumph of the Will* at the other extreme). What irked her was applause for pictures whose good intentions outstripped their accomplishments. "Intentions," she noted, "despite what schoolteachers say, are what we shouldn't have to think about in the arts and don't think about except when they're not achieved." On the radio, she once expressed the hope that her audience would "not think I am anxious for nuclear war or avid to see the world go off its axis if I say that, worthy purpose or no, *The Day the Earth Caught Fire* is not a very good movie." What was a joke in 1961 soured in later years when she really was denounced for knocking movies that some critics considered too noble to dish. In 1990, Georgia Brown of *The Village Voice* accused her of racism ("Racial inattentiveness is more like it," Brown amended her-

self after letters of protest came in) for failing to support Spike Lee's *Do the Right Thing* at the annual voting for the New York Film Critics Circle awards. The angriest response to one of her reviews, though, came from American Jews enraged by her (cogent, careful, brutal) critique of Claude Lanzmann's 1985 Holocaust documentary, *Shoah*.

"So this is what it all ends in," the critic Alfred Kazin thundered in an article titled "Americans Right, Left, and Indifferent: Reponses to the Holocaust"—"a movie not up to Pauline Kael's standards! The Holocaust does not make a satisfactory film." Kazin considers her objections and finds her "incapable of responding to the material." But his subtitle gives his argument away: Kael was reviewing a film—she wasn't reviewing the Holocaust. As she put it clearly in her opening sentence, "Probably everyone will agree that the subject of a movie should not place it beyond criticism." Not Kazin. He's outraged that a critic "famous for her delight in 'sexy,' aggressive movies like *Shampoo* and *The Warriors*" should find fault with a film on an infinitely more important topic.

The criticism is bogus, of course; by this criterion, *any* movie on a Holocaust theme, no matter how inept, is above reproach. Yet Leon Wieseltier, the literary editor of *The New Republic,* took the same tack in his own angry rejoinder, objecting to strictures "from the woman who was engaged by *Sheena, Queen of the Jungle*." (It's true. She enjoyed *Sheena* as a "lighthearted adventure film" that "never forgets its own silliness.") Kazin and Wieseltier are clearly no friends of pop culture, but I hope they wouldn't try to argue that an affection for fluff rules out appreciation for deeper work. Even if they would, their swipe is a red herring: they ignore the core of Kael's argument, which

is that *Shoah* fails *as a film*. Wieseltier adopts Adler's slander about Kael's lust for violence: "I think I understand her frustration. Here was nine hours about the most spectacular act of violence in history, and the screen showed no violence. All that torture cinematically squandered for mere reflection! Just think what Brian De Palma could have done with it." Kael doesn't object to reflection. Her beef is that Lanzmann isn't reflective *enough*—"Though he took a doctor's degree in philosophy, he works like a detective (and sometimes a prosecutor) rather than a philosopher"—that for reflection he substitutes "facile judgment." In this grievance she remains true to a preference she often stated. A good example (from a very different context) is a discussion of camera technique that comes up in the course of "Raising Kane":

> In the thirties, Jean Renoir had been using deep focus (that is, keeping the middle range and the background as clear as the foreground) in a naturalistic way. The light seemed (and often was) "natural." You looked at a scene, and the drama that you saw going on in it was just part of that scene, and so you had the sense of discovering it for yourself, of seeing drama in the midst of life. This was a tremendous relief from the usual studio lighting, which forced your attention to the dramatic action in the frame, blurred the rest, and rarely gave you a chance to feel that the action was part of anything larger or anything continuous.

Of *Harlan County, U.S.A.* (a film that otherwise impressed her), she complained, "The director doesn't leave us to our own resources enough; she doesn't allow us a chance to fill in from

our own feelings," and she put the Scottish writer-director Bill Forsyth "in a class by himself" because in his work "nothing is forced; something is raised, and then it's up to you." Her dislike of being told how to respond was a constant in her criticism, and this was her principal objection to *Shoah*: that Lanzmann trusted his audience too little, that the film "doesn't set you to thinking" but, rather, "closes your mind." Comparing *Shoah* to a documentary she thought truly was great—*The Sorrow and the Pity*, Marcel Ophuls's 1970 study of French collaboration under the Vichy regime—she wrote, "When you come out of *The Sorrow and the Pity*, there has been so much packed into its four hours and twenty minutes—so many widely differing instances of collaboration and resistance, and such a steady accumulation of perspectives—that your mind is buzzing." *Shoah*, at more than twice that length (it was screened in two parts), was far less packed. The published text came to under two hundred pages; Lanzmann "slows down this material," she complained, "stretching it almost languorously." (Her protest that he "aestheticizes everything for us" recalls Sontag's qualms about the aestheticizing tendencies of photojournalism.) The result was, in her view, numbing. Whether her reproach is justified is debatable, but Kazin and Wieseltier don't even deal with it. Instead they charge that her "dissenting view of a film that is widely regarded as a masterpiece," as she put it, is a dissenting view, as Wieseltier puts it, "about the film and the catastrophe." *What?* Where is there any evidence that she takes a dissenting view of the Holocaust—and what on earth *is* a dissenting view of the Holocaust? To deduce from her misgivings about *Shoah* that she viewed the Holocaust with insufficient gravity is malignantly unfair. (And, by the way, untrue.)

J. Hoberman, writing in *The Village Voice*, thought Kael saw the film "as a stand-in for paranoid Jews wallowing in self-pity," and that undercurrent is there. She was repelled by the politics of victimization, and she never considered herself a victim either as a Jew or as a woman (though as a writer, maybe). Like Wieseltier, Hoberman angrily quotes Kael's declaration that "*Shoah* is a long moan" without quoting what follows: "This is not necessarily an aberrant or irrational notion, and a moan is not an inappropriate response to the history of the Jews. But the lack of moral complexity in Lanzmann's approach keeps the film from being a great moan." He also bristles at her description of the film as "a Jew's pointing a finger at the Gentile world and crying, 'You lowlifes—you want to kill us!'" "Given her contempt for *Shoah*'s 'lack of moral complexity,'" Hoberman writes, "the coarseness of Kael's formulation is astonishing." The formulation *is* coarse, and I wish she'd put it differently; the tone of that sentence didn't do her argument any service. Hoberman also quotes another sentence that Wieseltier quoted—"If you were to set him [Lanzmann] loose, he could probably find anti-Semitism anywhere"—and, again like Wieseltier, he fails to add the palliative qualification. What Kael wrote was this:

If you were to set him loose, he could probably find anti-Semitism anywhere. Maybe any of us could if we looked for it, but he looked in special places, and it's shocking to see the unself-conscious forms of it that he turned up among people who lived close enough to the death centers to smell the stench.

Hoberman stops with the first sentence. Then he adds—
in closing—"Imagine, he actually found anti-Semitism in
Treblinka. If he's not tied up again, he could probably find it
in *The New Yorker.*"

That sentence has haunted me ever since I first read it, in 1986.
Could it possibly mean what it appears to mean—that Kael's
review is anti-Semitic? A less incendiary reading would be that
anti-Semitism is so entrenched and widespread that a careful
combing of even so enlightened an institution as *The New Yorker*
could turn it up. Hoberman is a critic I admire, and that's what
I hope he meant. But it's not how the statement strikes my ears.
Hoberman is writing, as a Jew, about the words of a Jew in a mag-
azine that was edited by a Jew, in a polemic that bluntly insists
the "essential question" *Shoah* raises is "one of identification. If
one doesn't identify with the Jews in *Shoah*, one is left with the
Poles." Either you're one of us or you're one of them. Having
only a few words before accused Kael of astonishing coarseness,
it's an accusation of astonishing coarseness.

Even at his most splenetic, though, Hoberman couldn't
approach the vitriol of the group that, during the eighties, tried
to tar Kael as a homophobe. (And here, because the accusations
took on a life of their own and did real damage to her reputa-
tion, I intend to examine them at some length.) The campaign
began over her review of *Rich and Famous*, a 1981 drama with
a footnote value as the last film by George Cukor; the plot
involves the twenty-year friendship of a giddy popular novel-
ist (Candice Bergen) and an occasionally promiscuous high-
brow novelist (Jacqueline Bisset). Cukor was famously, but not
publicly, gay, a circumstance that Kael, who found the movie

idiotic, tried to address without forcing him out of the closet when she wrote, *"Rich and Famous* isn't camp, exactly; it's more like a homosexual fantasy. Bisset's affairs, with their masochistic overtones, are creepy, because they don't seem like what a woman would get into.*"* When Stuart Byron, of *The Village Voice,* read those sentences, he hit the ceiling:

> I have news for Pauline. However much male gay life has followed promiscuous patterns not available to straights until the advent of the postpill paradise, the gay fantasy has always been exactly the same as the straight fantasy: love and happiness with one person forever. . . . As for Bisset, it is apparent that Kael, like the straight men who seem to have shaped her romantic consciousness, won't accept that Bisset has one-night stands and *sometimes* enjoys them—and yet is not viewed as a sick nymphomaniac.

Vito Russo, the author of the pioneering 1981 study *The Celluloid Closet: Homosexuality in the Movies,* echoed Byron's contention in an interview the following year:

> *Rich and Famous* had a promiscuous heroine and got attacked for it, notably by Pauline Kael, who attributed the promiscuity of a heterosexual character, a woman, to a homosexual sensibility, as though straight women have never been promiscuous or been given the permission to be promiscuous. So when George Cukor created one for the first time, Kael said they shouldn't be like that; it's homosexual; they're the ones who are promiscuous.

No one familiar with Kael's writing on women and sex could take these words seriously. The most obvious rebuttal is her review of the 1977 *Looking for Mr. Goodbar,* in which Diane Keaton played a woman who, as Kael put it, "cruises singles bars the way male homosexuals cruise gay bars and s-m hangouts." Kael disliked the movie—not because it was debauched but because it wasn't sensual *enough* ("The teasing near-subliminal bedroom flashes are 'artistic,' not sensual") and because, like the novel it was drawn from, it moralized and psychologized ("as if a woman wouldn't want sex unsanctified by tenderness unless she was crippled, psychologically flawed, self-hating") for an audience that, in fact, already accepted the anonymous sex. It was "something that most women have probably done at some time—or, at least, have wanted to do," she commented. "It's what nice people do when they're not feeling so nice."

In his revised (1987) version of *The Celluloid Closet,* Russo wrote, "Pauline Kael attacked George Cukor's *Rich and Famous* (1981) for having a covert gay sensibility." No: she *noted* the film had a covert gay sensibility. She *attacked* it for being, as she wrote, "hopelessly demented. . . . It's full of scenes that don't play, and often you can't even tell what tone was hoped for." But she did find the gay undercurrent problematic. "I see it as a picture with what is now called a closeted sensibility," she later elaborated. "The erotic passages simply didn't feel convincing to me as heterosexual, but surely it's not anti-gay to point out that the nuances of male-male and male-female pickups and seductions are somewhat different?" Apparently Russo thought it was, and though the film's pickup scene, with its heavy silences and tight smiles, reads to me as

inescapably gay, there's probably no way to prove it. Russo didn't read it that way. No matter how he read it, though, it was contradictory for him to write that Cukor's homosexuality was something Kael "couldn't overtly discuss while the director was still alive because it's such a disgusting thing to say about some-one in print that you can be sued for it"—which misrepresents her reluctance to out him—and then claim, on the same page, "Pauline Kael simply calls George Cukor a faggot."

Kael's gay critics saw the picture as something of a break-through. "*Rich and Famous* was perhaps one of the first American films to treat males as sex objects without deri-sion," Russo wrote. He could have dispensed with that "per-haps." The movie belongs to the era of the first giant Calvin Klein men's-underwear billboards on Times Square, and to that extent, I suppose, it retains some sociological interest. But that doesn't make it sexually advanced. Byron chided Kael for calling Bisset's tightly wound novelist "masochistic," but the character doesn't appear to get much pleasure out of her esca-pades—her deepest desire, too, is for love and happiness with one person. Her hunger for the juvenile hustler who picks her up on the street is less lusty than abject. (She's a typical movie intellectual, starved for love.) And when she asks her old friend Bergen for a New Year's kiss at the end of the film, the reply she gets is, "After all these years, are you going to tell me that there's something strange about you?"—not a line you'd expect in a movie championed by gay critics.

Byron, Russo, and the most rabid of Kael's accusers, Ed Sikov (who published a long prosecutorial essay about her in the gay *New York Native* in 1984), took issue with practically

every word Kael had ever written on gay topics, and there were
many. A particular irritant was a wisecrack about lesbian sex
that she'd made in the course of reviewing *The Children's Hour*,
the 1961 film version of Lillian Hellman's play about school-
teachers accused of sexual misconduct: "I always thought this
was why lesbians needed sympathy—that there isn't much they
can do." Byron thought it showed that "her knowledge of sex-
ual practices has always been modest," and Sikov added, "It
wouldn't take more than thirty seconds of idle contemplation
on a crowded bus to come up with at least five possible lesbian
sex acts." Neither of them noticed that the line is a joke. (Nor
did they recognize that, in context, Kael was chiding Hellman
for not delivering on the story's lesbianism.*)

She took up the treatment of gay characters again in her
review of *Victim*, the 1961 thriller about the blackmail of homo-
sexuals that Britain's antigay statutes then encouraged:

> A minor problem in trying to take *Victim* seriously even as
> a thriller is that the suspense involves a series of "revela-
> tions" that several of the highly-placed characters have been

*"I can't help thinking she wouldn't waste any sympathy on sex-
ual deviation among the rich. Aren't we supposed to feel sorry for
these girls because they're so hardworking, and because, after all,
they don't *do* anything—the lesbianism is all in the mind. (I always
thought this was why lesbians needed sympathy—that there isn't
much they *can* do.)" Russo, Byron, and Sikov, incidentally, all mis-
quote the line slightly, substituting *that* for *this*—suggesting, since
Russo came first, that Byron and Sikov simply repeated his allega-
tion without bothering to look up what Kael actually said.

concealing their homosexuality; but actors, and especially English actors, generally look so queer anyway, that it's hard to be surprised at what we've always taken for granted—in fact, in this suspense context of who is and who isn't, it's hard to believe in the actors who are supposed to be straight.

Is this bigotry? To me it shows enough ease with the topic to be able to crack jokes—in a dark period when other reviewers (like *Time*'s), as she jeered, "felt that if homosexuality were not a crime it would spread." But her larger—and more controversial—criticism is that the film's rectitude tips over into piety: "I'm beginning to long for one of those old-fashioned movie stereotypes—the vicious, bitchy old queen who said mean, funny things. We may never again have those Franklin Pangborn roles, now that homosexuals are going to be treated seriously, with sympathy and respect, like Jews and Negroes." Predictably, Kael's gay critics miss the irony (and the humor) in this passage and conclude that she's arguing *against* treating homosexuals "with sympathy and respect." But here, as that "seriously" signals, those terms are corroded. (Compare the pejorative spin she always gave *virtuous*.) "In *Victim*," she complained, "there is so much effort to make us feel sympathy toward the homosexuals that they are never even allowed to be *gay*." To Russo, "This was like saying that there was so much effort to make us feel sympathy for blacks in *Nothing but a Man* or *One Potato, Two Potato* that they were never allowed to tap dance or eat a slice of watermelon." Nonsense. It's Russo who, with the best intentions (and I use the word advisedly), is falsifying his experience. As Kael had argued back in "Movies, the Desperate Art,"

The situation is not simple. Art derives from human experience, and the artist associates certain actions and motivations with certain cultural and vocational groups because that is how he has observed and experienced them. . . . It is the germ of observed truth that pressure groups fear, a germ which infects only the individual but which the group treats as epidemic.

She wasn't cavalier. "To allow the artist to treat his experience freely may be dangerous," she acknowledged. But to deny that freedom—to demand "whitewashes, smiles, and lies"—is worse. And, if I can say so without being misinterpreted, there is considerable beauty in tap dancing. Twenty-four years after *Victim*, Kael returned to her defense of the nelly queen in her review of *Kiss of the Spider Woman*, Hector Babenco's 1985 film version of the Manuel Puig novel about a window dresser and a revolutionary locked together in a Latin American prison cell. Babenco's adaptation struck her as timid—it would have been better, she thought, "if the sexual relationship between the two men had been ongoing (as it is in the book), and not just the one-night affair of the movie"—but her larger objection was to Babenco's treatment of the gay window dresser, Molina, who represented "the delirium of excess" to Puig and to her. "Babenco, in all his earnestness, is out to prove that silly old queens are useful, upstanding citizens, and he has steamrollered the romance and absurdity out of the material," she protested. "I don't believe that Puig saw any need for Molina to be redeemed."

Byron and Sikov take offense at her observation, in her review of *The Sergeant* (1969), that "inside the leather trappings

and chains and emblems and Fascist insignia of homosexual
'toughs' there is so often hidden our old acquaintance the high-
school sissy." But isn't the "germ of observed truth" (more than
a germ, if you ask me) what angers them? (Russo, in fact, agrees
with her.) Meanwhile, they ignore the grounds—remarkably
blasé in a review written six months before the Stonewall upris-
ing—on which she dismisses the movie:

> In *The Sergeant,* Rod Steiger chases after John Phillip Law
> so long that when he grabs him and kisses him it's the cli-
> max of the picture. Then Law slugs him and Steiger goes out
> and shoots himself, and that's it. If Steiger had grabbed Law
> and been rebuffed an hour and a half earlier, he could have
> said, "All right, so I made a mistake," and maybe the picture
> could have gone on and been *about* something.

"I don't believe that the overt or honest expression of a homo-
sexual theme has ever offended me in any way," Kael said in a
1983 interview with Sam Staggs; "it's only the covert that I've
kidded." "Kidded" is a bit mild for her pan of the 1973 Paul
Newman–Robert Redford vehicle *The Sting*:

> I would much rather see a picture about two homosexual men
> in love than see two romantic actors going through a routine
> whose point is that they're so adorably smiley butch that they
> can pretend to be in love and it's all innocent. (It was more
> fun in the forties and fifties, when male couples played these
> games and we guessed from the way they looked at each other
> that they really were lovers offscreen.)

And she was alert to real homophobia. A 1972 observation about blaxploitation films—"These movies are often garishly anti-homosexual; homosexuality seems to stand for weakness and crookedness—'corruption'"—still applies to the hip-hop scene. She denounced Ken Russell's gay-themed movies ("homo-erotic in style, and yet in dramatic content . . . bizarrely anti-homosexual") as "flaming anti-faggotry." And she was sensitive to subtler kinds of homophobia, as in the 1977 ballet picture *The Turning Point*:

> Would movie audiences care whether the male dancers were actually homosexual, as long as they moved with precision and refinement, and could soar when necessary? Maybe some still would; maybe there is a sound commercial instinct behind this picture's attempt to ingratiate itself by showing ballet as "normal." But . . . it would be more honorable to take a chance on the audience.

In her review of *Slap Shot* the same year, she not only blasts "the constant derisiveness about homosexual practices and the outright baiting," she goes so far as to place part of the onus for "the ugliest scene in the picture" on its star, Paul Newman: "If Newman had refused to play the scene this way, what could the moviemakers have done? You can't blackball Paul Newman."

In fact, sifting through the dozens upon dozens of references to homosexuality in Kael's work, I find only one that really bothers me. In the 1961 British film *A Taste of Honey*, the unmarried and pregnant young working-class heroine sets up household with a sissy friend who sees her through her pregnancy and

helps her care for the infant, until the girl's hateful mother shows up and throws him out. Kael likes the material (but not Tony Richardson's direction of it), finding an "old-fashioned but sweet pathos" in the friendship that takes her back to the pictures of an earlier era: "The sweet man is now a motherly little queen who looks after the heroine, but the basic emotion is the same as it was in the gentle sentimental love stories of the twenties and thirties—the hero and heroine, friendless babes in the woods who need each other." But this "beauty-of-pathos stuff," as she once called it in reference to Chaplin (and the end of the picture reminds her of Chaplin), also puts her on her guard:

> Audiences longing for a hero to lavish their sympathies on have a new unfortunate they can clasp to their social-worker hearts: the ideal "little man," the homemaker, the pure-in-heart, childlike, non-threatening male, the man a girl can feel safe with—and who could be more "deprived"? They can feel tender and tolerant, and they can feel contemptuous, and in-the-know at the same time: the man a girl can feel safe with is a joke, he's not a man at all.

Rather than brush these words aside, I'll concede that I wish she hadn't written them, or written them this way. Are they homophobic? No. She isn't making a pronouncement about gay men; she's referring to a specific weakling, and she never had room in her heart for weaklings. (Who else would describe Don José in *Carmen* as "a suffering middle-class clod"?) The problem with the passage isn't homophobia but sexism; "not a man at all," with its implication that effeminacy (or, by extension, femininity) represents a failure of worth, is a locution no

right-thinking writer would use today, and one that Kael herself would have shunned in her later years. It reflects the tenor of the times better than it does the tenor of her thought—there's no other evidence that she considered women inferior to men.

But, but . . . if she really was the model of tolerance I knew her to be, then why did she become a symbol of bigotry to a group of gay critics? Part of the answer lies in her tone. I don't mean simply the pugnacity, though the pugnacity always inflamed readers and made them want to argue back (which was part of what made her addictive). It's also the lack of piety and especially the contempt for liberal pieties. Kael assumed that she didn't need to *profess* her goodwill. She would have found it offensive—to her readers and to herself—to assure them she was enlightened. But her failure to assure them had consequences, and not just around gay issues. Recently I met a young woman who admires Kael but, to my surprise, faulted her for a deficiency of feminist consciousness. Kael, she argued, passed up too many opportunities to offer a feminist analysis in her reviews. No doubt she's unaware that years ago Stanley Kauffmann noted the "persistent feminism" in *I Lost It at the Movies,* that Sarris decried Kael's "misapplied feminist zeal," or that the young men who composed the editorial board of *Movie* accused her of "fanatical feminism." This young woman wasn't entirely wrong. Kael had firm politics, but she was wary of what firm politics could do to criticism. Although she could be ferocious in pointing out how a coffee-table book or a movie like *Straw Dogs* demeaned women, she was equally ferocious in demonstrating, in her reviews of *The Stepford Wives* and *One Sings, the Other Doesn't* and *Entre Nous,* how a shallow and self-serving feminism could distort dramatic thinking. Ditto

her views on sexual orientation: what she called special plead-
ing irked her not because the plea wasn't just but because too
often it outbalanced verisimilitude, character development, *art*.
Of the Steiger character in *The Sergeant* she demanded, "Is he
consciously or unconsciously homosexual? We don't know
anything about him except that he's fat and domineering and
chases the hero. He's a middle-aged man; what has he been
doing all these years? If this flirtation is one in a series, why is
he so inept? (And why does he kill himself?) And if this is his
first crush, what set it off? Why *this* boy?" Or, to cite a paral-
lel example from a film about race, in her review of *The Great
White Hope* (1970) she complained that "the *conscious* conspir-
acy" of "the sneaky, rotten whites plotting against one noble
black" was "in movie terms, banal. When the whites' ignorance
and their unconscious fears and resentments . . . are turned
into an overt conspiracy to keep the blacks down, we're in
Fakesville." Without artistic integrity, "intentions" were use-
less—worse than useless.

Kael was direct. If she had disliked homosexuals, she would
have said so; she wasn't, as she wrote so disdainfully of Stanley
Kramer, running for office in the arts. But the enemy wasn't
gays. The enemy was fraud, the enemy was cant, and she
had an almost visceral need to expose it. If the tone in some
of her earlier reviews now strikes us as less than sensitive, it
hardly seems fair to hold a critic writing in the early sixties to
post-Stonewall standards of delicacy. And it should be remem-
bered that she wrote those reviews at a time when the rest of the
press typically referred to gay men and lesbians in terms that
survive today only on the far-right fringe. Her attitude is sym-
pathetic in her reviews of such explicitly gay-themed movies as

By Design, My Beautiful Laundrette, and *Law of Desire.* In 1982, she showed how the cross-dressing comedy *Victor/Victoria* was actually reactionary in its sexual attitudes (Russo later offered much the same analysis); the movie's popularity with gay audiences mystified her. Sikov's reaction to this extremely hip, extremely sage review: "It was exactly the openness of the gay theme that enraged her."

The gay attacks on Kael are obviously painful to me, and not just because, as a gay friend of hers, I feel injured by assaults on her good name. To me they represent something far more destructive. They embody the same hopeless script that progressives have enacted again and again for the past century. Why does the left persist in exhausting itself by attacking its allies instead of its enemies? Why do deviations from orthodoxy provoke so much bitterness that the left winds up shifting its energy, its passion, away from the true threats? What was gained by creating a straw villainess out of Kael at a time when homosexuals had so many real antagonists who were virulent, indefatigable, and gleefully out in the open?

There was something horrible in the way a group that had once been persecuted by smears turned itself into a smear factory. But the eighties was an ominous era for gay men and women. The backlash that had begun in 1977 with Anita Bryant's successful campaign against an antidiscrimination ordinance in Dade County, Florida, seemed to be gathering strength. In 1986, the Supreme Court shattered any hope for constitutional justice when it endorsed, in *Bowers v. Hardwick,* the continued criminalization of sodomy. And then, of course, there was AIDS—the epidemic that was to claim both Byron and Russo among its countless casualties—and the indifference

of the Reagan administration to the death toll. The necessity of militance was clear, and the rise of Larry Kramerism was probably inevitable. Activists felt, as they always have, that if a few bystanders fell under the bullets, they always have.

As Kramerism demonstrated, there's a thin line between militance and hysteria. A measure of the hysteria was that not even Sontag was safe from the bullets. In a blistering analysis of the 1989 *AIDS and Its Metaphors,* the literary scholar D. A. Miller found in the studied neutrality of Sontag's language evidence of "AIDS panic in its looniest form to date"—not to mention homophobia, racism, and all-around cultural conservatism:

> A lexicon that not only prefers "homosexual" and "sodomy," say, to "gay" and "anal intercourse," but also, in the definitively heterosexist manner, lets its preference go without saying, puts writing in the service of the homophobic oppression that is exacerbated by AIDS and that underpins the stigmatization of those with AIDS, gay or not. . . . Sontag appears to enjoy an obliviously good conscience even as her language continues to ratify the prejudice, oppression, and violence that gay people and people with AIDS daily encounter.

Grave charges. The principal difference between Miller and Kael's gay antagonists is that Miller is bewitchingly smart. He makes eye-opening points about the deployment of language, and he brings sparkle and wit to the rarefied academic mode. He's also slightly off his rocker, or at least that's how he sounds when, briefly revisiting "Notes on 'Camp,'" he interprets Sontag's statement "One feels that if homosexuals

hadn't more or less invented Camp, someone else would" as a "phobic de-homosexualization of Camp." His pique parallels the denigration of the pre-Stonewall Kael, but it's even more of a stretch to find anything homophobic in "Notes on 'Camp.'" For Christ's sake, Sontag is *gay*.

It's not that Miller's approach is illegitimate. To consider the implications of a writer's argument and of her tone, and to condemn on the basis of that evidence, is a basic critical strategy. But Miller appears to be operating in a moral delirium now common on campuses. We all absorb nasty biases—even members of the groups they victimize absorb them—which it's an ongoing struggle to recognize and eradicate. Today a lot of academic energy goes into ferreting out those attitudes in the writing of the past. Unfortunately, the resulting criticism tends to be as cocksure morally—that is, as devoid of empathy and sympathy and as generally benighted—as what it censures. Miller's eagerness to put Sontag in stocks in the town square is hard to bear, and his qualifier that her (putative) homophobia is "unexamined and, I assume, largely unconscious" doesn't begin to counterbalance the rest of his (alas, somewhat influential) argument; even within that caveat, the "I assume" and "largely" are evidence of malice. I feel confident in avowing that Miller isn't Sontag's moral superior. And I'm dead sure that his argument, no matter how exquisitely sensitive it is to the cultural nuances of language, is myopic and wrong, since the detached neutrality of Sontag's prose, in which he detects a phobic strategy of "decontamination," has been a glaringly obvious feature of her style since she first started publishing criticism, years before AIDS.

IF IN ANY (OR MUCH) OF the foregoing I've sounded defensive—well, I haven't meant to. And I hope that, in synopsizing a large number of arguments, I haven't been seduced into the reductiveness that distorts so many of them. Don't laugh when I say that I welcome criticism of Sontag and Kael. I do—theoretically. I can *imagine* useful attacks on them. I cherish argument, as anybody who's had dinner with me can attest. Argument is how we learn; argument is how we *think*. I admired William Deresiewicz's testy review of *Where the Stress Falls*, Sontag's 2001 collection, in *The New York Times Book Review*—he abused her for some of the same things I've abused her for—though I thought a little generosity would have leavened it. (When he wrote, "She sounds like Matthew Arnold," he wasn't saluting her growth.) The best thing about Deresiewicz's review, though, and my main reason for mentioning it, was the letter of protest it drew from Edmund White, the novelist who had once been a friend of Sontag's. Their friendship was presumably history after White published his 1985 roman à clef, *Caracole*, whose unmistakable portrait of Sontag is the meanest thing about her I've ever read. (It's also the novel's sole point of interest.) In his letter to the *Times*, White sets up the reader expertly, loudly extolling Sontag's accomplishments ("main conduit for French culture to America . . . first and sometimes only American to recognize contemporary Eastern European authors . . . one of the few American intellectuals who had the necessary independence of spirit to denounce Communism," etc.) before slipping in a raspberry: "Indeed, in every domain Sontag, *despite her personal arrogance and her humorlessness*, can only be described as 'exemplary.'" Italics mine, and completely uncalled for. (Dear Ed White: Please don't ever write a letter

in defense of *me*.) He must have gotten that "exemplary" from Mudrick.

But though White's letter is a frivolous example, I suspect that criticism of this kind is essential during a writer's lifetime, before canonization sets in. Kael's defects are already fading into "traits." Someday the same thing will happen to Sontag: "her personal arrogance and her humorlessness" will level off into a neutral, perhaps even endearing part of her personality, because the writers who live on in literature, as I expect both Sontag and Kael to, are, almost by definition, heroes. With very few exceptions (Wagner comes to mind), we cease to care much about the personality defects of the giants who entrance us. "With genius, as with beauty—all, well almost all, is forgiven," Sontag says in *The Volcano Lover*. Beyond that: we cease to be able to *see* those defects. Only contemporaries really can.

That nod to reasonableness out of the way, I can now say: most of the attacks on Sontag and Kael I've encountered are pretty second-rate. Ninety percent of everything, as Theodore Sturgeon observed, is shit; in criticism, the percentage must be ninety-nine. Most of the attempts to knock Sontag and Kael down to size suffer from the inferiority of practically any prose to theirs. Cloddish writing goes hand in hand with cloddish thinking—if, indeed, it isn't the same thing. My favorite of all the assaults on Kael is a 1981 article that compares her invidiously with Stanley Kauffmann, citing material from their respective reviews of *The China Syndrome*. Except Kael never reviewed *The China Syndrome*. The boob who wrote the piece failed to notice that he was quoting *The New Yorker*'s other film critic, Penelope Gilliatt.

So it is that out of several hefty folders in my "Attacks" file, I find the ambush that holds up best is, surprisingly, Renata Adler's—surprisingly, because I've hated that piece of writing for more than twenty years. I've already enumerated the ways in which I think it misses. But I also have to admire the deadly cadence of Adler's sentences; she's easily the most capable of Kael's antagonists. And there's a significant level on which her blitz remains resoundingly legitimate. Adler keeps trying to put her finger on what it is she dislikes about Kael, but she can't pinpoint it, because it's . . . *everything*. She just can't stand her. And that's where criticism begins. Call it sensibility or call it taste, we embrace what we love and trash what we loathe; but the response—the recoil—comes first. In articulating her loathing, Adler gives me a better handle on my love. That makes her a real critic.

Most of the rest of this stuff is tomato throwing. It's useful as a way of tracking my subjects' careers, and the backdrop of disagreement helps bring their thought into sharper relief. But again and again, what starts out as a critical dispute turns into a slur on a critic's integrity; again and again, we're told that Sontag or Kael adopted this or that view as a means of career enhancement (often in the form of publicity), when she didn't just adopt it out of indecency. In fact, it would be difficult to find two writers who have compromised themselves less. Go ahead—name me an instance when either of them wrote something she believed to be untrue. It's a basic critical responsibility to know your enemy. Any critic who can be convinced, without hard evidence, that an opposing viewpoint stems from dishonorable motives is a lousy critic.

4

B U T I S I T A R T ?

Well, what's art? This question is one that critics of Kael, especially, tend to raise, since she has a habit of throwing the term around: "*La Femme Infidèle* isn't a failure, but it isn't a work of art, either." "*Klute* is far from a work of art, but it's a superior thriller-melodrama." "Although what they do is a formidable accomplishment in terms of current movies (and *Accident* is the best new movie around), it's too easy for art." You might reasonably concur with the commentator who demurred, "All movies are art or none are. 'Art' is not an accolade to be bestowed by each critic on his half dozen favorites."

To which Kael might reasonably reply: Why not? (And she'd bridle at that "half dozen.") To declare "All movies are art" is to deploy *art* as a generic term. Adopting this usage, claiming that Hollywood junk isn't art would be like claiming that fast food isn't food. (And to the extent that art is a human requirement, most Americans do seem content with the aesthetic equivalent of

Pizza Hut.) But that isn't how Kael typically uses the word. For her, art *is* an accolade, whose antonym is junk or trash or kitsch. Even here, though, she's inconsistent. "There is more energy, more originality, more excitement, more *art* in American kitsch like *Gunga Din, Easy Living,* the Rogers and Astaire pictures like *Swingtime* and *Top Hat,* [etc.] . . . than in the presumed 'High Culture' of *Hiroshima Mon Amour, Marienbad, La Notte, The Eclipse,* and the Torre Nilsson pictures." Well, which is it? "If debased art is kitsch," she writes farther down on the same page, "perhaps kitsch may be redeemed by honest vulgarity, may become art. Our best work transforms kitsch, makes art out of it; that is the peculiar greatness and strength of American movies." Whoa! cries the pedant: "Since Kael has never really defined either 'art' or 'kitsch,' the foregoing statements are semantically meaningless."

Oh, horseshit. The objection *might* have some legitimacy in the arena of formal philosophy, but no ordinary reader is going to be confused by the meaning of "art" in these passages or anywhere else in Kael's writing; it's always clear in the context. This is a buffoon's cavil. As usual, Kael's best defense is her own words—in this case, the masterly put-down that launches the 1962 "Is There a Cure for Film Criticism?":

Siegfried Kracauer is the sort of man who can't say "It's a lovely day" without first establishing that it *is* day, that the term "day" is meaningless without the dialectical concept of "night," that both these terms have no meaning unless there is a world in which day and night alternate, and so forth. By the time he has established an epistemological system to sup-

port his right to observe that it's a lovely day, our day has
been spoiled.

So much for establishing our right to the word. The question
remains: *Is it art?*

Tempting as it is to blurt, Good God, how could it be any-
thing *else?* it's essential to draw some distinctions between what
the critic and the artist do and how they do it. To begin with,
the artist's sole responsibility is to his or her—let's say her—
vision. The critic's *primary* responsibility is to the work of art,
though her vision (*sensibility* is probably a better word) will
frame her view of it. Glory is for artists. A critic's duty, first
and foremost, is to get it right.

Which isn't to say criticism that's wrong is valueless, or even
that greatness is out of its reach. Ruskin, espousing the nobility
of Gothic against the depravity of Renaissance styles, may be at
his greatest at his most benighted, arguing from piety and wob-
bly history. *Right* and *wrong* are, like *true* and *false,* a tar baby
in the realm of art. Sontag is fond of quoting Wilde's maxim "A
Truth in art is that whose contradictory is also true." But that
doesn't mean she's frivolous about the critic's obligations to the
truth. As she reasoned in a 1988 interview,

> If I say that Chekhov is better than Françoise Sagan, there is
> always someone who can say: "Well, that is just your opin-
> ion, how do you know? There is no way of proving it." Yet
> I am *sure* that this is *true.* I mean I would stake my life on it.
>
> Now, if just one example of this kind is true, then that
> means there is a possibility of making judgments. It does not

mean that we are not wrong sometimes but it means that it is
correct or admissible to make this kind of aesthetic judgment.

And judgment is the critic's turf. It's only the *beginning* of crit-
icism, and while most if not all criticism is built around judg-
ments of merit, they're its flimsiest component (Kael: "We read
critics for the perceptions, for what they tell us that we didn't
fully grasp when we saw the work. The judgments we can
usually make for ourselves"), except to consumers who want to
know whether to see a movie or read a book—and who even-
tually learn, if they have any discernment, that you can't trust
critics. But the requirement to judge does mean that critics have
responsibilities, and strictures, that artists don't. When Kael
says criticism is exciting "because you must use everything you
are and everything you know that is relevant," the small phrase
that is relevant is a concession to humility, an admission that
criticism doesn't have unlimited freedom to roam. Whatever
else she brings into her writing, the critic has to keep her gaze
focused on the work of art, and this willingness to place one's
talent, one's ego, at the service of the artwork is central to any
decent criticism. That's why Sontag writes novels, and why she
insists on their primacy among her books. She's never adulter-
ated her criticism with her aspirations to glory, which is one
reason the prose of her essays is so much more constrained, so
much narrower (by which the last thing I mean is less accom-
plished), than the prose of her fiction, where those aspirations
are frank. Sontag believes—and I share her conviction—that to
promote criticism as an art is to betray the purposes of criticism.

All of which may seem obvious enough. But there's a joker
in the deck, which takes the form of a glitch in the exchange

between critic and reader, to wit: what we take away from criticism isn't necessarily what the critic puts in. (Not, at least, once we reach the critical stratosphere.) While her gaze is burning into the artwork, ours may be content to linger on her response. While Sontag and Kael are laboring to do justice to what's before them, we may be drinking in the generosity, the intensity, the passion they pour into their effort. OK, OK, one of these days I fully intend to get around to *Auto-da-Fé* and *Shoeshine* and *Days and Nights in the Forest*. I know they're great. But will they really rival the high that reading Sontag and Kael on them brings me?

Kael's attitude regarding these issues is more complicated than Sontag's, for reasons that it's not hard to guess. Asked by an interviewer, "Is film criticism an art form comparable to the novel or short story?" she snapped, "Those are arbitrary and silly distinctions, sort of like worrying about whether somebody's a critic or a reviewer. Who cares?" *She* cared, as the curtness of her retort suggests. Almost everyone holds criticism at a lower value than art, as a subsidiary, even parasitic activity; in John Updike's memorable phrase, the artist sails in the open sea while the critic hangs back, hugging the shore. That isn't how I'd describe what Sontag and Kael do, and Kael wouldn't, either. "I regard criticism as an art," she said flatly in a 1963 broadcast, replying to "some extraordinarily unpleasant anonymous letters" from listeners who clearly didn't share her opinion:

> I recognize your assumptions: the critic is supposed to be rational, clever, heartless and empty, envious of the creative fire of the artist, and if the critic is a woman, she is supposed

to be cold and castrating. The artist is supposed to be delicate and sensitive and in need of tender care and nourishment. . . . My dear anonymous letter writers, if you think it so easy to be a critic, so difficult to be a poet or a painter or film experimenter, may I suggest you try both? You may discover why there are so few critics, so many poets.

"One does not set out in life to become a movie critic; it is where one ends up," John Gregory Dunne twitted Kael, with some justice—though, owing to her inspiration on younger generations, his statement is no longer true. ("But why?" a popular novelist asked me when, at nineteen, I told him my aspirations. "People don't raise statues to critics!") As a matter of fact, Kael did set out to be a more conventional artist, a playwright. Later she was content to leave her youthful plays interred ("There was probably too much soul-wrestling," she said), but she never forsook her artistic ambitions, and the brilliance of her style remains unusual, to put it mildly, among critics. But she retained her all-important critical humility. Her focus never veered from the work, even when the work was wretched; she never dismissed movies lightly (as Renata Adler thought she should have), never reduced them to occasions for a display of wit like the gentleman-critics for whom she harbored such contempt. William Shawn's *New Yorker*, though, was a place that worshipped writers, and she knew why she was there; nobody ever said she lacked self-regard. She fully appreciated her skill, and she felt it deepen, which is no doubt why her later writing is so much more self-conscious, so full of "touches." But as coruscating as the late style is, there's a pathos about her early work—a small constriction

in the prose, a hiccup of academia—that, for me, raises it above the work in which she navigates with the freedom and control of a master. The slight strain, the trace of struggle to find the words that fit her ideas, lightens her tanklike tonnage; it humanizes her. Which is to say that Kael's best writing isn't necessarily Kael's best writing.

Here once more, Sontag, with her conviction that criticism *isn't* an art, is the anti-Kael. Again and again she's said that her essays are just an adjunct to her fiction. "In early 1962 I finished my first novel, *The Benefactor*," she recounted in the introductory note to the paperback edition of *Against Interpretation*. "In late 1965 I began a second novel. The energy, and the anxiety, that spilled over into criticism had a beginning and an end." If that's what she needed to tell herself, I tell myself, fine. But I don't mean it. It shocks me that the jacket copy on her books of the past twenty years slights her critical masterpieces in favor of her fiction. "I consider my novels much more important and certainly much more interesting to me than my essays," she insisted in a 1969 interview—I doubt that anybody else did— and in 2003 she was still insisting: "I think narrative is what lasts, and I wouldn't mind if the essays eventually evaporated." *I* would. Though her publisher has done her the honor of keeping *The Benefactor* and *Death Kit* and her volume of short fiction, *I, etcetera,* in print, I'd be surprised to learn that copies fly off the shelves. Few of the literate people I know have read them, or have any desire to.

That slap out of the way, I can go on to add that the more I study Sontag's fiction, the more deeply I respect it. *The Benefactor* still eludes me; it concerns a man obsessed with his dreams, and there's not much that bores me stiffer than

dreams do. Some of it is supposed to be funny, I think, but I can't tell what. *Death Kit* is a sort of dream, too, a hallucination in the mind of a dying man, like the Ambrose Bierce story "An Occurrence at Owl Creek Bridge." But it's busy with tactile detail—it doesn't feel dreamlike. I like *Death Kit.* The revulsion against corporate values, the intoxications of sexual freedom and an anything-goes moment in the arts, and something in the quality of the prose that calls to mind black-and-white film stock bring back the sixties as sharply as a showing of *A Hard Day's Night* does. After the desiccated cleverness of *The Benefactor,* there's real feeling in the polarity Sontag constructs between Dalton "Diddy" Harron, the cultivated drone who is the novel's bland protagonist, and Angelo Incardona, the railroad worker he kills (or thinks he kills . . . don't ask), who seems to represent the revenge of animal instinct on the repressive intellect. Humbert Humbert couldn't outdo Sontag's shudder at the Incardona family's white trashiness. These people—the kind Kael might call vulgar but alive, early Jonathan Demme characters viewed with none of Demme's affection—represent everything Sontag despises. I suppose it's to her credit that she can recognize Incardona as a part of Diddy. But then all she can think of for Diddy to do is take a crowbar to him.

Still, *Death Kit* is surprisingly engaging for such a self-consciously modernist work. It even has flashes of humor, not to mention a grandeur of conception that raises it, in its final pages, from its gray-flannel story line to an epic vision of the kingdom of death. But I couldn't recommend it to a friend. Sontag skillfully gets you absorbed in the plot while at the same time setting up any reader who wants to know how it all turns out

to feel like a jerk. In a sense, she trashes her own book. This is doubtless what she meant, in her 1965 essay "Nathalie Sarraute and the Novel," by "'progress' in the arts," but to me it feels more like her description, in the same essay, of risky, experimental new works as "monstrous hulks, like abandoned tanks, lying about the landscape," and especially of *Finnegans Wake* as a novel "left to the care of academic exegetes who may decipher the book for us, but cannot tell us why it should be read or what we can learn from it."

Sontag's short fiction is even more forbidding, but it's also more rewarding. Her short stories, if you can call them that, are unvaryingly intelligent (of course), and their emotions run deep—deeper, for the most part, than in her novels—even though they don't make any attempt to satisfy those more or less basic requirements of prose fiction: character and plot. The beauty of feeling in them is more like poetic melancholy. She's said that as a young writer "poetry is the one form that I found, and continue to find, extremely daunting"; yet "Project for a Trip to China" "Debriefing," "Baby," "Unguided Tour," "Description (of a Description)," "The Letter Scene," even "The Way We Live Now" operate less like stories than like extended prose poems. Their language is both spare (in its effects) and dense (in its patterns), and it's hard to make much of them the first and sometimes the fifth time through; they seldom add up neatly even once you've found their groove. The more narrative stories—"American Spirits," "The Dummy," "Doctor Jekyll," "Old Complaints Revisited"—are, in fact, the hardest to read. Maybe it was to compensate for their more familiar technique that she made them so grating; *they're* not suffused with poetic melancholy. They're not fun, either. The

thread of plot raises expectations . . . and then they lose you.
Sontag the puritan always makes sure that nothing is free; as in
a workfare program, you get the benefits only if you commit to
the labor. Kael, reviewing a bloated remake of *Lost Horizon* in
1973, mocked the producer, Ross Hunter, by observing, "In a
sense, all his movies are lost horizons; they're for people nos-
talgic for a simpler pop culture." Sontag's fiction up through
the eighties is for people nostalgic for a simpler *high* culture.
Carefully, almost priggishly, her writing holds pop and post-
modernism at bay, which may explain its wariness toward plea-
sure.

But by the nineties, even she had to concede that the bat-
tle was over. As Cynthia Ozick lamented in her rueful and
beautiful essay of 1989, "T. S. Eliot at 101," "High art is dead.
. . . The wall that divided serious high culture from the popu-
lar arts is breached." Ozick, who is five years Sontag's senior,
knew there was no arguing with history, but she still mourned
"that golden cape of our youth, the power and prestige of
high art." Sontag has no intention of putting her own cape in
storage, and yet—always self-inventing, self-transcending—
she responded to the death of high art with a startling, and
startlingly brazen, aesthetic U-turn. *The Volcano Lover* is a
remarkable novel, part history, part essay, and part potboiler,
wildly different in approach from her fiction of even just a few
years earlier but fueled by long-standing themes: collecting
(Walter Benjamin's compulsion), feminism, and class injus-
tice. The scenes of torture and mayhem evoke real horror, the
never forgotten horror that the twelve-year-old Sontag (as
she relates in *On Photography*) experienced when, browsing in
a Santa Monica bookshop, she happened on shots of Bergen-

Belsen and Dachau and was "sharply, deeply, instantaneously" cut. The postmodern novel provided a flexible new form for her moral fervor, one loose enough to allow space for miniature essays and homilies ("Nothing is more hateful than revenge"; "Nothing is more admirable than mercy") and capacious enough to contain her passion and her rage; the book's last words are "Damn them all."

It isn't only familiar themes that link the novel with her earlier work. The volcano lover of the title, Sir William Hamilton, is very much like the protagonists of *The Benefactor* and *Death Kit*: bland and repressed. ("It may be said that I lack a sense of humor," Hippolyte, the antihero of *The Benefactor*, observes, speaking for them all.) Sontag's aversion to autobiography is a point of honor ("My urge to write is an urge not to self-expression but to self-transcendence"), but, as I've noted, that scruple doesn't keep her from being helplessly confessional. When she's writing about Sir William, whom she calls the Cavaliere, it's clear that she's also writing about herself:

His is the hyperactivity of the heroic depressive. He ferried himself past one vortex of melancholy after another by means of an astonishing spread of enthusiasms.

He is interested in everything.

Even more than wanting to be admired, he liked admiring.

Like many who were melancholy as children, he had a great capacity for self-discipline. He never refused an exertion, nor a commission that he could include in his large sense of duty, of calculation, of benevolence.

He starts to collect it, or to write about it, or both. Because of these proselytizing efforts, what no one paid attention to or liked many now find interesting or admirable.*

The Cavaliere was never bored.

To the extent that the Cavaliere is a self-portrait, though, he's an unattractive one. Sontag's volcano lover is pitifully unvolcanic himself—a cerebral connoisseur, a cold fish, honorable, admirable, and dehydrated. Only a few cognoscenti, like Sontag, even remember Sir William as a connoisseur at all. Everyone else remembers him as England's most famous cuckold.

But if this less-than-preening portrait of the intellectual hints at a nagging self-doubt, she did away with it eight years later, when she raised her next novel, *In America*, around a central character who's so magnetic, so glamorous, so gorgeous, and so appallingly self-assured that the whole world collapses at her feet. "It felt so natural to Maryna to be engulfed by admiration," Sontag writes of her heroine, the unrivaled queen of the Polish stage, circa 1876; and, elsewhere, "It's astonishing how one becomes accustomed to applause." A saloon keeper who belongs to her hordes of admirers sums it up neatly: "You're beautiful. You're a star. Everyone loves you. You can do anythin' you want." Apparently she can. The critic Michael Silverblatt has offered a scintillating reading of the novel in which he views Maryna as a monster—she even calls herself one—and he's got me convinced.

*Here she's talking about not just Sir William but also the collector in general.

But Sontag isn't entirely down on monsters. *In America* is her version of *The Tragic Muse,* a portrait of the novelist as an artist in another medium. In Maryna, an actress before whom so many barriers have fallen that the only ones left are the ones she erects for herself, she's created her most frightening portrait of the self-transcender, and Maryna's preposterous determination to make it on, of all places, the American stage parallels Sontag's determination to make it as a novelist. All the talk in the book about the will ("America: a whole country of people who believe in the will") is vintage Sontag. Heroism excites her, and the (putatively egalitarian) discomfort with heroism inflames her. As early as "Trip to Hanoi," she was complaining about "the discrediting of the heroic effort" in American society. She took up the theme again in *The Volcano Lover*:

> We feel oppressed by the call to greatness. We regard an interest in glory or perfection as a sign of mental unhealthiness. . . . We want to admire but think we have a right not to be intimidated. We dislike feeling inferior to an ideal. So away with ideals, with essences. The only ideals allowed are healthy ones—those everyone may aspire to, or comfortably imagine oneself possessing.

She isn't afraid of being a monster, if that's what it takes. A meditation on genius in the same book echoes Kael's sketch of the "major artist" as a mixture of maniac, messiah, and charlatan: "He is pretentious, overbearing, humorless, aggressive, condescending. A monster"—N.B.—"of egotism. Alas, he's also the real thing."

Hence Maryna's pull for her. Unfortunately, the lengthy catalogue of Maryna's triumphs has no dramatic intensity ("It's hard to think of an American writer with *less* dramatic sense," Kael wrote in her review of *Duet for Cannibals*), and eventually it begins to feel creepy and narcissistic. "A triumph beyond anything she could have hoped for." "The houses were always full, the ovations more prolonged and rapturous, the cohort of opulently dressed admirers . . . ever larger." "Nothing but panegyrics—the *Herald*: 'She won all hearts'; the *Times*: 'Popular Success, Artistic Triumph'; the *Tribune*: 'She is a great actress'; the *Sun*: 'Greatest actress since Rachel'; the *World*: 'Not to be missed.'" "Her success has grown like an avalanche." "The greatest actress on the American stage is a Pole." And so forth. Triumphant, yes; dramatic, no. Sontag seems to want to thrill us with Maryna's success, asking us to share her pleasure in it, but I don't. Silverblatt, who loves the book, doesn't either, exactly. His reading focuses on the extent to which Maryna turns herself into a hack, performing more and more drivel in order to win over coarse American audiences. The parallel I see here is the one that Silverblatt would never draw, but it accounts for what makes *In America* so uncomfortable to read and so alien among Sontag's works: it's the only ingratiating book she's ever written.

But even when her fiction is hitting its best and truest notes, it doesn't touch the mastery of her criticism. The confidence is missing. There's no flood of ideas; there's only the awesome will, the implacable determination to make art. "I want the essays to be as well-written and as dense as possible," she once said. "Ideally there should be a new idea in every sentence." In the fiction, there's seldom a new idea on every *page*. The

struggle isn't to channel the flood but to find the form. Maybe that's why the formal daring of her novels, stories, and scripts never feels organic to me, why she never seems quite herself—or anybody—there. The experimentation feels too willed, and so does the decision to jettison the experimentation. How many artists can you name who have radically shifted their styles in response to shifts in the culture? Sontag's fiction is reactive—a barometer of the cultural weather—and that's a hallmark of the critical, not the artistic, impulse. She has said that fiction comes much easier to her than criticism does; where the essays might go through ten or fifteen drafts (she once described the process as "making soup into a bouillon cube"), in her fiction, 80 percent is there in the first draft. I deeply distrust this profession of ease. It summons up the stern passage from *Nietzsche Contra Wagner* that, as a college freshman, I typed on an index card and taped over my desk:

> That hidden and masterful something for which we long do not have a name, until finally it proves itself to be our task—this tyrant in us wreaks horrible revenge for every attempt we make to dodge or escape it. . . . Every time, sickness is the response when we want to doubt our right to *our* task, when we begin to make things easier for ourselves in any way. Strange and at the same time terrible! It is the *easing* of our burden which we must atone most harshly.

Histrionic, I know, but it goes a long way toward explaining why it's only when Sontag turns away from her true métier, when she *sets out* to create art, that she flags as an artist. Even the finest of her novels, *The Volcano Lover*, pales next to the

real thing. The five interior monologues at the end come as a splash of cold water; I think she was daft to invoke comparisons to Joyce and Faulkner. But come on, you might object, isn't it unfair to hold *any* contemporary novelist to such a standard? Of course it's not. I wouldn't insult Sontag by holding her to any lesser one. She's earned the right to be judged in the company of masters.

And besides, a major part of the problem lies beyond her control. That's the historical situation of fiction itself. We like to think of our art forms as set in stone, but they're not. It's unnerving for those of us who grew up before the era of the VCR and the DVD to reflect that the classical motion picture, projected on a large screen in a darkened auditorium, may belong to the twentieth and early twenty-first centuries as expressly as the tragedy written in heroic couplets belonged to the Restoration. The symphony, which developed in the eighteenth century, was nearly exhausted by the middle of the twentieth. It's probably safe to say that the sonnet's great age is as finished as the LP's. And the life signs of the novel, which hasn't been a heavyweight form for three hundred years yet, aren't looking so hot. Consider, for example, a statement Sontag made in relating the circumstances that led to her writing *Illness as Metaphor*: "A narrative, it seemed to me, would be less useful than an idea." And then imagine George Eliot saying something like that. No novelist would have drawn Sontag's distinction between narrative and idea in the era when the novel was the choice *literary* vehicle for conveying ideas. Flaubert and James, with their advanced notions about art, brought the form to maturity, but the very term *maturity* implies aging, and aging implies dotage and death. I don't mean there aren't

masterpieces yet to be created. Another Pynchon is no doubt enduring a diaper change as I write these words. But the situation of the art novel today resembles the situation of the long poem a century ago: *The Waste Land* and *Howl* were among the supreme works still on the horizon, but the form no longer answered to the needs it once had, and its audience was dwindling. The rising popularity of nonfiction forms in recent years hasn't just been a matter of marketing.

If Sontag and Kael had been born a hundred years earlier, they would have put their ideas into novels. But by their time, the novel of ideas was looking shopworn. Certainly it was anathema to the Sontag who argued that "a work of art encountered as a work of art is an experience, not a statement or an answer to a question," that "the knowledge we gain through art is an experience of the form or style of knowing something, rather than a knowledge of something (like a fact or a moral judgment) in itself." When speaking of herself as an artist, she used to say things like "I have very little consciously in mind. . . . The most I could say about *Brother Carl* or *Duet for Cannibals* or about the two novels"—this was 1972—"are things I have discovered after I have finished them, often through other people's comments. The story of *Brother Carl* was born in two hours. I saw the whole situation, and I didn't reflect on it at all." She and Kael began writing in an era when the art object—the Abstract Expressionist canvas is the leading example—was a little bit embarrassed by ideas, and ideas were their pencils and paints. Art wasn't merely intimidating; art, the way these two writers thought of it, didn't offer them the proper space for bringing forth what was in them. But without the masters breathing down their necks—without the pressure

to find a voice and to find a form and to measure up to their *notion* of art—self-consciousness disappeared, and the voice, the form, and the art emerged. In criticism, Kael recalled, "I wasn't inhibited the way I was in other art forms," in which "you were struggling to express yourself, and it was altogether more painful and less entertaining for other people." Adjust her words to allow for Sontag's leeriness toward self-expression, and she speaks for them both. Once they'd cleared the hurdle of art and could get down to the business of finding the words for what they had to say, they were masters.

And they knew it. They could feel it. And their self-assurance stuck in untold craws. Hilton Kramer howled at Sontag's "stridency and militancy." Andrew Sarris fumed over Kael's "papal infallibility." That wasn't just thin skin talking. Decrying the torments that Hollywood businessmen visit on film artists, Kael once lashed out at "the hatred of those who can't for those who can"; part of the demonic energy that animates her writing and Sontag's is the scorn of those who can for those who can't. In another denunciation, Kael lambasted Stanley Kramer and his screenwriter, Abby Mann, for violating "what is perhaps the only possible basic moral code: to refuse compromise for ourselves, and to have sympathy and understanding for those who *do* compromise." She and Sontag were magnificently uncompromised, but their work isn't bursting with "sympathy and understanding." Those who can have a moral obligation toward those who can't, the obligation that Henry James articulated so beautifully when he counseled, "Three things in human life are important. The first is to be kind. The second is to be kind. And the third is to be kind." But criticism—unfortunately for the criticized—isn't human life. Notwithstanding their many

enthusiasms and their palpable delight in praising, Sontag and Kael don't deserve any awards for kindness. And that's as it should be. Niceness, in criticism, is a form of bad faith. Nature *is* red in tooth and claw, and distinguishing those who can from those who can't is the very first thing a critic has to do. Those who can't get their own back, anyway. (They become studio heads and magazine editors.) "Tactful" pans are no less damaging to artists' feelings than candid ones are, and the reader can sense their dishonesty. Crude, flat pans are something else again. It can be sickening to watch second-rate critics wielding their blunt instruments; there is, as Dryden famously noted, "a vast difference betwixt the slovenly butchering of a man, and the fineness of a stroke that separates the head from the body, and leaves it standing in its place." We've all read hatchet jobs by critics who are scandalously inferior to the artists they're judging. But there's not much you can do about critical ineptitude, other than write a letter to the editor, reassure your artist friends, and hope that the situation will improve in heaven.

I'm talking about geniuses, though, not nitwits, and geniuses, almost necessarily, *are* monsters. There's something monstrous in the titanic will it takes to produce a world-class oeuvre, not to mention the coldness it takes to pronounce somebody else's work wanting. Kael's way with a wisecrack did a lot to smooth her sharpness. So did her frequent—to my mind—errors of judgment. I hope you don't think that because I'm crazy about her writing I bought all her opinions. "Infallible taste is inconceivable," she wrote; "what could it be measured against?" If Sontag's taste seems less controversial, surely that's because she's allotted most of her criticism to Olympian work. This determination to play the admirer

is what, in her view, justifies her claiming she's not a critic: "I really do think an important job of the critic is to savage this, to say this is garbage, this is terrible, this is pernicious." So do I, but her distaste for that side of the job doesn't free her from the mantle of criticism; it just makes her a critic who doesn't do half her job. I was dismayed to find her, in looking back on *Against Interpretation* thirty years after its initial publication, repudiating the series of reviews collected under the title "Going to Theater, etc." They're wonderful reviews, and they give some indication of what she might have done if her ambition hadn't been so fastidious. For a critic to address only what she loves is as skewed as it is for her to confront only what she hates. Demolition is probably the primary critical task; to be the bad conscience of one's time, as Nietzsche charged the philosopher, has now become the critic's responsibility. In any age, and especially in an age driven by hype and wholly given over to, in Sontag's phrase, "mercantile values," *somebody* has to say no.

Fortunately, and perhaps inevitably, Sontag is a naysayer in spite of herself. For all her admirations, she has seldom regarded the state of the culture with anything other than horror. "Against Interpretation" is a denunciation of contemporary criticism; "Nathalie Sarraute and the Novel," of contemporary fiction. In the same 1966 diatribe that contains the cancer-of-history barb, she fulminates, "The quality of American life is an insult to the possibilities of human growth; and the pollution of American space, with gadgetry and cars and TV and box architecture, brutalizes the senses, making gray neurotics of most of us." Writing about Syberberg in 1979, she twice derides the present as "the era of cinema's unprecedented mediocrity."

And now she declares that we've "entered, really entered, the age of nihilism." That's doing what a critic is *supposed* to do. Kael, who subtitled the introduction to her first book "Are the Movies Going to Pieces?" did it all the time.

It's a measure of their greatness that what we take away from their work isn't the *no* but the *yes*. They fret, they recoil, they prophesy—but their enthusiasms sweep them away. No one can write great criticism without bringing so much passion to the task that she risks making a fool of herself, and God knows they've both been mocked. Robert Brustein spoke for many when he charged Kael with "press agentry"; she's still catching hell for comparing the first screening of *Last Tango in Paris* to the first performance of *Le Sacre du Printemps*. And Sontag will always be hawking the Next Big Thing in the eyes of her enemies. After the sixties, though, Sontag didn't often stand up for the disreputable the way Kael did. And even in the early essays on science fiction and camp and pornography, she is much, much cooler than Kael. Her warmth went into her fiction; none of her criticism contains the emotion of a story like "Debriefing." Kael didn't have fiction to save the best parts of herself for. Everything went into those glittering reviews. Sontag's essays don't glitter; they glimmer, with a subdued but very beautiful light. She isn't going for effects, or at least not for the big, theatrical effects that Kael relishes, and even her admirers don't often discuss her essays in terms of literary style.

Kael, in contrast, was, as I've said, a celebrated stylist, though not many of those who called her one stopped to consider the word's implications. They hailed her for being strong, smart, and funny, but it never occurred to them to call her an

artist. They had the experience, you might say, but missed the meaning. Few even among those who adored her writing recognized—and I don't believe she did, either—that what she left behind wasn't merely a body of criticism but a body of *literature*, one of the signal literary achievements of the second half of the twentieth century. Instead they were focused, understandably enough, on something more immediate: the movies, and the arguments pro and con. But Kael accomplished something that only the greatest writers achieve. She brought everything into her work. She created a cosmos; her shelf of books is her *Comédie Humaine*, her Yoknapatawpha County. When she remarked, "Aesthetic theories don't always allow for the variety of what we enjoy," when she noted, "In the arts, one can never be altogether sure that the next artist who comes along won't disprove one's formulations," she wasn't thinking about her own work. But when I read those words, I do.

Her books are as dense with characters as novels are—denser—and she handles them with a novelist's curiosity, palpating, evaluating. She became the omniscient narrator movies don't have, posing and elaborating motives with such an impassioned empathy that sometimes she drew more out of the characters than the filmmakers did. And there was a second level of characters in the actors. Marlon Brando, Katharine Hepburn, John Travolta, Diane Keaton, even poor Meryl Streep and Clint Eastwood (when she was through with them)—they were like recurring characters in a long-running serial. So were certain directors—Peckinpah, Altman. The movie review provided Kael with what the short story provides comparable artists: a workspace for the narrative intelligence. She didn't just point out the flaws in the films she wrote about. She plastered the

cracks and plugged the leaks; she gave them the elegance and the symmetry they lacked; she turned them into what they could have been. I used to wonder, with some irritation, why, in her later reviews, she took up more and more space recounting plots. Now I can see the practice for the artistic strategy it was: she was making the movies hers. By then, her allegiance had shifted, consciously or not, to her writing. Those later reviews are fully formed aesthetic objects, and the movies that occasioned them tend to drop away, like excrescences. In truth, they drop away from all her reviews. When I read Kael now, the pictures she wrote about seem like footnotes to *her* work. I've spent decades scanning newspaper listings and rep-house schedules in an effort to catch up with the films she wrote about in *I Lost It at the Movies* and *Kiss Kiss Bang Bang*; those books were the foundation of my education in film. And half my reason for going to a new movie used to be to see whether I agreed with her assessment. Since she experienced films more intensely than most of us, including filmmakers, experience anything, her review was usually better—richer, deeper—than the movie in question. Greil Marcus captured the sensation of reading her perfectly when he called it "a kind of wonder: what would it feel like to write like that—to feel that alive?" In some cases I can't even remember whether I saw a film, but I can remember her review. I always thought I was reading her to get a handle on the movies, but I had it backward: I was seeing the movies to get closer to that mind. I love movies. I still go all the time. But my first allegiance, like hers, is to words, and what captured me was her words.

And she pulled it all off within the ludicrous confines of *movie reviewing*. But maybe that's not as remarkable as it sounds at

first. Virtually all great writing flows from an initial narrowing. The most important thing a writer has to learn is what he *can't* do. Eventually he finds his subject and he finds his style and then off he goes, and we seldom miss what's not there. Sontag is an exception. She, too, has the Dickensian compulsion to grab hold of everything in the world and get it onto the page, but her refusal to settle into an approach makes her a prodigy— in the sense of wonder and in the sense of freak—among writers. She'll try anything, and she's not good at everything. Kael flourished with a consistency unmatched by any American writer since Henry James. Sontag's work is the opposite: a jumbled landscape of peaks and valleys. There's no more unity to it than there is to the world. It's amazing that a writer as self-conscious as she is has the nerve to be seen so often at less than her best. But Sontag *is* amazing, and her fearlessness is half of her genius. She isn't afraid of anything, and she certainly isn't afraid of making a fool of herself. Kael, I believe, grew more timid in her later years. Though she never lost any of her surface effrontery, she hated, *hated* being attacked—a crazy anxiety, I know, in a writer who practically lived by the motto "Make my day." One reason for treating her later reviews as autonomous works of art may have been the opportunity it gave her to retreat inside them. As she grew frailer, her work ranged less widely. It doesn't have the amplitude of Sontag's— which is why Sontag often seems to me the greater writer.

Anyone who's read this far will understand what that statement costs me. I waffle myself. And what does "the greater writer" mean, anyway? It certainly doesn't mean the *better* writer. Kael could write circles around Sontag (and her style

has been a far wider influence on younger critics). We don't judge literature by the sentence, though. We judge it by the work, and by bodies of work, and so while Sontag's work is wildly uneven and sometimes flat-out embarrassing, it's so majestic in its scope that you can't take it all in at once. Yet when it comes to making a case for criticism as art, Sontag is the more problematic of the two, since the neutrality of her language gives her essays the appearance of something art-less—pure idea. It's a ruse: she's every bit the performer that Kael is, but she's a performer who pretends not to perform, to be above performance. That isn't hypocrisy and it isn't fakery; it's the nature of her genius as a performer. "The taint of artistry," she pointed out in *Regarding the Pain of Others,* "is equated with insincerity or mere contrivance." She was discussing atrocity photographs, but the objection also applies to criticism—and so she addresses it by, in her phrase, "flying low, artistically speaking." In "The Aesthetics of Silence" she observed, "There is no talented and rigorous asceticism that, whatever its intention, doesn't produce a gain (rather than a loss) in the capacity for pleasure." Those words could be *her* motto. And if my appetite for her austerity seems to conflict with my belief that her coolness reflects a reluctance to enter fully into her criticism, as my ardor for Kael's abundance might seem to conflict with my conviction that it's a betrayal of criticism for the critic to treat it as art, I can only answer, somewhat sheepishly, that a Truth in art is that whose contradictory is also true, and that the very nature of thinking is *but.*

Sontag and Kael deal in ideas, but I don't reread them for their ideas, which I've assimilated about as well as I'm ever

going to. I reread them—and reread and reread them—for what's left over *after* their ideas. I don't know what else but art that could be. And when the art is at this level, deciding who is the greater master is really a clod's errand. I said at the beginning that I don't have to choose, and since there's no need to raise the question at all, it should be obvious that I'm bringing it up in order to do some justice at the eleventh hour to a great writer I worry I've wronged. But no matter how tender my conscience gets, I'll never have the relationship with her—as a reader, I mean—that I had with Kael. Renata Adler thought the weekly grind would wear down the hardiest critic, but her skepticism misses sight of what can happen, and *did* happen, between the right columnist and the right readers. I waited for those reviews. They lit up my week, and I can remember where I was when I read practically each one of them. Of course, I have sense-memories of Sontag's essays, too. "The Imagination of Disaster": a bed-sitting room in Notting Hill Gate; the scorching summer of 1976, a fermata between two dull years at Oxford, during which I saw practically no one, read like a fiend, and devoured several movies a day. "The Pornographic Imagination": an apartment on East 11th Street I holed up in during a blizzard in early 1978, shortly after I'd arrived in New York and before I'd found work. *On Photography*: a sixth-floor walk-up on hopelessly unhip East 65th Street, where I had a deal on a four-room shotgun; the book was a present for my twenty-sixth birthday. *AIDS and Its Metaphors*: countryside, northern California.

But there's nothing unusual about attaching memorable reads to a place and a time. With Kael it's different: rereading

her work from beginning to end as I set out to write this volume, I saw my own life passing. It was like the experience she describes at the beginning of "Movies on Television":

> The plane circled above the San Francisco area, and spread out under me were the farm where I was born, the little town where my grandparents were buried, the city where I had gone to school, the cemetery where my parents were, the homes of my brothers and sisters, Berkeley, where I had gone to college, and the house where at that moment, while I hovered high above, my little daughter and my dogs were awaiting my return. It was as though my whole life were suspended in time—as though no matter where you'd gone, what you'd done, the past were all still there, present, if you just got up high enough to attain the proper perspective.

Seeing ectoplasmic old movies on TV awakened the same feelings in her; that's the subject of her essay. For me, the past is still there, present, when I read her reviews. Here, for example, is "The Come-Dressed-as-the-Sick-Soul-of-Europe Parties." And there I am, a high-school junior at a former military academy that felt like a jail, chortling at it in bed after lights-out; a film fanatic I'd met the previous summer had sent me *I Lost It at the Movies*. The dilapidated paperback, its front cover detached, is next to me now as I write. (The front cover has separated from my copy of *Against Interpretation*, too.) Here's "Raising Kane," and I'm spellbound in Room 1, the empty classroom that served as the office of the school newspaper and a clubhouse for disaffected literary types. Here's the review of

McCabe and Mrs. Miller that I read in a *New Yorker* purchased
in the Monroe, Louisiana, airport, on my way to I don't know
where—Atlanta, probably. The review of *The Trojan Women*
I read on a sunny October morning out behind Tressider
Union at Stanford; my *New Yorker* subscription was a gift
from Morty and Carol Raphael, long dead now. *A Clockwork
Orange*: a group from the dorm drove into San Francisco to see
the movie, and when we returned, elated, I dived for *The New
Yorker* and read Kael's review aloud; her hostility silenced us.
And her extravagant praise for *The Godfather*: I saw the movie
on a trip to L.A. with the same group of friends; afterward we
huddled in a 7-Eleven, poring over her excited words. I don't
remember whether we were too impatient to take the magazine
out to the car or, more probably, just too cheap to pay for it.
Here's *Nashville*: Palo Alto, spring, and I'm packing up. Here's
the Cary Grant profile I read that summer at my cousin's mod-
est apartment in Nashville; she lives in a mansion now. And
the reviews that came out during my two years at Oxford: of
Smile, a movie Kael effervesced about in a talk I heard her give
at the National Film Theatre, in London, where I spent a lot
of hours; of *The Man Who Would Be King*, which I read in a
stationery shop, instantly resolving to see the film, which I still
haven't done; the essay "Notes on Evolving Heroes, Morals,
Audiences," which I read on one of several trips to Paris to visit
a friend who had a job as an au pair, a woman I haven't spoken
to in years. The review of *Star Wars* and *The Truck* (with its
surprising delicacy of feeling for Marguerite Duras), which I
read back in Louisiana in what had once been my sister's bed-
room, because my father, beginning his years of illness, had

taken over the bedroom my brother and I used to share. And the reviews of *Coming Home* and *Blue Collar*, which mark my move to New York; and of *Fingers* and *The Fury*, published after I'd landed a job as a typist at *The New Yorker*, which, of course, meant only one thing to me. I remember the first time I caught sight of Pauline, buzzing down the hall (she really did seem to quiver with a current) on her way to Shawn's office, galleys in hand. And our first conversation, in her tiny office; immediately afterward, I reconstructed it word for word. (I have no idea where I've put those pages.) And if you were a writer and you met an articulate twenty-five-year-old who was so enraptured with your work that he could quote it better than you could, wouldn't you think he was a fine young man, too?

Here's the review of Cheech and Chong's *Up in Smoke*. One Sunday morning Pauline phoned me at my apartment on East 65th Street: could I come into the office and type up her manuscript? She was one of those people who have no qualms about asking for favors—she didn't type, and she didn't drive. You can imagine my alacrity, since all that the pool ordinarily typed for her was envelopes for her responses to letters from readers. It's the only first draft of hers I've ever seen, written in pencil in her rather clumsy hand on, as I recall, yellow sheets of legal paper, and, for all the editing and self-editing it would get, it was polished enough to have gone straight into print. "Pauline," I reminded her gently when I was done, "I got promoted. I'm not a typist anymore." "I know," she told me, just as gently.

As a fact-checker, I did my best to nab her columns before anybody else could lay claim to them, and the other check-

ers were nice about it, mostly. Here's the spate of reviews I checked: *Get Out Your Handkerchiefs, Midnight Express, The Stunt Man, The Elephant Man.* . . . Sometimes she'd seek reassurance about her word choices or her titles. She always wanted to know your opinion of the picture. One of the bonuses of checking her reviews was going to the movies to verify details; I saw *Urban Cowboy, Popeye,* and *Altered States* at Times Square matinees, happy to be out of the office.

Here's her review of *Atlantic City.* Pauline took me to a screening and then out to dinner, to say good-bye; I was moving out west. The movie put us into a wonderful mood, and that evening I fulfilled an ambition by finally getting a line into one of her columns: as we were walking out, I compared Robert Goulet's appearance to a Bill Murray routine from *Saturday Night Live;* Pauline said, "Wait a minute" and scribbled what I'd said on her steno pad. ("It's like an epic-size Bill Murray routine" is what she later wrote.) I'd brought along two of her books for her to inscribe—her most recent, *When the Lights Go Down,* which contained pieces I had checked, and my ratty old paperback of *I Lost It at the Movies,* in which she wrote these perfect words: "Craig—I'm touched by how worn it is."

Here are the reviews that came out during the year I lived in Portland, Oregon, writing, writing. Her excitement over *Blow Out* had me at the first Portland showing, where I met a strange, gaunt, prodigiously well-read man who was there for the same reason; he and I saw dozens of movies together, and when the gravel-voiced grandmother he was living with expired—he'd moved to Portland to help her out during her final years—we packed our stuff and drove down to San Francisco together. He died of AIDS a few years later. I read Pauline on *Tales*

of Ordinary Madness and *The Right Stuff* and *The Bostonians*
in the group apartment I shared near the corner of Haight
and Ashbury Streets; a happy time. Here's the review of *Stop
Making Sense* that so dazzled Silvana when he read it in bed, in
our Mission District flat, not long after we moved in together.
Secret Honor: he and I were visiting New York. We met Pauline
and several of her friends after the *Secret Honor* screening, and
at dinner Sil sat next to her; they bonded over salad greens,
ridiculous as that sounds. The *Shoah* review: Pauline was in San
Francisco, and she told me, shaking with fury, that Shawn was
holding it, the first time he'd done such a thing. The review of
The Secret of My Success, with its small, nice nod to our actress
friend Carol Ann Susi, which thrilled her. And the review of
The Unbearable Lightness of Being, a movie that, Pauline and I
later agreed, we loved so much we'd find it hard to feel as we
had about friends who didn't, though the truth was we both had
adored friends who were cool to it and our feelings about them
didn't change at all.

Here's her short, enthusiastic review of *Hairspray,* one of
a handful of movies that, when I had a half-time job as a sec-
ond-string movie critic for *The San Francisco Examiner,* we
both wrote about. And her review of *The Adventures of Baron
Munchausen,* the only one I ever thought went on for too long;
she later said she felt the same way. And *Casualties of War,*
which we talked about on another of her trips to San Francisco;
we were walking through the Academy of Sciences in Golden
Gate Park with Gina and Gina's small son, Will, and Pauline's
passion for the film was so raw that I think in this one instance
I might have dissembled if I'd had a low opinion of it. And then
the reviews that came out after I'd moved back to New York: of

GoodFellas, The Grifters, Reversal of Fortune (I ran into Pauline at the 57th Street movie house where it was playing), *Dances with Wolves* (with the crack "Costner has feathers in his hair and feathers in his head" that, unfortunately for Kevin Costner, got quoted and quoted in her obituaries). And her last review, published in the February 11, 1991, issue of *The New Yorker,* where I was doing a six-week return stint in the checking department; and though it wasn't that long ago, I can't remember whether I checked it or someone else did.

After Pauline stopped writing, I wasn't the only one of her readers who went into withdrawal, but I had the privilege of getting my fix from the source. On three-day weekends, Sil and Elvis and I would drive up to her sprawling hilltop house in the Berkshires. She adored Elvis, a black-and-white terrier who is, like her, from Petaluma, a distinction I may have pointed out too often. For the first few years of her retirement, we'd go out to movies (we were always escorting her to the summer block-busters; coming out of *Independence Day*—or was it *Twister?*—she said, "Why does every movie you see have to be like the first movie you ever saw?") and to the excellent local restaurants. As she grew feeble, we stuck around the house more and cooked and watched the tapes of new movies that directors and publicists were always sending her. She got weaker, rallied, got worse. I began work on this book, and she made a highly uncharacteristic effort to be gracious toward Sontag; when the essay "Where the Stress Falls" appeared in *The New Yorker* in June 2001, she phoned to tell me she thought it was the best thing Sontag had ever written. (I didn't.) I went up the following month to spend a week helping out Gina, who was fairly frazzled by this time from caring for her mother. I was

reading *When the Lights Go Down,* and I feared I had too much Pauline in my head. It was warm in the house, and I would sit on her bed, which by then she no longer wanted to leave, with Elvis between us, just shooting the breeze. I'd reached "Fear of Movies," one of the few things she ever wrote that I dislike, and I regretted that we couldn't talk about it. She made only one request regarding the book, and it was really less a request than a piece of advice. She said, "Keep it short."

Postscript

I NEVER DID MEET SONTAG. She died a few months after this book was first published—and thirty years after her doctors told her she had cancer and her days were numbered.

Her life had a gratifying last act. She finally achieved the control that had been missing in her speeches and essays of the Vietnam era and matured into a political writer of power and substance. At the end her unflinching moralism both fueled and balanced her fury at the policies of an American government once again waging a mad and futile war, this time in Iraq. In a 2003 speech honoring Israeli soldiers who were refusing to serve in the Occupied Territories, she cited the resonance of Thoreau's example, which had "not ceased to inspire principled resistance to injustice" even though his famous night in jail for refusing to pay the poll tax had "hardly stopped" the Mexican War. "The likelihood that your acts of resistance cannot stop the injustice," she exhorted her audience, "does not exempt

you from acting in what you sincerely and reflectively hold to be the best interests of your community." A few months later, in accepting the Peace Prize of the German Book Trade (at a ceremony from which the American ambassador was conspicuously absent), she said,

> A writer, I think, is someone who pays attention to the world. That means trying to understand, take in, connect with, what wickedness human beings are capable of; and not be corrupted—made cynical, superficial—by this understanding.

Finally, in May 2004 she published an essay on the photographs that American soldiers had taken of themselves tormenting and humiliating their charges in the Abu Ghraib prison outside Baghdad, pictures whose dissemination had shocked the world and deeply embarrassed the Bush administration. Rhetorically, "Regarding the Torture of Others" surpasses even the splendid 2003 essay to which its title marks it as a pendant. It grows out of a despondency over the country and its leaders at one with the disaffection she'd been enunciating since the 1960s:

> All acts are done by individuals. The issue is not whether a majority or a minority of Americans performs such acts but whether the nature of the policies prosecuted by this administration and the hierarchies deployed to carry them out makes such acts likely.
>
> Considered in this light, the photographs are us.

The entire essay recalls, in its horror and disgust, the pivotal moment she described in *On Photography* when, as a girl of

twelve, she happened on her first lacerating pictures of the concentration camps. But there's more than horror and disgust. Reassuming the mantle of the thinker and aesthete she'd worn in *On Photography* and (even more astutely) in *Regarding the Pain of Others* affords her a crucial distance. Insight balances fury; understanding neither corrupts nor makes cynical:

> Looking at these photographs, you ask yourself, How can someone grin at the sufferings and humiliation of another human being? Set guard dogs at the genitals and legs of cowering naked prisoners? Force shackled, hooded prisoners to masturbate or simulate oral sex with one another? And you feel naive for asking, since the answer is, self-evidently, People do these things to other people. Rape and pain inflicted on the genitals are among the most common forms of torture. Not just in Nazi concentration camps and in Abu Ghraib when it was run by Saddam Hussein. Americans, too, have done and do them when they are told, or made to feel, that those over whom they have absolute power deserve to be humiliated, tormented.
>
> Even more appalling, since the pictures were meant to be circulated and seen by many people: it was all fun.

Fun: a startling word, peculiarly alien to this writer's universe.

The quality of the prose has also changed because the quality of the anger has changed. In the era of Vietnam, her frantic rage was motivated by a frantic need: to *do something*—to stop the war. And the urgency of the need implied a hope, a shred of hope: Something *could* be done. The war *could* be stopped. But by 2004 the United States had become a society very differ-

ent from what it had been during even the ugliest years of the Vietnam era, and the rage smoldering underneath every one of Sontag's sentences is a different order of rage: a rage without hope. Speaking out, speaking angrily no longer has a goal so simple as stopping the war, since "the Bush administration has committed the country to a pseudo-religious doctrine of war, endless war—for 'the war on terror' is nothing less than that."

"The torture of prisoners is not an aberration." "The photographs are us." These are despairing words. But despair isn't really a Sontagian emotion. It's worth noting that *endless war*, the phrase she keeps hammering at with such disquieting control, carefully avoids the easy, even useful echo of Orwell's *permanent war*; the conditions of *1984* don't exactly apply to the situation in Iraq. It's worth further noting that such care with words implies the opposite of despair. The very act of writing implies the opposite of despair. I was amazed to learn that when Sontag wrote this last great, judgmental essay, she had already been hospitalized with the cancer that would finally kill her.

Notes

Books by Susan Sontag

The Benefactor (novel). New York: Farrar, Straus and Company, 1963.

Against Interpretation and Other Essays. New York: Farrar, Straus and Giroux, 1966.

Death Kit (novel). New York: Farrar, Straus and Giroux, 1967.

Styles of Radical Will (essays). New York: Farrar, Straus and Giroux, 1969.

Duet for Cannibals (screenplay). New York: Noonday Press/Farrar, Straus and Giroux, 1970.

Brother Carl (screenplay). New York: Noonday Press/Farrar, Straus and Giroux, 1974.

On Photography (essays). New York: Farrar, Straus and Giroux, 1977.

Illness as Metaphor (essay). New York: Farrar, Straus and Giroux, 1978.

I, etcetera (short fiction). New York: Farrar, Straus and Giroux, 1978.

Under the Sign of Saturn (essays). New York: Farrar, Straus and Giroux, 1980.

A Susan Sontag Reader. New York: Farrar, Straus and Giroux, 1982.

AIDS and Its Metaphors (essay). New York: Farrar, Straus and Giroux, 1989.

The Way We Live Now (short story). New York: Noonday Press/Farrar, Straus and Giroux, 1991.

The Volcano Lover (novel). New York: Farrar, Straus and Giroux, 1992.

Alice in Bed (play). New York: Farrar, Straus and Giroux, 1993.

In America (novel). New York: Farrar, Straus and Giroux, 2000.

Where the Stress Falls (essays). New York: Farrar, Straus and Giroux, 2001.
Regarding the Pain of Others (essay). New York: Farrar, Straus and Giroux, 2003.

BOOKS BY PAULINE KAEL

I Lost It at the Movies. Boston: Atlantic Monthly Press/Little, Brown, 1965.
Kiss Kiss Bang Bang. Boston: Atlantic Monthly Press/Little, Brown, 1968.
Going Steady. Boston: Atlantic Monthly Press/Little, Brown, 1970.
The Citizen Kane Book (containing Kael's essay "Raising Kane" and Herman J.
 Mankiewicz and Orson Welles's shooting script of *Citizen Kane*). Boston:
 Atlantic Monthly Press/Little, Brown, 1971.
Deeper into Movies. Boston: Atlantic Monthly Press/Little, Brown, 1973.
Reeling. Boston: Atlantic Monthly Press/Little, Brown, 1976.
When the Lights Go Down. New York: Holt, Rinehart and Winston, 1980.
5001 Nights at the Movies (capsule reviews). New York: Holt, Rinehart and
 Winston, 1982; revised and expanded, 1991.
Taking It All In. New York: Holt, Rinehart and Winston, 1984.
State of the Art. New York: E. P. Dutton, 1985.
Hooked. New York: E. P. Dutton, 1989.
Movie Love. New York: E. P. Dutton, 1991.
For Keeps. New York: E. P. Dutton, 1994.

INTERVIEWS WITH SONTAG AND KAEL

Conversations with Susan Sontag. Edited by Leland Poague. Jackson: University
 Press of Mississippi, 1995.
Conversations with Pauline Kael. Edited by Will Brantley. Jackson: University Press
 of Mississippi, 1996.
Afterglow: A Last Conversation with Pauline Kael. By Francis Davis. Cambridge,
 Mass.: Da Capo Press, 2002.

All page numbers for books by Sontag and Kael refer to the first editions listed
above, except where noted. The fastidious reader should be warned that in quoting
I've freely changed uppercase to lower, and vice versa, to suit my sentences.

1

2 "When I use harsh words": Friedrich Nietzsche, second postscript to *The Case
 of Wagner*, in *Basic Writings of Nietzsche*, ed. and trans. Walter Kaufmann
 (New York: Modern Library, 1992), p. 642.

3 nothing like the need: Arthur Lubow, "Pauline Kael," *People*, April 18, 1983, p. 55.

Sontag objects to the term: *Conversations with Susan Sontag*, p. 176.

4 "Filmed plays": "Filmed Theatre" (review of *The Sea Gull*), in *Going Steady*, p. 230.

"what motion picture art": "Is There a Cure for Film Criticism?" in *I Lost It at the Movies*, p. 276.

"Who cares whether": ibid.

5 "there is no reason": "Theatre and Film," in *Styles of Radical Will*, pp. 102 and 106.

"Sometimes I feel": *Conversations with Susan Sontag*, p. 245.

"No one who loves": "Simone Weil," in *Against Interpretation*, p. 51.

"Still another use": "The Aesthetics of Silence," in *Styles of Radical Will*, p. 20.

"Artaud changed": "Approaching Artaud," in *Under the Sign of Saturn*, p. 42.

"When I denounced": "Thirty Years Later . . . ," in *Where the Stress Falls*, pp. 272–273.

6 "Seriousness has become her ruling passion": Lionel Trilling, introduction to *The Princess Casamassima*, by Henry James (New York: Macmillan, 1948); reprinted in *The Liberal Imagination* (New York: Viking, 1950), and in *The Moral Obligation to be Intelligent: Selected Essays*, ed. Leon Wieseltier (New York: Farrar, Straus and Giroux, 2000), p. 176.

"I couldn't persuade": "Zeitgeist and Poltergeist; or, Are the Movies Going to Pieces?" in *I Lost It at the Movies*, p. 26.

"*Faces* has the": "The Corrupt and the Primitive" (review of *Faces*), in *Going Steady*, p. 199.

"When he tried": "Nicholson's High" (review of *The Last Detail*), in *Reeling*, p. 272.

"Wise brings": "Kaputt" (review of *The Hindenburg*), in *When the Lights Go Down*, p. 120.

"Representations of Americans": Kael, "Movies, the Desperate Art," in *The Berkley Book of Modern Writing*, vol. 3, ed. William Phillips and Philip Rahv (New York: Berkley Publishing, 1956), p. 201; reprinted in Daniel Talbot, ed., *Film: An Anthology* (Berkeley: University of California Press, 1959), p. 68. Regrettably, the essay isn't in any of Kael's collections.

"the Great work": "Syberberg's Hitler," in *Under the Sign of Saturn*, p. 138.

"I do find": "What's Happening in America (1966)," in *Styles of Radical Will*, p. 199.

7 "The new-style": "Notes on 'Camp,'" in *Against Interpretation*, p. 289.

"How can you embrace": "What's Wrong with This Picture?" (review of *Another Woman*), in *Movie Love*, p. 16.

"There's no vulgar": "Busybody" (review of *Silkwood*), in *State of the Art*, p. 110.

"Vulgarity is not": "A Bagel with a Bite out of It" (review of *Fiddler on the Roof*), in *Deeper into Movies*, p. 327.

"I don't trust": "Notes on Heart and Mind," in *Deeper into Movies*, p. 232.

"I think the sense": introduction to "Notes on 280 Movies," in *Kiss Kiss Bang Bang*, p. 227.

8 Kael more insistently: See, for example, *Conversations with Pauline Kael*, p. 8; "Notes on Heart and Mind," in *Deeper into Movies*, pp. 230–238.

"How can they": "Circles and Squares," in *I Lost It at the Movies*, p. 313.

"I'm an incorrigible puritan": *Conversations with Susan Sontag*, p. 86.

interview with a Polish periodical: Leland Poague and Kathy A. Parsons, *Susan Sontag: An Annotated Bibliography, 1948–1992* (New York: Garland Publishing, 2000), pp. 286–287 (entry F62).

9 how *to* live: See, for example, *Afterglow: A Last Conversation with Pauline Kael*, p. 34.

"And if it be": "So Off-Beat We Lose the Beat," in *Kiss Kiss Bang Bang*, p. 21.

"Ours is indeed": "The Imagination of Disaster," in *Against Interpretation*, p. 224.

"a gladness": "An Argument About Beauty," *Dædalus*, fall 2002, p. 21.

10 "The color is black": *Under the Sign of Saturn*, p. 105.

"Movies on Television": in *Kiss Kiss Bang Bang*, pp. 217–226.

"sensory stimulants," "sensuous material": "Marat/Sade/Artaud," in *Against Interpretation*, p. 171.

loved the way Roland Barthes: "Writing Itself: On Roland Barthes," in *Where the Stress Falls*, p. 76.

"a bookish girl from a bookish family": quoted in Studs Terkel, *Hard Times: An Oral History of the Great Depression* (New York: Random House, 1986), p. 35.

11 first movie review: "Some Notes On Chaplin's *Limelight*," *City Lights* 3 (spring 1953), pp. 55–58. The review isn't in any of Kael's collections, but it has been reprinted in *The Oxford American* (spring 1992), pp. 52–53, and in *Artforum* (March 2002), pp. 123–124.

"When I started": *Conversations with Pauline Kael*, p. 113.

"San Francisco is like": quoted in Phillip Lopate, "The Passion of Pauline Kael," in *Totally, Tenderly, Tragically: Essays and Criticism from a Lifelong Love Affair with the Movies* (New York: Anchor Books, 1998), p. 236 (originally published as "The Lady in the Dark," in *New York Woman* [summer 1989]).

"I had come": *Conversations with Pauline Kael*, p. 12.

12 "The first few": ibid., pp. 155, 156.

"It is 'knowing'": "Morality Plays Right and Left," in *I Lost It at the Movies*, p. 325 n.

"the trap of": "Notes on Heart and Mind," in *Deeper into Movies*, p. 231.

"It doesn't even": Dwight Macdonald, *Against the American Grain* (New York: Random House, 1962), p. 4.

13 "the distinction between": "One Culture and the New Sensibility," in *Against Interpretation*, pp. 302, 303.

Godard *and*: ibid., p. 304.

"Whom could it": "The Sound of . . . ," in *Kiss Kiss Bang Bang*, p. 177. The italics are Kael's.

14 wanted to talk about movies the way people talk about them leaving the theater: *Afterglow: A Last Conversation with Pauline Kael*, p. 46.

"No one has *ever*": John Bennet made his remarks at a memorial for Kael at the Walter Reade Theater in New York City on November 30, 2001; I'm grateful for his permission to quote them. See Mark Feeney, "A Fitting Farewell for a Celluloid Hero," *Boston Globe*, December 1, 2001, pp. G-1, G-5, for a report on the memorial.

15 "I don't play": Oscar Wilde, *The Importance of Being Earnest*, opening of Act 1.

16 "When I was nine": "Pilgrimage," *The New Yorker*, December 21, 1987, p. 44.

"long prison sentence": ibid., p. 38.

17 "If hedonism": "One Culture and the New Sensibility," in *Against Interpretation*, pp. 302–303.

"*the* art of the": "Syberberg's Hitler," in *Under the Sign of Saturn*, p. 138.

18 "A country in": "Psychoanalysis and Norman O. Brown's *Life Against Death*," in *Against Interpretation*, p. 257.

19 "Society allows": Sontag, "The Double Standard of Aging," *Saturday Review*, September 23, 1972, p. 36.

"Wrinkles and creases": Leslie Garis, "Susan Sontag Finds Romance," *New York Times Magazine*, August 2, 1992, p. 21. In the article, "floe" is spelled "flow."

20 support of Salman Rushdie: See, for example, Sontag, "From the Testimony of Susan Sontag Before the Subcommittee on International Terrorism, Senate Foreign Relations Committee, 8 March 1989," in *The Rushdie File*, ed. Lisa Appignanesi and Sara Maitland (London: Fourth Estate, 1989), pp. 166–168.

21 "the levelling of": *Conversations with Susan Sontag*, p. 239.

22 "I find myself": ibid., p. 240.

"The very nature": ibid., p. 111.

"If the mainstream": ibid., p. 239.

All of her writing: ibid., p. 240.

self-transcendence: ibid., p. 204.

"The poet was": *The Volcano Lover*, p. 150.

23 "the hypertrophy": "Against Interpretation," in *Against Interpretation*, p. 7.

The Manchurian Candidate and *Charade*: See, for example, "Zeitgeist and Poltergeist," in *I Lost It at the Movies*, pp. 24, 26.

"Thus Smith's": the original wording is in "A Feast for Open Eyes," *The Nation*, April 13, 1964, p. 375; the revised version is in "Jack Smith's *Flaming Creatures*," in *Against Interpretation*, p. 229.

"I think in treating": "Zeitgeist and Poltergeist," in *I Lost It at the Movies*, p. 19.

24 Goody Two-Shoes: "Pilgrimage," *The New Yorker*, December 21, 1987, p. 42.

"The moral pleasure": "On Style," in *Against Interpretation*, p. 24.

"Our response to": ibid., p. 25.

25 "the canonical example": *Regarding the Pain of Others*, p. 102.

Robert Bresson: "Spiritual Style in the Films of Robert Bresson," in *Against Interpretation*, pp. 177–195.

Danilo Kiš: "Danilo Kiš," in *Where the Stress Falls*, pp. 92–96.

Adam Zagajewski: "The Wisdom Project," in *Where the Stress Falls*, pp. 49–62.

"making forays": "The Pornographic Imagination," in *Styles of Radical Will*, p. 45.

26 "to suppress": "America, Seen Through Photographs, Darkly," in *On Photography*, p. 40.

"Life is not about": "Melancholy Objects," in *On Photography*, p. 81.

"a garbage-strewn": ibid., pp. 68–69.

"an ecology not": "The Image-World," in *On Photography*, p. 180.

27 "The best writing on": "The Heroism of Vision," in *On Photography*, p. 107.

"an ideology that": "The Literary Criticism of Georg Lukács," in *Against Interpretation*, p. 90.

she downplays the political effectiveness: See "In Plato's Cave," in *On Photography*, pp. 19–21.

28 dedicated "Notes on 'Camp'" to Oscar Wilde: *Against Interpretation*, p. 277.

"a deep sympathy": ibid., p. 276.

quarreled with some of the notions: *Regarding the Pain of Others*, pp. 104 ff.

"transforming," as she simply says: ibid., p. 76.

"There isn't going to": ibid., p. 108.

questioned the idea that image saturation makes us callous: ibid., p. 105.

"Let the atrocious": ibid., p. 115.

29 "Trash, Art, and the Movies": in *Going Steady*, pp. 85–129.

"one of the dozen": "Notes on 280 Movies" (capsule review of *Olympiad*), in *Kiss Kiss Bang Bang*, p. 323.

the hell she goes through: See, for example, Joan Acocella, "The Hunger Artist," *The New Yorker*, March 6, 2000, pp. 75, 76.

"I am perfectly": *Conversations with Susan Sontag*, p. 176.

30 "as a man": "The Artist as Exemplary Sufferer," in *Against Interpretation*, p. 42.

"a man flogging": "Michel Leiris' *Manhood*," in *Against Interpretation*, p. 67.

"a consciousness in": "The Pornographic Imagination," in *Styles of Radical Will*, p. 61.

"philosophy becomes": "'Thinking Against Oneself': Reflections on Cioran," in *Styles of Radical Will*, p. 80.

"Trip to Hanoi": in *Styles of Radical Will*, pp. 205–274.

31 "I'm temperamentally incapable": "Pauline Kael on the Fun of Writing Disrespectfully," Salon.com, March 16, 2000, available at http://dir.salon.com/books/log/2000/03/16/nbcc/index.html.

obsessional: *Conversations with Susan Sontag*, p. 176.

"It's very difficult": *Conversations with Pauline Kael*, p. 81.

"Dirty Harry" pictures: see her reviews of *Dirty Harry* ("Saint Cop," in *Deeper into Movies*, pp. 285–388), *Magnum Force* ("Killing Time," in *Reeling*, pp. 251–256), *The Enforcer* ("Harlan County," in *When the Lights Go Down*, pp. 253–255), and *Sudden Impact* ("Vanity, Vainglory, and Lowlife," in *State of the Art*, pp. 120–121).

"sheer pounding": "Urban Gothic," in *Deeper into Movies*, p. 317.

"It is, I think": ibid.

"implicitly saying": "Stanley Strangelove" (review of *A Clockwork Orange*), in *Deeper into Movies*, p. 377.

32 "as the seventies": *For Keeps*, p. xxii.

33 "my worst flaw": ibid.

"react to the incineration": *Reeling*, pp. xii–xiii.

"the placidity": *When the Lights Go Down*, p. 428.

"They've lost": ibid., p. 432.

"What does it mean": ibid., p. 437.

34 When Renata Adler brought out her furious attack: Renata Adler, "House Critic," in *Canaries in the Mineshaft: Essays on Politics and Media* (New York: St. Martin's Press, 2001), p. 325 (originally published as "The Perils of Pauline," *New York Review of Books*, August 14, 1980).

35 "The sexual transmission": *AIDS and Its Metaphors*, p. 26.

36 Wilde's proposition: Oscar Wilde, preface to *The Picture of Dorian Gray*.

"case studies": note to the paperback edition of *Against Interpretation*, p. viii.

"I'm frequently": introduction to *For Keeps*, p. xxii.

"I was very proud": "*Hud*, Deep in the Divided Heart of Hollywood," in *I Lost It at the Movies*, p. 88.

gazing down from an airplane: "Movies on Television," in *Kiss Kiss Bang Bang*, p. 217

37 "When *Shoeshine*": *I Lost It at the Movies*, p. 114. The ellipsis is Kael's.

38 "not a true melancholic": *Under the Sign of Saturn*, p. 164.

"One can be inspired": ibid., p. 68.

"I came into the": quoted by Sontag in the book's title essay, ibid., p. 111.

"Slowness is one": ibid., pp. 114, 117.

39 "That idea of": *Conversations with Susan Sontag*, p. 205.

"The process of": "Under the Sign of Saturn," in *Under the Sign of Saturn,* p. 117.

"If this melancholy": ibid., p. 120.

"learning was a form": ibid., p. 127.

"to learn everything": ibid., p. 187.

40 "an obsession whose": ibid.

"I remember what": *Conversations with Susan Sontag,* p. 195.

"He liked finding": "Under the Sign of Saturn," in *Under the Sign of Saturn,* p. 121.

"Benjamin's propensity": ibid., p. 122.

"Was there ever a": "Tourist in the City of Youth" (review of *Blow-Up*), in *Kiss Kiss Bang Bang,* p. 31.

"When I see something": from the manuscript (which Kael gave me) of Hal Espen's interview with Kael, which ran in *The New Yorker*'s issue of March 21, 1994, and is reprinted in *Conversations with Pauline Kael.* The remark didn't make it into the final version.

41 "will tend to avoid": "Writing Itself: On Roland Barthes," in *Where the Stress Falls,* pp. 66, 67.

"not because they're": *Conversations with Susan Sontag,* p. 8.

"writers are professional": Sontag, ed., introduction to *The Best American Essays 1992* (New York: Ticknor and Fields, 1992), p. xviii.

"what is most": "Under the Sign of Saturn," in *Under the Sign of Saturn,* p. 123.

42 the terms Schiller devised: Friedrich von Schiller, *On Naive and Sentimental Poetry* (1795–1796).

"We're not only": "Trash, Art, and the Movies," in *Going Steady,* p. 115.

43 "beneath the dignity": "Under the Sign of Saturn," in *Under the Sign of Saturn,* p. 130.

"debunking forays": "Remembering Barthes," in *Under the Sign of Saturn,* p. 170.

"So wholehearted": "Mind as Passion," in *Under the Sign of Saturn,* p. 182.

"All of his work": ibid., p. 192.

"evangelical zeal": *AIDS and Its Metaphors,* p. 13.

44 "Somebody says": *Conversations with Susan Sontag,* p. 121.

"quixotic": *AIDS and Its Metaphors,* p. 14; "Mind as Passion," in *Under the Sign of Saturn,* p. 192.

"Illness is the night-side": *Illness as Metaphor,* p. 3.

45 "The white race": ibid., p. 85; and "What's Happening in America (1966)," in *Styles of Radical Will,* p. 203.

"romanticizing": *Illness as Metaphor,* p. 36.

"The exemplary modern": "The Pornographic Imagination," in *Styles of Radical Will,* p. 45.

"The view of cancer": *Illness as Metaphor*, p. 48.

"I don't write": "Susan Sontag," in *Women Writers at Work: The "Paris Review" Interviews*, ed. George Plimpton (New York: Modern Library, 1998), p. 404 (interview originally published as "Susan Sontag: The Art of Fiction CXLIII," in *Paris Review*, 137 [winter 1995]).

"by focussing": "Pilgrimage," *The New Yorker*, December 21, 1987, p. 40.

46 "The metaphors and": *AIDS and Its Metaphors*, p. 14.

"*Illness as Metaphor* is not": ibid., pp. 14–15.

autobiographical elements: *Conversations with Susan Sontag*, p. 124.

47 "If I had to choose": "Thirty Years Later . . . ," in *Where the Stress Falls*, pp. 270–271.

"Rock & roll really": *Conversations with Susan Sontag*, p. 115.

"there was this total": ibid.

48 the Supremes, Dionne Warwick, and the Beatles: "One Culture and the New Sensibility," in *Against Interpretation*, pp. 303–304.

interested in everything: e.g., "Homage to Halliburton," in *Where the Stress Falls*, p. 258.

"Who at some point": *Going Steady*, p. 115.

49 "culture without pop": Leonard Quart, "'I Still Love Going to the Movies': An Interview with Pauline Kael," *Cineaste* 25, no. 2 (2000), p. 13.

"pastry pensées": *Hooked*, p. 428.

"Kundera was more": ibid.

50 "I don't think *The Conformist*": "The Poetry of Images," in *Deeper into Movies*, p. 273.

"inhuman pride": "Louis Malle's Portrait of the Artist as a Young Dog" (review of *Murmur of the Heart*), in *Deeper into Movies*, p. 308.

"He keeps us conscious": "Doused" (review of *The Last Wave*), in *When the Lights Go Down*, p. 535.

"She has no natural": "Busybody" (review of *Silkwood*), in *State of the Art*, p. 107.

"Meryl Streep imitates": ibid.

51 "the purpose of art": "One Culture and the New Sensibility," in *Against Interpretation*, p. 303.

more like an epileptic seizure: "The Pornographic Imagination," in *Styles of Radical Will*, p. 57.

"the ascendancy of": "Thirty Years Later . . . ," in *Where the Stress Falls*, p. 273.

"If art isn't": *Conversations with Pauline Kael*, p. 90.

"Having one's sensorium": "One Culture and the New Sensibility," in *Against Interpretation*, p. 303.

"an instrument for": ibid., p. 296.

"The seriousness of": ibid., pp. 302–303.

"Art is the army": ibid., p. 100.

52 "The behavior AIDS": *AIDS and Its Metaphors*, pp. 78–79.
"I thought I *liked*": Joan Acocella, "The Hunger Artist," *The New Yorker*, March 6, 2000, p. 75.
"I didn't like": ibid., p. 70.

53 "Samson Raphaelson is": Kael, introduction to *Three Screen Comedies by Samson Raphaelson* (Madison: University of Wisconsin Press, 1983), p. 19.

2

55 "The Matthew Arnold notion": "One Culture and the New Sensibility," in *Against Interpretation*, pp. 299–300.
"For we are what": ibid., p. 300.
"outraged humanists": ibid.

56 "It is humanism": *Conversations with Susan Sontag*, p. 251.
"the freedoms I": "Thirty Years Later . . . ," in *Where the Stress Falls*, p. 269.
"The judgments of": ibid., p. 273.
"When we championed": quoted in Paul Schrader, "Fruitful Pursuits," *Artforum* (March 2002), p. 129.
"a disinterested endeavour": Both this and the following quotation are from Arnold's 1864 essay "The Function of Criticism at the Present Time," fourth paragraph from the end.
wisdom project: "Susan Sontag," in *Women Writers at Work: The "Paris Review" Interviews*, ed. George Plimpton (New York: Modern Library, 1998), p. 394 (interview originally published as "Susan Sontag: The Art of Fiction CXLIII," in *Paris Review*, 137 [winter 1995]).
"If I must describe": "The Idea of Europe (One More Elegy)," in *Where the Stress Falls*, p. 286.

57 gazed with serenity: See, for example, his 1878 essay "Equality."
"the speed at which": note to the paperback edition of *Against Interpretation*, p. viii.
"were all the readers": "Susan Sontag at Washington University, April 24, 1984," *River Styx* (St. Louis), 17 (1985), p. 9.
"*NIETZSCHE*": Richard Howard, "A Description of 'Description (of a Description),'" in *Facing Texts: Encounters Between Contemporary Writers and Critics*, ed. Heide Ziegler (Durham, N.C.: Duke University Press, 1988), p. 149.

58 "Of course, I *could*": "Trip to Hanoi," in *Styles of Radical Will*, p. 224.
"Someday perhaps": Sontag, preface to *Writing Degree Zero*, by Roland Barthes (New York: Hill and Wang, 1968), p. xxi.
"not taking the arts": *Conversations with Pauline Kael*, p. 117.

59 "It's Only a Movie": in David C. Stewart, ed., *Film Study in Higher Education* (Washington, D.C.: American Council on Education, 1966), pp. 127–144. The essay isn't in any of Kael's collections.

Auschwitz commandant: *Regarding the Pain of Others*, p. 102.

"priestly" aims: "The Aesthetics of Silence," in *Styles of Radical Will*, p. 8.

60 "upholding one standard": "'Thinking Against Oneself': Reflections on Cioran," in *Styles of Radical Will*, p. 82.

"a freelance explorer": "The Pornographic Imagination," in *Styles of Radical Will*, p. 45.

"The republic of": "A Poet's Prose," in *Where the Stress Falls*, p. 4.

"the happy accident": "Against Interpretation," in *Against Interpretation*, p. 12.

"In primitive societies": "Notes on Evolving Heroes, Morals, Audiences," in *When the Lights Go Down*, p. 199.

61 "As soon as an artist": "On the Future of Movies," in *Reeling*, p. 327.

second thoughts: "Fascinating Fascism," in *Under the Sign of Saturn*, p. 97.

62 "Art that seemed": ibid., p. 98.

"Today's America": "What's Happening in America (1966)," in *Styles of Radical Will*, p. 194.

63 "After America was": ibid., p. 195.

"An integral part": Sontag, "Some Thoughts on the Right Way (for Us) to Love the Cuban Revolution," *Ramparts*, April 1969, p. 18.

"the honesty to see": *Kiss Kiss Bang Bang*, p. 53.

"We are bumpkins": ibid.

64 "When we in the audience": *When the Lights Go Down*, pp. 8–9.

"John Schlesinger in": "On the Future of Movies," in *Reeling*, p. 326.

"The camera makes": "Melodrama/Cartoon/Mess," in *Movie Love*, pp. 243, 245.

"The left can be": "Marriages" (review of *High Hopes*), in *Movie Love*, p. 88.

65 her objections to Arnold's definition: "One Culture and the New Sensibility," in *Against Interpretation*, pp. 299–300.

"Ours is a culture": "Against Interpretation," in *Against Interpretation*, pp. 13–14.

"the psychopathology of affluence": ibid., p. 289.

66 "To observe in": "Trip to Hanoi," in *Styles of Radical Will*, p. 255.

"A capitalist society": "The Image-World," in *On Photography*, pp. 178–179.

"One set of messages": *AIDS and Its Metaphors*, pp. 76–77.

67 "to incite people to buy more": "The Double Standard of Aging," *Saturday Review*, September 23, 1972, p. 31.

"a commercialized society": "Spoofing" (review of *Cat Ballou*), in *Kiss Kiss Bang Bang*, p. 29.

"want some meaning": ibid., p. 28.

"without a few": "Notes on Heart and Mind," in *Deeper Into Movies*, p. 232; see also *Conversations with Pauline Kael*, p. 48.

"What Marxists and": "Rhapsody in Blue" (review of *Diva*), in *Taking It All In*, p. 330.

68 "Those who don't": "Trip to Hanoi," in *Styles of Radical Will*, p. 224.

"They didn't even": *Conversations with Pauline Kael*, p. 113.

"And you, I suppose": KPFA broadcast, December 5, 1962. Kael long thought the tapes of her KPFA broadcasts had been wiped, but late in her life she came into possession of eight of them.

69 "deeply conservative": "Flag Nag," in *Taking It All In*, p. 284.

"There's a flag-waving": ibid., p. 286.

"This foursquare": ibid.

"The United States has": "Image Makers," in *State of the Art*, p. 77.

"Now and then, people": Sontag, "The Third World of Women," *Partisan Review*, 40 (summer 1973), p. 205.

70 "how difficult it is": "Replying to Listeners," in *I Lost It at the Movies*, p. 229.

"when this woman": "Families" (review of *Crimes of the Heart*), in *Hooked*, p. 234.

"*oooee*—she's": "Nannies and Noncoms" (review of *Gardens of Stone*), in *Hooked*, p. 306.

"a stunning actress and": "Mother, Husband, Brother" (review of *The Grifters*), in *Movie Love*, p. 286.

"degradation of": "Fantasies of the Art-House Audience," in *I Lost It at the Movies*, p. 36.

71 "I don't know who": *Conversations with Pauline Kael*, p. 185.

"an arch, high-strung": "Winging It" (review of *Billy Jack*), in *Deeper into Movies*, p. 341.

"You look at the sheer": "Creamed," in *When the Lights Go Down*, pp. 166–167.

72 "The obligation to": *Alice in Bed*, a note on the play, p. 113.

"The sensibility of": Angela McRobbie, "The Modernist Style of Susan Sontag," *Feminist Review* 38 (summer 1991), p. 8.

73 feels so much freer: "Susan Sontag at Washington University," p. 10.

"Most women who": Sontag, "Third World of Women," p. 206.

"Mary McCarthy has always": *Kiss Kiss Bang Bang*, p. 96.

74 "a woman who spends": Sontag, "Double Standard of Aging," p. 34.

"his narrow shoulders": "Celebrities Make Spectacles of Themselves" (review of *Wild 90*), in *Going Steady*, p. 15.

"In a nonrepressive": Sontag, "Third World of Women," p. 189.

75 "The liberation of women": ibid., p. 199.

proposals for female subversion: ibid., p. 196.

"The modern 'nuclear'": ibid., p. 201.

as Adrienne Rich suggested: Adrienne Rich, letter in "Feminism and Fascism: An Exchange," *New York Review of Books*, March 20, 1975, p. 31.

76 "Like all capital moral truths": Sontag, reply to Rich in ibid., pp. 31–32.

"The very nature": *Conversations with Susan Sontag,* p. 111.

"I dislike *The Stepford Wives*": "Male Revenge," in *Reeling,* pp. 444–446.

77 "Though the older": "Movies in Movies," in *Deeper into Movies,* p. 295.

"The affectation of *Lumière*": "This Is My Beloved," in *When the Lights Go Down,* p. 233.

78 "A few generations": "Doused," in *When the Lights Go Down,* p. 534.

"The white race": "What's Happening in America (1966)," in *Styles of Radical Will,* p. 203.

79 "*Salt* wasn't a strike": "Morality Plays Right and Left," in *I Lost It at the Movies,* p. 344.

"I tried to put my": *Conversations with Pauline Kael,* p. 161.

"an honest atheist": KPFA broadcast, March 14, 1962.

"Although he may": "*L'Avventura,*" in *I Lost It at the Movies,* p. 149.

80 "It is one of the": Jed Perl, "A Quarter Century with Kael," *Yale Review* 81, no. 2 (April 1993), p. 101.

"I expect I'll get": KPFA broadcast, March 14, 1962.

John Milius: See her reviews of *Jeremiah Johnson* ("Star Mutations," pp. 87–88), *The Life and Times of Judge Roy Bean* ("Unfair," pp. 98–100), and *Magnum Force* ("Killing Time," pp. 251–256), all in *Reeling.*

Clint Eastwood: See her reviews of the "Dirty Harry" pictures—*Dirty Harry* ("Saint Cop," in *Deeper into Movies,* pp. 285–388), *Magnum Force* ("Killing Time," in *Reeling,* pp. 251–256), *The Enforcer* ("Harlan County," in *When the Lights Go Down,* pp. 253–255), and *Sudden Impact* ("Vanity, Vainglory, and Lowlife," in *State of the Art,* pp. 120–121)—as well as of *Tightrope* ("Tight Little Thriller," in *State of the Art,* pp. 238–240) and *Heartbreak Ridge* ("The Good, the So-so, and the Ugly," in *Hooked,* pp. 246–247).

"narcissistic jingoism" of Sylvester Stallone: "Extremes" (review of *Rambo: First Blood Part II*), in *State of the Art,* p. 375.

"There's a strong element": "Mythologizing the Sixties," in *When the Lights Go Down,* p. 405.

81 "let us say roughly": "Some Notes on Chaplin's Limelight," *City Lights* 3 (spring 1953), p. 52; reprinted in *The Oxford American* (spring 1992), p. 52, and in *Artforum* (March 2002), p. 123.

"sometimes bad movies": "So Off-Beat We Lose the Beat," in *Kiss Kiss Bang Bang,* p. 21.

"prosperous, empty": "The Glamour of Delinquency," in *I Lost It at the Movies,* p. 45.

"when everybody was": "Hysterics" (review of *Twilight Zone—The Movie*), in *State of the Art,* p. 20.

"represent the voice": Kael, "Movies, the Desperate Art," in *The Berkley Book of Modern Writing,* vol. 3, ed. William Phillips and Philip Rahv (New York:

Berkley Publishing, 1956), p. 201; reprinted in Daniel Talbot, ed., *Film: An Anthology* (Berkeley: University of California Press, 1959), p. 65.

"When the delinquent": "The Glamour of Delinquency," in *I Lost It at the Movies*, p. 46.

82 "Our economic system": ibid., p. 61.

"It's a social lie": ibid.

"The morally awakened": Kael, "Movies, the Desperate Art," p. 61.

"When a choice": "Answers to a Questionnaire," in *Where the Stress Falls*, p. 297.

83 "How effective": Kael, "Movies, the Desperate Art," p. 62.

"real democratic disease": ibid., p. 63.

"Some editorial writers": "Everyday Inferno," in *Reeling*, p. 169.

"Films do not suffer": Kael, "Movies, the Desperate Art," pp. 63–64.

84 "The movies of the thirties": "After Innocence," in *Reeling*, p. 161.

85 corrupt industry had turned into a profit-making formula: ibid., p. 163.

"cut-rate pessimism": "America, Seen Through Photographs, Darkly," in *On Photography*, pp. 48, 47.

"When movie after movie": "After Innocence," in *Reeling*, p. 163.

86 "We will never know": ibid., p. 168.

"A few decades": *Reeling*, p. xiv.

"I had a very enjoyable": *Conversations with Susan Sontag*, p. 266.

"I was practically thirty": Joan Acocella, "The Hunger Artist," *The New Yorker*, March 6, 2000, p. 73.

identified herself as a Trotskyist: So I was told by Kael's college roommate, at lunch after the Kael memorial on November 30, 2001. For more on Kael's college years, see Terkel, *Hard Times*, pp. 346–347.

apostle of the new: The phrase isn't mine, but I can no longer locate the page where I came across it. My embarrassed apologies to the writer who coined it.

"frizzy-haired Jewish girl": "Three," in *Reeling*, p. 175.

87 "the spirit of the hysterical": ibid., p. 177.

88 "Communist propaganda takes": "Morality Plays Right and Left," in *I Lost It at the Movies*, p. 342.

"I, for one, feel": Sontag, "We Are Choking with Shame and Anger," in *Teach-Ins: U.S.A.: Reports, Opinions, Documents*, ed. Louis Menashe and Ronald Radosh (New York: Frederick A. Praeger, 1967), p. 349.

"flag-waving Legionnaires": "Trip to Hanoi," in *Styles of Radical Will*, p. 267.

"a place which": ibid., p. 259.

"Ever since my": Sontag, untitled essay in *¡Viva Che!: Contributions in Tribute to Ernesto "Che" Guevara*, ed. Marianne Alexandre (London: Lorrimer, 1968), p. 106.

"The fact that theaters": Sontag, "Posters: Advertisement, Art, Political Artifact, Commodity," introduction to *The Art of Revolution*, by Dugald Stermer (New York: McGraw-Hill, 1970), p. xviii.

89 "Viva Fidel": ibid., p. xxiii.

"Damn them all": *The Volcano Lover*, p. 419.

"I live in an unethical": "Trip to Hanoi," in *Styles of Radical Will*, p. 224.

Keats's remark: John Keats, letter to George and Georgiana Keats, March 19, 1819.

90 "It was not so clear": Michiko Kakutani, "For Susan Sontag, the Illusions of the 60's Have Been Dissipated," *New York Times*, November 11, 1980, p. C-5.

"played at being": Sontag, "The Meaning of Vietnam," *New York Review of Books*, June 12, 1975, p. 24.

"accept the fact": *Conversations with Susan Sontag*, pp. 102, 101.

91 "to stake out": Sontag, "Communism and the Left," Town Hall address, reprinted in *The Nation*, February 27, 1982, pp. 230–231, as well as in "The Hard Lessons of Poland's Military Coup," *Los Angeles Times*, February 14, 1982, p. IV-2, and (without her permission) in "Radical Will (and Testament)," *Soho News*, February 16, 1982, p. 13. A headnote in *The Nation* (p. 229) gives the variant about the *Reader's Digest*. The *L.A. Times* gives Sontag's official version; the *Soho News* gives, in somewhat truncated form, what she actually said, presumably because it was taken from notes or a recording.

92 disgruntled responses: "Comments," *The Nation*, February 27, 1982, pp. 231–237; "Susan Sontag's God That Failed," *Soho News*, March 2, 1982, pp. 10–13, 42–43. Sontag's response to the responses: "Reply," *The Nation*, February 27, 1982, pp. 237–238.

"I knew what I was doing": Charles Ruas, "Susan Sontag: Past, Present and Future," *New York Times Book Review*, October 24, 1982, p. 11.

93 "She clearly had": Julius Jacobson, "Reflections on Fascism and Communism," in *Socialist Perspectives*, ed. Phyllis Jacobson and Julius Jacobson (Princeton, N.J.: Karz-Cohl Publishing, 1983), p. 135.

94 "Led from museums": "Questions of Travel," in *Where the Stress Falls*, p. 282.

95 "Sontag has a trying": John Simon, "From Sensibility Toward Sense," in *The Sheep from the Goats: Selected Literary Essays of John Simon* (New York: Weidenfeld & Nicolson, 1989), p. 22 (a review of *Under the Sign of Saturn* originally published in *The New Leader*, December 15, 1980).

"Criticism is an art": "Circles and Squares," in *I Lost It at the Movies*, p. 295.

96 "I'm still digging my way": *Conversations with Susan Sontag*, p. 210.

"The disconnect between": *The New Yorker*, September 24, 2001, p. 32.

97 explained she'd been in Berlin: David Talbot, "The 'Traitor' Fires Back" (interview with Sontag), Salon.com, October 16, 2001, available at http://archive.salon.com/news/feature/2001/10/16/susans/.

"moral obtuseness": Charles Krauthammer, "Voices of Moral Obtuseness," *Washington Post,* September 21, 2001, p. A-37.

"moral idiocy": John Podhoretz, "America-Haters Within," *New York Post,* September 19, 2001, p. 37.

"I wanted to walk barefoot": Rod Dreher, "Painful to Live in Stricken N.Y.," *New York Post,* September 20, 2001, p. 9.

TV news program *Nightline:* Todd Gauziano, discussion on *Nightline,* ABC Television Network, October 3, 2001.

"It's not my thing": Talbot, "The 'Traitor' Fires Back."

98 "I cry every morning": ibid., p. 2.

99 accepting the Jerusalem Prize: Sontag, "The Conscience of Words" (acceptance speech for the Jerusalem Prize), *Los Angeles Times Book Review,* June 10, 2001, pp. 12–13.

likened to San Francisco: *Conversations with Susan Sontag,* p. 270.

one of its two still functioning theaters: "Waiting for Godot in Sarajevo," in *Where the Stress Falls,* p. 300.

100 "To protest the sincerity": ibid., p. 319.

lament for Bosnia: "'There' and 'Here,'" in *Where the Stress Falls,* pp. 323–329.

"morosely depoliticized intellectuals": "Waiting for Godot in Sarajevo," in *Where the Stress Falls,* p. 328.

"who don't want": ibid., p. 324.

"When they became political": "Raising Kane," in *The Citizen Kane Book,* sec. 10, p. 27.

101 "You find that": "Waiting for Godot in Sarajevo," in *Where the Stress Falls,* p. 324.

"The condescending": ibid., pp. 301–302.

"Perhaps I felt that": ibid., p. 313.

three pairs of Vladimirs and Estragons: ibid., pp. 305–306, 311–313.

102 known to take legal action: James Knowlson, *Damned to Fame: The Life of Samuel Beckett* (New York: Simon and Schuster, 1996), pp. 607–611.

"And we'd have to be": "Flag Nag," in *Taking It All In,* p. 286.

"a genuine bisexuality": Sontag, "Third World of Women," p. 189.

"before the advent": "On Paul Goodman," in *Under the Sign of Saturn,* p. 9.

"I don't talk about": Zoë Heller, "The Life of a Head Girl," *Independent on Sunday Review* (London), supplement, September 20, 1992, p. 12. The ellipsis is in the original.

103 "the new culture ruled": "Gombrowicz's *Ferdydurke,*" in *Where the Stress Falls,* p. 104.

"That I have had": Acocella, "The Hunger Artist," p. 74.

104 "One is an intellectual": "Answers to a Questionnaire," in *Where the Stress Falls,* p. 296.

"I suspect there was": "On Paul Goodman," in *Under the Sign of Saturn,* p. 9.

"The artist offers": Marcel Proust, "Madame Swann at Home," in *Within a Budding Grove*, trans. Terence Kilmartin (New York: Random House, 1981), vol. 1, p. 601.

"I don't think of": *Conversations with Susan Sontag*, p. 245.

105 "Somewhere along": ibid., p. 129.

"Compassion is an": *Regarding the Pain of Others*, pp. 101–102.

106 "I don't write": "Susan Sontag," in *Women Writers at Work*, p. 404.

said that a woman who hadn't been called: "Creamed," in *When the Lights Go Down*, pp. 166–167.

107 inhuman: e.g., "Notes on Heart and Mind," in *Deeper into Movies*, p. 232.

refuse to read reviews of her work: "Susan Sontag," in *Women Writers at Work*, p. 395.

3

109 "cheerfully eclectic": Irving Howe, "The New York Intellectuals," in *Selected Writings 1950–1990* (San Diego: Harcourt Brace Jovanovich, 1990), p. 250 (originally published in *Commentary*, October 1968).

"in favor of creamy": ibid., p. 275.

110 "It cares nothing for": ibid., p. 273.

The Liberal Imagination: Sontag speaks of her regard for Lionel Trilling in *Conversations with Susan Sontag*, p. 190, and in "Susan Sontag," in *Women Writers at Work: The "Paris Review" Interviews*, ed. George Plimpton (New York: Modern Library, 1998), p. 391 (interview originally published as "Susan Sontag: The Art of Fiction CXLIII," in *Paris Review*, 137 [winter 1995]).

111 "the hypertrophy of": "Against Interpretation," in *Against Interpretation*, p. 7.

lesser, coarser than those we get from literature: See, for example, "Notes on Heart and Mind," in *Deeper into Movies*, pp. 230–238.

"If you think movies": "It's Only a Movie," in David C. Stewart, ed., *Film Study in Higher Education* (Washington, D.C.: American Council on Education, 1966), p. 137.

"there is, in a sense": "One Culture and the New Sensibility," in *Against Interpretation*, p. 303.

modish: For example, in John Bayley, "Against a New Formalism," in *The Word in the Desert: The Critical Quarterly Tenth Anniversary Number*, ed. C. B. Cox and A. E. Dyson (London: Oxford University Press, 1968), p. 65; Emile Capouya, "The Age of Allegiance" (review of *Styles of Radical Will*), *Saturday Review*, May 3, 1969, p. 29.

"an obsessive modishness": Richard Freedman, review of *Against Interpretation*, *Kenyon Review*, 28 (November 1966), p. 709.

"The recent appearance": ibid.

112 "That's a forbidding": Alexander Cockburn, "Press Clips," *Village Voice,* October 11, 1983, p. 21.

"cultivating her image": Carol Iannone, "At Play with Susan Sontag," *Commentary,* February 2001, p. 56.

Andrew Sarris and John Simon are the only writers: See, for example, Andrew Sarris, "The Queen Bee of Film Criticism," *Village Voice,* July 2–8, 1980, p. 30; and John Simon, "The Great Pop Critic," *Reverse Angle: A Decade of American Films* (New York: Clarkson N. Potter, 1982), p. 435.

"a consistently extreme": Capouya, "The Age of Allegiance," p. 29.

"aesthetic detachment": Elisabeth Stevens, "Miss Camp Herself" (review of *Against Interpretation*), *New Republic,* February 19, 1966, p. 26; "autistic": sic.

113 "one of the most important": Hilton Kramer, "The Evolution of Susan Sontag," *New York Times* Sunday "Arts and Leisure" section, February 9, 1975, p. D–31.

"To call Leni Riefenstahl's": "On Style," in *Against Interpretation,* p. 25.

"in 'Fascinating Fascism' she writes as if": Hilton Kramer, "Susan Sontag: The Pasionaria of Style," in *The Twilight of the Intellectuals: Culture and Politics in the Era of the Cold War* (Chicago: Ivan R. Dee, 1992), p. 231 (a review of *A Susan Sontag Reader* originally published in *The Atlantic Monthly,* September 1982).

"the context has": "Fascinating Fascism," in *Under the Sign of Saturn,* p. 98.

114 "untroubled aesthetic": Kramer, "The Evolution of Susan Sontag," p. D–1.

"one case among many": Kramer, "The Pasionaria of Style," p. 225.

"the whole ethos of moral": ibid., p. 223.

"'Notes' spoke for fun": ibid., p. 228.

115 "one cheats oneself": "Notes on 'Camp,'" in *Against Interpretation,* p. 287.

"Why should we deny": "Movies on Television," in *Kiss Kiss Bang Bang,* p. 222.

"I am strongly drawn": "Notes on 'Camp,'" in *Against Interpretation,* p. 276.

"This hint of a disclaimer": Kramer, "The Pasionaria of Style," p. 229.

"Whereas formalism attempts": ibid., pp. 227–228.

116 "A work of art, so far": "On Style," in *Against Interpretation,* p. 26.

"in a kind of split level way": Sontag, quoted in Charles Jencks, "Recent American Architecture: Camp–Non Camp," in *Modern Movements in Architecture* (Garden City, N.Y.: Anchor Press/Doubleday, 1973), p. 209.

when he writes about her politics: See, for example, Hilton Kramer, "Anti-Communism and the Sontag Circle," *New Criterion,* September 1986, pp. 1–7; and Hilton Kramer, "In Sarajevo, False Echoes of Spain," *Wall Street Journal,* August 24, 1993, p. A-14.

"spiritual bankruptcy of the": Hilton Kramer, "Postmodern: Art and Culture in the 1980s," in *The Revenge of the Philistines: Art and Culture, 1972–1984* (New York: Free Press, 1985), p. 10 (originally published in *The New Criterion,* September 1982).

117 "It severed the link": ibid., p. 8.

"Miss Camp Herself": Stevens, "Miss Camp Herself."

I haven't allowed": *Conversations with Susan Sontag*, p. 186.

"corruption of standards": Kramer, "Postmodern," p. 7.

"the pulling-down of critical hierarchies": Iannone, "At Play with Susan Sontag," p. 55.

"the vanished world": ibid., p. 58.

"once-provocative argument": Stephen Farber, "Why Do Critics Love Trashy Movies?" *American Film*, April 1981, p. 66.

118 "She is a lively writer": Simon, "The Great Pop Critic," p. 435.

"Intelligent writing": Richard Gilman, "Pauline Kael Lost It All at the Movies," *Village Voice*, June 7, 1976, p. 40.

"This critical game": John Podhoretz, "She Lost It at the Movies," *American Scholar* (winter 1989), p. 121.

"Her critical values": Richard Schickel, "The Perils of Pauline" (review of James Harvey's *Movie Love in the Fifties*), *Los Angeles Times Book Review*, November 18, 2001, p. 9.

"admiration and respect": *I Lost It at the Movies*, p. v.

119 "Movies are, happily": ibid., p. 244.

"The hell with that": Dwight Macdonald, *Dwight Macdonald on Movies* (Englewood Cliffs, N.J.: Prentice-Hall, 1969), p. 474.

"some comprehension, disdain": Stanley Kauffmann, "Focus on Criticism," *Harper's*, June 1965, pp. 116, 114.

"Notes on the Auteur Theory in 1962": by Andrew Sarris, originally published in *Film Culture*, 27 (winter 1962–1963); reprinted in Andrew Sarris, *The Primal Screen: Essays on Film and Related Subjects* (New York: Simon and Schuster, 1973), pp. 38–53, and in Gerald Mast and Marshall Cohen, eds., *Film Theory and Criticism* (New York: Oxford University Press, 1974), pp. 500–515.

"just simple discrimination": "Circles and Squares," in *I Lost It at the Movies*, p. 313.

120 "Poor misguided Dostoyevsky": ibid., pp. 295, 302.

"It is an insult": ibid., p. 300.

"She certainly seems": Andrew Sarris, "Why Doesn't Richard Gilman Love Pauline Kael Anymore?" *Village Voice*, June 21, 1976, p. 122.

"She can outdo": Stephen Farber, "The Concise Pauline Kael," *New York Times Book Review*, November 14, 1982, p. 20.

121 "The main argument of": *Movie* Editorial Board, "Correspondence and Controversy: *Movie* vs. Kael," *Film Quarterly* 17, no. 1 (fall 1963), p. 58.

"Isn't the anti-art": "Circles and Squares," in *I Lost It at the Movies*, pp. 318–319.

"She seems to think she can": *Movie* Editorial Board, "Correspondence and Controversy: *Movie* vs. Kael," p. 61.

122 "If I had wished": Kael, "Correspondence and Controversy: Criticism and Kids' Games," *Film Quarterly*, 17, no. 1 (fall 1963), p. 62.

"The Auteur Theory and the Perils of Pauline": by Andrew Sarris, *Film Quarterly* 17, no. 4 (summer 1963), pp. 26–33.

"a lady critic with": Andrew Sarris, *The American Cinema* (New York: E. P. Dutton, 1968), p. 26.

"I was no match": Andrew Sarris, "Auteurism Is Alive and Well and Living in Argentina," *Film Comment*, July-August 1990, p. 20.

"I've always been a little": *Conversations with Pauline Kael*, p. 135.

"I can only *suspect*": "Circles and Squares," in *I Lost It at the Movies*, p. 305 n.

123 "The phone rang": Sarris, "Queen Bee," pp. 1, 30.

"homophobic innuendoes": Andrew Sarris, "Pauline and Me: Farewell, My Lovely," *New York Observer*, September 17, 2001, p. 19.

"assiduous self promotion": Sarris, "Queen Bee," pp. 30, 31, 70.

"I can't say I": Sarris, "Pauline and Me," p. 19.

"Raising Kane": Page numbers for "Raising Kane" refer to *The Citizen Kane Book*. "Raising Kane" is also available in a less cumbersome British volume, *Raising Kane and Other Essays* (London: Marion Boyars, 1996).

124 "I felt there was nothing": *Conversations with Pauline Kael*, p. 13.

"Orson Welles: There Ain't No Way": In *Kiss Kiss Bang Bang*, pp. 196–202.

"the one great creative": ibid., p. 200.

"blatant bias against Welles": Andrew Sarris, "Citizen Kael vs. *Citizen Kane*," in *The Primal Screen: Essays on Film and Related Subjects* (New York: Simon and Schuster, 1973), p. 132 (originally published in four issues of *The Village Voice*: April 15, April 29, May 27, and June 3, 1971).

"an excuse to lower": ibid., p. 112.

"malignant anti-auteurism": ibid., p. 123.

"Orson Welles is not significantly": ibid., p. 113.

"Though Mankiewicz provided": "Raising Kane," sec. 19, pp. 52–53.

125 "cinema is the work": ibid., sec. 3, p. 8.

"The director should": ibid., sec. 27, pp. 74–75.

"had a vitalizing": ibid., p. 74.

"There are monsters": ibid., sec. 12, p. 32.

"a director who cares": "Fear of Movies," in *When the Lights Go Down*, pp. 430–431.

"Welles often shows": Sarris, "Citizen Kael vs. *Citizen Kane*," p. 131.

"set off the most impassioned": Robert L. Carringer, preface to *The Making of Citizen Kane* (Berkeley: University of California Press, 1996), p. ix.

126 "Cleaning up after": quoted in Peter Bogdanovich, "The Kane Mutiny," *Esquire*, October 1972, p. 190.

as Sarris points out: Sarris, "Citizen Kael vs. *Citizen Kane*," p. 113.

"He has lived all": "Raising Kane," sec. 30, p. 84.

"perhaps the one American": ibid., sec. 1, p. 3.

127 "It isn't a work of": ibid., pp. 4–5.

"What most other critics": Sarris, "Citizen Kael vs. *Citizen Kane*," p. 127.

"Pop Gothic": "Raising Kane," sec. 19, p. 53.

"*kitsch* redeemed": ibid., sec. 26, p. 74.

"a *shallow* masterpiece": ibid., sec. 1, p. 4.

"he was free to": ibid., sec. 27, p. 74.

"Welles has the approach": "Orson Welles: There Ain't No Way," in *Kiss Kiss Bang Bang*, p. 199.

128 "I would argue that": "Raising Kane," sec. 26, p. 74.

"The mystery in *Kane*": ibid., sec. 1, p. 5.

"The assumption of": ibid., sec. 21, p. 61.

"It is both a limitation": ibid., sec. 25, pp. 72–73.

"he took the Mankiewicz": ibid., sec. 22, p. 62.

129 "One of the great things": *Afterglow: A Last Conversation with Pauline Kael*, p. 34.

"Sontag's real motive": Colin L. Westerbeck, Jr., "On Sontag," *Artforum*, April 1978, p. 58.

"to refute photography": Dru Shipman, "Sontag on Photography," *Afterimage*, January 1975, p. 4.

"She has spent four": Westerbeck, "On Sontag," p. 57.

130 "She doesn't see": ibid., p. 60.

"It is only in": Shipman, "Sontag on Photography," p. 4.

131 "It was important": "Under the Sign of Saturn," in *Under the Sign of Saturn*, p. 133.

132 "the authority of high": George P. Elliott, "High Prophetess of High Fashion," *TLS*, March 17, 1978, p. 304.

"a prisoner of": Alfred Kazin, "Sontag Is Not a Camera," *Esquire*, February 1978, p. 51.

"There is no evidence": Michael Lesy, "An Unacknowledged Autobiography," *Afterimage*, January 1978, p. 5.

"Reading her on film": John Gregory Dunne, "Pauline," in *Quintana and Friends* (New York: E. P. Dutton, 1978), p. 152.

"Only the skilled": C. S. Lewis, *A Preface to Paradise Lost* (1942; reprint, London: Oxford University Press, 1961), p. 11.

133 "There is a standard": "Replying to Listeners," in *I Lost It at the Movies*, p. 231.

"Does Sontag actually": Westerbeck, "On Sontag," p. 56.

"fiction": Bogdanovich, "The Kane Mutiny," p. 188.

134 "Susan Sontag, refusing": Marvin Mudrick, "Susie Creamcheese Makes Love Not War," *Harper's*, February 1982, p. 62.

135 "dithers and bungles on": ibid., p. 63.

136 "Both statements illustrate": *A Susan Sontag Reader*, p. 329.

"I'm afraid you don't": Mudrick, "Susie Creamcheese," p. 64.

137 "It took me many dutiful": "Off With the Statues' Heads!" (review of *de Sade*), in *Deeper into Movies*, p. 18.

"she's usually winging it": Mudrick, "Susie Creamcheese," p. 62.

"something that hits her": ibid., p. 64.

138 "piece by piece, line by line": Renata Adler, "House Critic," in *Canaries in the Mineshaft: Essays on Politics and Media* (New York: St. Martin's Press, 2001), p. 329 (originally published as "The Perils of Pauline," *New York Review of Books,* August 14, 1980).
 "no art can support": ibid., p. 325.

139 "The simple truth": ibid., p. 326.
 "an actor's scowl": "Trash, Art, and the Movies," in *Going Steady,* p. 88.
 "holding too many": Adler, "House Critic," p. 329.
 "disdains the good manners": Andrew Sarris, "Notes on the Auteur Theory in 1970," in *The Primal Screen: Essays on Film and Related Subjects* (New York: Simon and Schuster, 1973), p. 56.
 "to coerce, actually": Adler, "House Critic," pp. 329, 330.

140 "bullying, presuming": ibid., p. 334.
 "becomes a bandwagon": ibid., p. 341.
 even her beloved Renoir: See, for example, "The Making of *The Group,*" in *Kiss Kiss Bang Bang,* p. 76; *Conversations with Pauline Kael,* p. 166; and her reviews of *Eléna et Les Hommes* and *Picnic on the Grass* in *5001 Nights at the Movies.*
 "I've heard a few": *Conversations with Pauline Kael,* p. 154.

141 "it wasn't being cruel": ibid., p. 162.
 "Gere is to De Niro": "Forty-Eight Characters in Search of a Director" (review of *Bloodbrothers*), in *When the Lights Go Down,* p. 447.
 "If Woody Allen finds": "The Frog Who Turned into a Prince, the Prince Who Turned into a Frog" (review of *Stardust Memories*), in *Taking It All In,* p. 92.
 "still seemed to feel": Adler, "House Critic," p. 329.
 "an affectation of": ibid., p. 330.
 "It is overwhelmingly": ibid., p. 334.
 "She has, in principle": ibid., p. 329.

142 "an undercurrent of": ibid., p. 328.
 "sexual conduct, deviance": ibid., p. 331.
 half-column-long list: ibid., pp. 332–334. "Half-column" refers, of course, to the way the original article was laid out in *The New York Review of Books.* In *Canaries in the Mineshaft,* it covers the better part of two pages.
 "One gasbag": "Kaputt," in *When the Lights Go Down,* p. 120.

143 "quietly": Adler, "House Critic," p. 326.
 "shrill": ibid.
 "strident": ibid., p. 328.
 "overbearing," "hysterical": ibid.
 "quiet authority," "somewhat violent spectacle," "frenzy": ibid.
 "energy" and "good sense": ibid., p. 327.
 "interesting": ibid.
 "There was always": ibid., p. 343.
 "Let's leave aside": ibid., p. 339.

"The degree of": ibid., p. 331.

"She'd crunch": "Lazarus Laughs," in *When the Lights Go Down*, p. 35.

"all the squishing": Adler, "House Critic," p. 331.

144 "pure Kaelism": ibid., p. 332.

"(Did Altman run out of marshmallows?)": "The Altman Bunker," in *When the Lights Go Down*, p. 550.

"infatuation with": Adler, "House Critic," p. 339.

"It is difficult to": ibid., p. 334.

145 "a sign of integrity": ibid., p. 326.

146 "Art, perhaps unfortunately": Kael, "Movies, the Desperate Art," in *Film: An Anthology*, ed. Daniel Talbot (Berkeley: University of California Press, 1959), p. 64.

"It may be that": Linus Pauling, quoted in "The Intentions of Stanley Kramer," in *Kiss Kiss Bang Bang*, p. 207.

"Six years have": "The Intentions of Stanley Kramer," in *Kiss Kiss Bang Bang*, p. 207.

"Intentions, despite": ibid., p. 214.

"not think I am": *"The Day the Earth Caught Fire,"* in *I Lost It at the Movies*, pp. 176–177.

accused her of racism": Georgia Brown, "Bite the Ballot," *Village Voice*, January 9, 1990, pp. 73, 78.

"Racial inattentiveness": Georgia Brown, "Letters: Cinema in the Round," *Village Voice*, January 23, 1990, p. 4.

147 "So this is what": Alfred Kazin, "Americans Right, Left, and Indifferent: Responses to the Holocaust," *Dimensions* 4, no. 1 (April 1988), p. 14.

"incapable of responding": ibid., p. 12.

"Probably everyone": "Sacred Monsters," in *Hooked*, p. 83.

"famous for her": Kazin, "Americans Right," p. 12.

"from the woman who": Leon Wieseltier, "Washington Diarist: Moans," *New Republic*, February 3, 1986, p. 43.

"lighthearted adventure film": "Roger and Edwina, Sheena, and Uncle Jean," in *State of the Art*, pp. 224, 226.

148 "I think I understand": Wieseltier, "Washington Diarist," p. 43.

"Though he took": "Sacred Monsters," in *Hooked*, p. 86.

"facile judgment": ibid., p. 87.

"In the thirties": "Raising Kane," sec. 19, p. 53.

"The director doesn't": "Harlan County," in *When the Lights Go Down*, p. 253.

149 "in a class by": "Three Cheers," in *State of the Art*, p. 271.

"doesn't set you": "Sacred Monsters," in *Hooked*, pp. 86–87.

"closes your mind": ibid., p. 88.

"When you come out": ibid., p. 86.

"slows down this": ibid., p. 84.

"aestheticizes everything": ibid.

"dissenting view of": ibid.

"about the film and the catastrophe": Wieseltier, "Washington Diarist," p. 43.

150 "as a stand-in for": J. Hoberman, "Shoah Business," *Village Voice*, January 28, 1986, p. 65.

"*Shoah* is a long moan": "Sacred Monsters," in *Hooked*, p. 88.

"a Jew's pointing": ibid.

"Given her contempt": Hoberman, "Shoah Business," p. 65.

"If you were to set": "Sacred Monsters," in *Hooked*, pp. 87–88.

151 "Imagine, he actually": Hoberman, "Shoah Business," p. 65.

"essential question": ibid., p. 64.

152 "*Rich and Famous* isn't camp": "Three Pairs," in *Taking It All In*, p. 248.

"I have news": Stuart Byron, "Rules of the Game," *Village Voice*, November 11–17, 1981, p. 48.

"*Rich and Famous* had a promiscuous": Vito Russo, quoted in Al LaValley, "Out of the Closet and on to the Screen," *American Film*, September 1982, p. 63.

153 "cruises singles bars": "Goodbar, or How Nice Girls Go Wrong," in *When the Lights Go Down*, p. 317.

"The teasing near-subliminal": ibid., pp. 318–319.

"as if a woman": ibid., p. 318.

"something that most": ibid., pp. 317, 320.

"Pauline Kael attacked": Vito Russo, *The Celluloid Closet: Homosexuality in the Movies*, rev. ed. (New York: Harper and Row, 1987), p. 299.

"hopelessly demented": "Three Pairs," in *Taking It All In*, pp. 247, 248.

"I see it as": *Conversations with Pauline Kael*, p. 97.

154 "couldn't overtly": Russo, *Celluloid Closet*, p. 299.

"*Rich and Famous* was perhaps": ibid.

"masochistic": "Three Pairs," in *Taking It All In*, p. 248.

155 "I always thought": "*A View from the Bridge*, and a Note on *The Children's Hour*," in *I Lost It at the Movies*, p. 176.

"her knowledge of sexual": Byron, "Rules of the Game," p. 48.

"It wouldn't take more than": Ed Sikov, "Pauline at the Movies," *New York Native*, January 2–15, 1984, p. 30. A revised version of the article appears in—I'm sorry to say—Emanuel Levy, ed., *Citizen Sarris, American Film Critic: Essays in Honor of Andrew Sarris* (Lanham, Md.: Scarecrow Press, 2001).

"A minor problem": "*Victim*," in *I Lost It at the Movies*, p. 203.

156 "felt that if": ibid., p. 202.

"I'm beginning to": ibid., p. 201.

"In *Victim*, there is": ibid., p. 203.

"This was like saying": Russo, *Celluloid Closet*, p. 153.

157 "The situation is not simple": Kael, "Movies, the Desperate Art," p. 63.

"if the sexual": "Tangled Webs," in *Hooked*, p. 28.

"the delirium of excess": ibid., p. 29.

"I don't believe": ibid., p. 26.

"inside the leather": "Baggy Pants," in *Going Steady*, p. 240.

158 Russo, in fact, agrees: Russo, *Celluloid Closet*, p. 194.

"In *The Sergeant*, Rod": "Baggy Pants," in *Going Steady*, p. 240.

"I don't believe": *Conversations with Pauline Kael*, p. 98.

"I would much rather": "Survivor," in *Reeling*, p. 244.

159 "These movies are often": "Notes on Black Movies," in *Reeling*, p. 64.

"homo-erotic in style": "Genius" (review of *The Music Lovers*), in *Deeper into Movies*, p. 242.

"flaming anti-faggotry": "The Lower Trash/The Higher Trash" (review of *Valentino*), in *When the Lights Go Down*, p. 335.

"Would movie audiences": "Shouldn't *Old Acquaintance* Be Forgot?" in *When the Lights Go Down*, pp. 345–346.

"the constant derisiveness": "Hill's Pâté," in *When the Lights Go Down*, p. 277.

"If Newman had refused": ibid.

160 "old-fashioned but sweet": "*A Taste of Honey*," in *I Lost It at the Movies*, p. 197.

"The sweet man is now": ibid., p. 198.

"beauty-of-pathos stuff": "Tourist in the City of Youth" (review of *Blow-Up*), in *Kiss Kiss Bang Bang*, p. 31.

"Audiences longing for": "*A Taste of Honey*," in *I Lost It at the Movies*, pp. 200–201.

"a suffering middle-class": "Mozart and Bizet," in *State of the Art*, p. 255.

161 "persistent feminism": Kauffmann, "Focus on Criticism," p. 114.

"misapplied feminist zeal": Sarris, "Notes on the *Auteur* Theory in 1970," p. 55.

"fanatical feminism": "Correspondence and Controversy: *Movie* vs. Kael," p. 61.

162 "Is he consciously": "Baggy Pants," in *Going Steady*, p. 240.

"the *conscious* conspiracy": "Clobber-Move," in *Deeper into Movies*, pp. 160–161.

running for office in the arts: "The Intentions of Stanley Kramer," in *Kiss Kiss Bang Bang*, p. 214.

163 Russo later offered: Russo, *Celluloid Closet*, pp. 280–282.

"It was exactly the openness": Sikov, "Pauline at the Movies," p. 32.

164 "AIDS panic in its looniest": D. A. Miller, "Sontag's Urbanity," *October* 49 (summer 1989), p. 92.

"A lexicon that not only": ibid., pp. 94, 98.

165 "One feels that if": "Notes on 'Camp,'" in *Against Interpretation*, p. 291.

"phobic de-homosexualization": Miller, "Sontag's Urbanity," p. 93.

"unexamined and, I assume": ibid., p. 92.

alas, somewhat influential: Kim Michasiw, in "Camp, Masculinity, Masquerade," in *Feminism Meets Queer Theory*, ed. Elizabeth Weed and Naomi Schor (Bloomington: Indiana University Press, 1997), p. 82, comments, "In more recent works a footnoted reference to 'Sontag's Urbanity' permits the author to

proceed as if Sontag's homophobia had been proved beyond doubt." Michasiw provides examples; Poague provides another in his introduction to Leland Poague and Kathy A. Parsons, *Susan Sontag: An Annotated Bibliography, 1948–1992* (New York: Garland Publishing, 2000), pp. xxx–xxxii.
"decontamination": Miller, "Sontag's Urbanity," p. 92.

166 "She sounds like Matthew": William Deresiewicz, "The Radical Imagination," *New York Times Book Review*, November 4, 2001, p. 7.
"main conduit for French": Edmund White, "Letters: In Defense of Sontag," *New York Times Book Review*, November 25, 2001, p. 4.

167 "With genius, as": *The Volcano Lover*, p. 152.
compares her invidiously with Stanley Kauffmann: Raymond Carney, "Film Criticism I: Kael, Kauffmann, and Sarris," *Raritan* 1, no. 2 (fall 1981), pp. 95 ff.

4

169 "*La Femme Infidèle* isn't": "The Bourgeoisie and the Rabble," in *Deeper into Movies*, p. 54.
"*Klute* is far from": "Pipe Dream," in *Deeper into Movies*, p. 281.
"Although what they": "The Comedy of Depravity," in *Kiss Kiss Bang Bang*, p. 106.
"All movies are": Mitch Tuchman, "Pauline Kael: The Desperate Critic," *Take One*, November 1977, p. 32. Tuchman supplied the three aforementioned examples.

170 "There is more energy": "Zeitgeist and Poltergeist," in *I Lost It at the Movies*, p. 24.
"Since Kael has never": Edward Murray, "Pauline Kael and Pluralistic, Nonaesthetic Criticism," in *Nine American Film Critics* (New York: Frederick Ungar, 1975), p. 131.
"Siegfried Kracauer is the sort": "Is There a Cure for Film Criticism?" in *I Lost It at the Movies*, p. 269.

171 Sontag is fond of quoting: See, for example, *Conversations with Susan Sontag*, p. 85; and introduction to Sontag, ed., *Best American Essays 1992*, p. xviii. Wilde's remark comes at the end of his essay "The Truth of Masks."
"If I say that Chekhov": *Conversations with Susan Sontag*, pp. 240–241.

172 "We read critics for": *Conversations with Pauline Kael*, p. 121.
"because you must use": "Circles and Squares," in *I Lost It at the Movies*, p. 309.

173 "Is film criticism an art": *Conversations with Pauline Kael*, p. 89.
John Updike's memorable phrase: John Updike, *Hugging the Shore* (New York: Alfred A. Knopf, 1983), p. xv.
"I regard criticism as": "Replying to Listeners," in *I Lost It at the Movies*, p. 234.

174 "One does not set out": John Gregory Dunne, "Pauline," in *Quintana and Friends* (New York: E. P. Dutton, 1978), p. 152. Kael made a very similar observation herself; see *Conversations with Pauline Kael*, p. 40.

"There was probably too much": *Conversations with Pauline Kael*, p. 113.

like the gentleman-critics: "Notes on Heart and Mind," in *Deeper into Movies*, p. 231.

175 "In early 1962" : note to the paperback edition of *Against Interpretation*, p. vii.

"I consider my novels": *Conversations with Susan Sontag*, p. 19.

"I think narrative": Sontag, interview by Susan Swain, *Bookspan: In Depth*, C-SPAN 2 Cable Network, March 2, 2003.

177 "'progress' in the arts": "Nathalie Sarraute and the Novel," in *Against Interpretation*, p. 103.

"monstrous hulks": ibid., pp. 103–104.

Sontag's short fiction: collected in *I, etcetera*, with the following exceptions: "Description (of a Description)," *Antaeus*, 53 (autumn 1984), reprinted in *Harper's*, January 1985; "The Letter Scene," *The New Yorker*, August 18, 1986; "The Way We Live Now," *The New Yorker*, November 24, 1986, reprinted as *The Way We Live Now* (New York: Farrar, Straus and Giroux, 1991).

"poetry is the one form": Sontag, "The Writer, The Work: Thrown Voices," *PEN America* 1, no. 1 (winter 2000–2001), p. 103.

178 "In a sense, all his": "Lost and Found," in *Reeling*, p. 137.

"High art is dead": Cynthia Ozick, *Fame and Folly* (New York: Alfred A. Knopf, 1996), p. 47.

"that golden cape": ibid., p. 49.

179 "sharply, deeply, instantaneously": "In Plato's Cave," in *On Photography*, pp. 19–20.

"Nothing is more hateful": *The Volcano Lover*, p. 313.

"Nothing is more admirable": ibid., p. 316.

"It may be said": *The Benefactor*, p. 241.

"My urge to write": *Conversations with Susan Sontag*, p. 204.

"His is the hyperactivity": *The Volcano Lover*, p. 20.

"Even more than wanting": ibid., p. 23.

"Like many who were": ibid., p. 68.

180 "He starts to collect": ibid., p. 71.

"The Cavaliere was never": ibid., p. 79.

"It felt so natural": *In America*, p. 273.

"It's astonishing how": ibid., p. 47.

"You're beautiful": ibid., p. 289.

views Maryna as a monster: Michael Silverblatt, "For You O Democracy," *Los Angeles Times Book Review*, February 27, 2000, pp. 1–2.

she even calls herself one: *In America*, p. 319.

181 "America: a whole": ibid., p. 342.

"the discrediting of": "Trip to Hanoi," in *Styles of Radical Will,* p. 257.

"We feel oppressed": *The Volcano Lover,* p. 197.

Kael's sketch of the "major artist": "Fear of Movies," in *When the Lights Go Down,* pp. 430–431.

"He is pretentious": *The Volcano Lover,* p. 155.

182 "It's hard to think": "Private Worlds," in *Deeper into Movies,* p. 35.

"A triumph beyond": *In America,* p. 262.

"The houses were": ibid., p. 265.

"Nothing but panegyrics": ibid., p. 301.

"Her success has": ibid., p. 345.

"The greatest actress": ibid., p. 367.

"I want the essays": *Conversations with Susan Sontag,* p. 235.

183 essays might go through ten or fifteen drafts: Joan Acocella, "The Hunger Artist," *The New Yorker,* March 6, 2000, p. 76.

"making soup into a bouillon cube": *Conversations with Susan Sontag,* p. 257 (where "bouillon" is misprinted "boullion").

"That hidden and masterful something": Friedrich Nietzsche, "How I Broke Away from Wagner," sec. 2, *Nietzsche Contra Wagner,* in *The Portable Nietzsche,* ed. and trans. Walter Kaufmann (New York: Viking, 1968), p. 677.

184 "A narrative, it seemed": *AIDS and Its Metaphors,* p. 13.

185 "a work of art encountered": "On Style," in *Against Interpretation,* pp. 21, 22.

"I have very little": *Conversations with Susan Sontag,* p. 24.

186 "I wasn't inhibited": *Conversations with Pauline Kael,* p. 113.

"stridency and militancy": Hilton Kramer, "Susan Sontag: The Pasionaria of Style," in *The Twilight of the Intellectuals: Culture and Politics in the Era of the Cold War* (Chicago: Ivan R. Dee, 1992), p. 229 (a review of *A Susan Sontag Reader* originally published in *The Atlantic Monthly,* September 1982).

"papal infallibility": Andrew Sarris, "Pauline and Me: Farewell, My Lovely," *New York Observer,* September 17, 2001, p. 19.

"the hatred of those who": "On the Future of Movies," in *Reeling,* p. 317.

"what is perhaps": "The Intentions of Stanley Kramer," in *Kiss Kiss Bang Bang,* p. 210.

"Three things in human": Leon Edel, *The Master: 1901–1916,* vol. 5 of *The Life of Henry James* (Philadelphia: J. B. Lippincott, 1972), p. 124.

187 "a vast difference betwixt": John Dryden, "A Discourse Concerning the Original and Progress of Satire" (1693).

"Infallible taste is": Circles and Squares," in *I Lost It at the Movies,* p. 308.

188 "I really do think": *Conversations with Susan Sontag,* p. 176.

repudiating the series: "Thirty Years Later . . . ," in *Where the Stress Falls,* p. 272. She also speaks of her distaste for these reviews in "Susan Sontag," in *Women Writers at Work: The "Paris Review" Interviews,* ed. George

Plimpton (New York: Modern Library, 1998), pp. 388–389 (interview originally published as "Susan Sontag: The Art of Fiction CXLIII," in *Paris Review* 137 [winter 1995]).

the bad conscience of one's time: Friedrich Nietzsche, *Beyond Good and Evil*, sec. 212, in *Basic Writings of Nietzsche*, ed. and trans. Walter Kaufmann (New York: Modern Library, 1992), p. 327.

"mercantile values": *Regarding the Pain of Others*, p. 23.

"The quality of American": "What's Happening in America (1966)," in *Styles of Radical Will*, p. 194.

"the era of cinema's": "Syberberg's Hitler," in *Under the Sign of Saturn*, pp. 140, 163.

189 "entered, really entered": "Thirty Years Later . . . ," in *Where the Stress Falls*, p. 272.

"press agentry": Robert Brustein, "Pauline Kael, Still Going Steady" (review of *Reeling*), *New York Times Book Review*, April 4, 1976, p. 2.

comparing the first screening of *Last Tango*: "Tango," in *Reeling*, pp. 27–28.

190 "Aesthetic theories don't": "Metamorphosis of the Beatles" (review of *Yellow Submarine*), in *Going Steady*, p. 190.

"In the arts, one": ibid.

191 "a kind of wonder": Greil Marcus, "Pauline Kael: *I Lost It at the Movies*," *Artforum*, September 1993, p. 141.

193 "The taint of artistry": *Regarding the Pain of Others*, p. 26.

"flying low": ibid., p. 27.

"There is no talented": "The Aesthetics of Silence," in *Styles of Radical Will*, p. 8.

195 "The plane circled": "Movies on Television," in *Kiss Kiss Bang Bang*, p. 217.

198 "It's like an epic-size": "Chance/Fate," in *Taking It All In*, p. 177.

200 "Costner has feathers": "New Age Daydreams," in *Movie Love*, p. 295.

POSTSCRIPT

203 2003 speech honoring Israeli soldiers: "On Courage and Resistance," *The Nation*, May 5, 2003, pp. 11–14; also available at http://www.tomdispatch.com/index.mhtml?pid=616b.

204 accepting the Peace Prize: Sontag's speech is excerpted as "Literature and Freedom" in the *Los Angeles Times Book Review*, October 26, 2003, pp. R–10 and R–11. The full speech is available at http://www.tomdispatch.com/index.mhtml?pid=1031.

"Regarding the Torture of Others": *New York Times Magazine*, May 23, 2004, pp. 24–29, 42.

"All acts are done by individuals": ibid., p. 26.

the pivotal moment: *On Photography*, pp. 19–20.

205 "Looking at these photographs": "Regarding the Torture of Others," p. 28.

206 "the Bush administration has committed": ibid., p. 29.

"The torture of prisoners": ibid.

"The photographs are us": ibid., p. 26.

Orwell's *permanent war: 1984*, Chapter IX, near the end of the "War Is Peace" section, in the paragraph beginning "The war, therefore."

Acknowledgments

I'M GRATEFUL—DEEPLY GRATEFUL—to the following friends and colleagues for their help: John Bennet, Jacqueline Carey, Judith Coburn, Bruce Diones, Ian Frazier, Ruth Henrich, Richard Howard, Gina James, Charles Loxton, Danny Mangin, Laura Miller, Silvana Nova, Linda Olle, Jim Peterson, Kathleen Quinn, Jim Standard, Judith Steinsapir, and Alice Truax. A fellowship from the National Arts Journalism Program at Columbia University allowed me to work on *Sontag & Kael* full-time. Anyone doing research on Sontag owes thanks to Leland Poague and Kathy A. Parsons for their exhaustive *Susan Sontag: An Annotated Bibliography, 1948–1992*. And I have an old and unrepayable debt to Cleo Hudson.

Index

Printed in the United States
by Baker & Taylor Publisher Services